THE LOST CITY OF
LONDON

London, thou art of townes a *per se*.
Soveraign of cities, seemliest in sight,
Of high renoun, riches and royaltie;
Of lordis, barons, and many a goodly knyght;
Of most delectable lusty ladies bright;
Of famous prelatis, in habitis clericall;
Of merchauntis full of substaunce and of myght:
London, thou art the flour of Cities all …

Above all ryvers thy Ryver hath renowne,
Whose beryall stremys, pleasaunt and preclare,
Under thy lusty wallys renneth down,
Where many a swan doth swymme with wyngis fair;
Where many a barge doth saile and row with are;
Where many a ship doth rest with top-royall.
O, towne of townes! patrone and not compare,
London, thou art the flour of Cities all.

Upon thy lusty Brigge of pylers white
Been merchauntis full royall to behold;
Upon thy stretis goeth many a semely knyght
In velvet gownes and in cheynes of gold.
By Julyus Cesar thy Tour founded of old
May be the hous of Mars victoryall,
Whose artillary with tonge may not be told:
London, thou art the flour of Cities all.

Strong be thy wallis that about thee standis;
Wise be the people that within thee dwellis;
Fresh is thy ryver with his lusty strandis;
Blith be thy chirches, wele sownyng be thy bellis;
Rich be thy merchauntis in substaunce that excellis;
Fair be their wives, right lovesom, white and small;
Clere be thy virgyns, lusty under kellis:
London, thou art the flour of Cities all.

Thy famous Maire, by pryncely governaunce,
With sword of Justice thee ruleth prudently.
No Lord of Parys, Venyce, or Floraunce
In dignitye or honour goeth to hym nigh.
He is exampler, loode-ster, and guye;
Principall patrone and rose orygynalle,
Above all Maires as maister most worthy:
London, thou art the flour of Cities all.

William Dunbar, *In Honour of the City of London*, 1501.

THE LOST CITY OF
LONDON

Before the Great Fire of 1666

ROBERT WYNN JONES

AMBERLEY

First published 2012

Amberley Publishing
The Hill, Stroud
Gloucestershire, GL5 4EP

www.amberley-books.com

British Library Cataloguing in Publication Data.
A catalogue record for this book is available from the British Library.

ISBN 978 1 4456 0848 8

Typeset in 10pt on 12pt Sabon.
Typesetting and Origination by Amberley Publishing.
Printed in the UK.

CONTENTS

About the Author 7

Acknowledgements 8

Preface 9

A Brief History of the Lost City of London 11

 Bedrock 11

 Foundation 11

 Ancient British or Celtic London ('Caire Lud') 12

 Roman London (Londinium) 13

 Anglo-Saxon and Viking London (Lundenburg) 18

 Norman to Stuart London (Londinopolis) 20

 The Great Fire of 1666 38

 Aftermath 43

Surviving Structures and Streets 46

Appendix: Suggested Itineraries for Walks 144

Cited and Other References 148

Other Resources 156

List of Illustrations 157

ABOUT THE AUTHOR

Robert Wynn Jones is a professional palaeontologist, and an interested amateur archaeologist and historian. He has lived in London practically all his adult life.

His distant ancestor John West, born in 1641, lived in London in the late seventeenth to early eighteenth centuries. John West served a seven-year apprenticeship as a Clothworker from 1658, becoming a Freeman by servitude of the Clothworkers' Company in March, 1666, a Liveryman in 1673, and a Master in 1707. He also served as a Scrivener, a Deputy Alderman of *Walbrook* Ward, and a Governor of *Christ's Hospital*. He was married in the church of *St Gregory by St Paul's* in February, 1666 to the widow Frances Mickell (whose first husband Robert had died in the Great Plague in 1665). John and his wife are recorded as having lived in a house near the Stocks Market in the heart of the city, which presumably, like the church in which they were married, would have been burnt down during the Great Fire of September, 1666. They were noted benefactors of *Christ's Hospital*, of *St Bartholomew's Hospital*, and of the parish church of *St Christopher-le-Stocks*. John died in 1723, and Frances in 1725, and both were buried in *St Christopher-le-Stocks*, although after that church was demolished their remains were disinterred and moved to Nunhead Cemetery, where there are no surviving memorials to them (although, incidentally, their names can still be seen on a board listing the benefactors to *St Bartholomew's Hospital* in the Great Hall of that institution, and also on another board listing the 'Benefactors to the Parish of St Christopher London' in the north-west corner of *St Margaret Lothbury*). It appears that in life John West numbered among his acquaintances Sir John Moore, Lord Mayor of London in 1681–2, and, even more amazingly, Samuel Pepys, and that he was one of the witnesses to Pepys's will and codicils, and attended Pepys's funeral in *St Olave Hart Street*, in 1703.

John West's father Simon was a Freeman by servitude of the Worshipful Company of Stationers, and a Bookseller, who owned a shop under the sign of the Blackamoor's Head in *Wood Street*, off *Cheapside*. He was also a Warden of the church of *St Peter Westcheap* in 1662–3, just before it, too, was burnt down in the Great Fire of 1666. He was married three times, the last time in 1677 in *All Hallows London Wall*.

ACKNOWLEDGEMENTS

Thanks to my wife Heather and sons Wynn and Gethin, and to Wynn's girlfriend Jess, for their help with various aspects of the project (especially to Gethin for producing the maps); and to Nicola Gale and Tom Furby at Amberley for seeing it through to completion. Also to Hildegard von Bingen for musical inspiration.

PREFACE

At first glance, one might think that not much remains today of the anatomy of the City of London* from before the time of the Great Fire of 1666, which according to contemporary accounts and maps destroyed 80 per cent of the City, including around 13,000 private residences and places of business within and immediately without the walls, eighty-four parish churches and *St Paul's Cathedral*, forty-four Livery Company Halls, the *Custom House*, the *Guildhall*, the *Royal Exchange*, the *Royal Wardrobe* and *Castle Baynard*.

But dig a little deeper, literally or metaphorically, and it is still possible to uncover hidden treasures from that ancient time. Dab away at the accumulated tarnish of the centuries, and it is still possible once more to bring to light an ancient masterpiece.

That is what this is all about. Re-establishing the ancient City limits and street plans from surviving structures and streets, maps and historical records, and archaeological finds. And recreating the ancient lives, sights, sounds and smells of those streets in the City of one's imagining.

* The City of London as presently or previously defined, and as discussed below, incorporates some areas that lie a little outside the original walls (including *Southwark*, south of the river). Pre-Great Fire Greater London extended even further out, especially along the Thames: on the north side of the river, as far west as *Westminster*, and as far east as *Wapping*, *Shadwell*, *Ratcliff*, *Limehouse*, *Poplar* and *Blackwall*; and on the south side, as far west as *Lambeth*, and as far east as *Bermondsey* and *Rotherhithe*. The Great Fire was substantially confined to the old walled City.

A BRIEF HISTORY OF THE LOST CITY OF LONDON

Bedrock

The bedrock on which London may be said to have been built is arranged in the form of a basin, with its base buried beneath the city, and its rim exposed at the surface surrounding it, in the Chilterns to the north and in the North Downs to the south (Clements, 2010). The basin is filled with, in order, chalk, London Clay, and Thames Alluvium. Chalk is composed of the skeletal remains of innumerable individually microscopic algae and associated organisms that once flourished in an ancient ocean around 100 million years ago. It is a porous rock, and contains an abundant underground water supply, capable of being tapped into through so-called Artesian wells. London Clay, in contrast, is non-porous, impervious to the flow of water, and poorly drained, and often associated with presently or formerly marshy areas. It is constituted of detrital clay, silt and sand as well as abundant plant and primitive animal fossils, for which latter the site of Abbey Wood in south-east London is famous, that accumulated on the strandline of a sub-tropical sea some fifty million years ago. Thames Alluvium is formed of material deposited along the water-course of the city's river, past and present. The Thames assumed its present course when its past one was diverted, by ice, during the Ice Age, a few hundred thousand years ago (Sidell *et al.*, 2000). During glacial periods of the Ice Age, woolly mammoths roamed the then tundra around what is now London (their remains have been found at Southall to the west of the city). During the last inter-glacial, elephants and hippopotamuses wallowed in water-holes in what is now Trafalgar Square!

Foundation

The ancient human occupation of Britain began during the Ice Age. Artefacts have been found in inter-glacial deposits at Happisburgh in Norfolk that date back around three-quarters of a million years, and actual archaic human remains in inter-glacial deposits at Boxgrove in West Sussex that date back around half a million years. It appears, though, that humans were essentially unable to live in Britain

during glacial periods, and only really became established here in the post-glacial period, during the thaw, and the regrowth of the wildwood, commencing some ten thousand or so years ago. There is a little archaeological evidence from Uxbridge to the west of London, Hampstead to the north, *Shoreditch* to the east, and *Southwark* to the south, for hunting and gathering activity in the Late Palaeolithic (Old Stone Age), and for woodland clearance and settled farming in the Mesolithic (Middle Stone Age) and Neolithic (New Stone Age), between the eighth and fourth millennia BCE (Merriman, 1990). There is a lot of evidence from a number of localities for settlement and associated activity, including metal-working activity, in the Bronze Age, from the third millennium BCE, and in the Iron Age, from the first millennium BCE (Merriman). The many forts topping hills around London date from the Iron Age, for example, that on Wimbledon Common.

A 'Museum of London Archaeology Service' archaeology study records some Middle Bronze Age worked flints and pot-sherds from archaeological excavations at No. 25 *Cannon Street* in the City of London (Elsden, 2002).

Ancient British or Celtic London ('Caire Lud')

London itself would appear to have been founded by the ancient Britons or Celts in the Bronze or Iron Age, at the crossing-point on the Thames closest to the sea. According to the now sadly thoroughly discredited Geoffrey of Monmouth, quoted by John Stow, in his magisterial *Survay of London, written in the Year 1598*, it was founded under the reign of King Lud, sometime in the first century BCE, and at that time called 'Caire Lud', or Lud's town (or fort). When Lud died, his two sons Androgeus and Tenvantius, or Theomantius, as Stow put it, ' ... being not of an age to govern ... , their uncle Cassibelan [Cassivellaunus] took upon him the crown; about the eighth year of whose reign, Julius Caesar arrived in this land with a great power of Romans to conquer it'. The Roman invasion under Caesar, described in his *Gallic Wars*, was in 55–54 BCE.

Unfortunately, the only surviving structures from the Celtic period in London are some enigmatic pits and post-holes interpreted as representing the sites of former homesteads or farmsteads, in *Leicester Square* in the West End, near the Houses of Parliament in *Westminster*, and south of the Thames in *Southwark* (and the remains of a bridge at *Vauxhall*). There are no surviving structures or streets from the Celtic period in the City of London, perhaps at least in part because, again as Stow put it, ' ... the Britons call that a town ... when they have fortified a cumbersome wood with a ditch and rampart'. This period of the city's history remains shrouded in mist and mystery.

Important archaeological finds from the Celtic period in London include (among more or less everyday items such as coins in potin, or tin-rich bronze, in bronze, in silver and in gold) much equipment associated with

horses and chariots, a ceremonial horned helmet recovered from the Thames at Waterloo, and an ornate bronze shield recovered from the Thames at Battersea. It has been speculated that the last-named might have been offered as a plea to the gods of the river at the time of the Roman invasion.

Roman London (Londinium)

History

The Roman invasion under Claudius was in AD 43, and Roman London, or Londinium, was established in around 50, on strategically important high ground immediately north of the Thames, at a point at which the river was still tidal, and hence readily navigable by boat (Merrifield, 1969, 1983; Webb, 2011a). If Rome was built on seven hills, Roman London was built on two, *Ludgate Hill* to the west, and *Cornhill* to the east, with the valley of one of the Thames tributaries – the Walbrook – in between. The early Roman city was razed to the ground by revolting ancient Britons under Boudicca (Boadicea of the Victorian re-imagining), the Queen of the Iceni, in 60 or 61, while the legions were away attacking the druid stronghold on Anglesey (the Britons were subsequently routed at the Battle of Watling Street, the precise location of which remains uncertain). The city was then rebuilt, in phases, one of which followed its partial destruction by a fire in 125, and it was designated capital of Britannia Superior in 200. The Roman Empire as a whole came under attack both from within and without during the late second, third and fourth centuries, and the Emperor Honorius decided not to send any further troops from an increasingly beleaguered Rome to defend outposts of empire such as Britain in 410 (in fact, some legions were recalled to Rome in that year). Archaeological evidence indicates that Roman London had been essentially abandoned by the mid-fifth century. Further evidence points to an Anglo-Saxon presence in the city, although not a full-scale occupation, from around 430–50.

Social History
Everyday life in Roman – as indeed in all other – times would have revolved around the requirement and search for sustenance for body and soul.

Religion
The predominant religion during the Roman occupation was paganism, at least until the time of conversion to Christianity of Emperor Constantine in 312, and the Council of Arles in 314, which was attended by representatives from Londinium. During the pagan period, there were perceived deities in all things, abstract as well as tangible. The principal funerary rite was cremation, although this later gave way to inhumation. Remains were buried outside the city limits, for example, just outside *Aldgate*, *Bishopsgate*, or *Newgate*.

Food and Drink

The diet of the average citizen of Roman London would appear to have been a surprisingly healthy one. By the turn of the first and second centuries, the City was already not only an administrative centre, but also a important commercial and trading one, with the port at its heart, and there were evidently numerous shops both within the *Basilica and Forum*, and lining the roads leading to and from it, where all manner of imported as well as locally produced foodstuffs could be bought, including olives, olive oil, wine, grape juice, dates, figs, salted fish and fish sauce, from all around the Empire, brought in by boat in pottery '*amphorae*'. Carbonised grain has been found in *Pudding Lane* and in *Fenchurch Street*, and points to the former presence of bakeries at these sites. Part of a donkey-driven mill found has been found in Princes Street.

Sanitation

Sanitary conditions were also conducive to good public health. There were numerous public bath-houses intended for daily use, for example, ones on *Cheapside* and *Huggin Hill*, dating to the late first or early second century; one in *Billingsgate*, dating to the late third or fourth, and one on *Strand Lane* (which may actually be a seventeenth-century copy). There was even a rudimentary sewerage system.

Building Works

Restoring the mosaic of Roman London from the isolated '*tesserae*' that remain is a challenging task. The Roman *London Bridge* and embryonic Port of London was originally built around AD 50 (Milne, 1985; Marsden, 1994). The *Governor's Palace* was built during the Flavian period of the late first century, around 69–96, on the then-waterfront, which was much further north in Roman times than it is today, and in use throughout the second and third, before being demolished in the late third or fourth, the remains only coming to light again during the nineteenth. The first undoubted *Basilica and Forum* were built around 70 (there may have been earlier ones, destroyed during the Boudiccan Revolt of 60 or 61), and rebuilt and considerably extended around 100–130, before being substantially demolished around 300, only coming to light again during excavations at 168 *Fenchurch Street* in 1995–2000. The *Amphitheatre* was originally built in timber around 75, rebuilt in stone in the second century, and renovated in the late second to third, before being abandoned in the fourth, and only coming to light again during excavations on the site of the Medieval *Guildhall* in 1987. The *City Wall*, incorporating the fort at Cripplegate to the north-west, was originally built in the early second century (substantially out of a building stone called Kentish Rag, which was quarried near Maidstone and transported by boat down the Medway and up the Thames to London), and strengthened and extended in the late second to

third, and again in the fourth, when a river wall was added. The *Temple of Mithras* on the bank of the *Walbrook* was originally built in the early third century, around 220–40, and abandoned in the fourth, when Christianity came to replace paganism throughout the Roman Empire. There may also have been a religious precinct in the south-west of the city in the third century.

The pattern of the Roman roads within and without the City may best be described as radiating out from the *Basilica and Forum* towards the various gates, which were, anti-clockwise from the east: *Aldgate, Bishopsgate, Cripplegate, Aldersgate, Newgate* and *Ludgate* (*Moorgate* was a later addition). Interestingly, the Romans do not appear to have had names for their roads. Ermine Street, which was the main south to north route of Roman Britain, linking London by way of *Bishopsgate* to Lincoln and York, takes its name from the Anglo-Saxon Earninga straet, after one Earn(e). *Watling Street*, the main east to west route, linking Richborough on the Kent coast to London by way of *Aldgate*, and from London by way of *Ludgate* to Wroxeter, takes its name from the Anglo-Saxon Waeclinga or Waetlinga straet, after one Waecel.

Surviving structures and streets are indicated on Map One, and are discussed in a little more detail immediately below, and in the appropriate part of the body of the text.

The *Governor's Palace* forms a Scheduled Ancient Monument substantially buried beneath Cannon Street Station. The so-called '*London Stone*' that stands opposite the station is likely a relic of the *Governor's Palace*. A pier base from the *Basilica* and *Forum* can be seen in the basement of No. 90 Gracechurch Street. The surviving structures of the *Amphitheatre* and associated artefacts can be viewed in the basement of the *Guildhall* on *Gresham Street*. The best-preserved sections of the – Roman and Medieval – *City Wall* are near the Museum of London on *London Wall* to the west, where battlements and substantially intact bastions can be seen, and around *Tower Hill* to the east. The *Temple of Mithras* is on Queen Victoria Street. Surviving parts of a *Roman* – or Roman-style – *bath-house* can be seen on *Strand Lane*.

Archaeological Finds

The more important, including 'high-status', archaeological finds from Roman London are on exhibition in the City's principal museums, that is to say, the Museum of London on *London Wall*, the British Museum in Bloomsbury in the West End, and the Victoria and Albert in South Kensington. A series of 'Museum of London Archaeology Service' monographs describe in detail the findings of archaeological excavations at the sites of *London Bridge*, the *Governor's Palace*, the *Basilica and Forum*, the *Amphitheatre*, and the recently discovered site on *Poultry*. Other publications describe the findings from around the various gates to the Roman City, on the waterfront, and south of the river in *Southwark*.

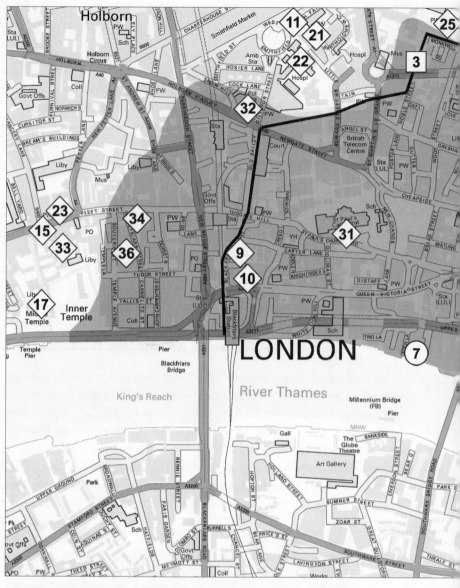

Map One: Structures Built Before the Great Fire of 1666 and Still Standing
Contains Ordnance Survey data © Crown copyright and database right (2012)
Bold line indicates that of City wall
Shaded area indicates that affected by Great Fire of 1666

Roman (Squares)	Saxon and Viking (Circles)	Norman to Stuart, or
1. Amphitheatre	6. All Hallows Barking	Medieval to Post-Medieval
2. Basilica and Forum	7. Queenhithe	(Diamonds)
3. City Wall		8. All Hallows Staining
4. Governor's Palace		9. Apothecaries' Hall
5. Temple of Mithras		10. Blackfriars Monastery

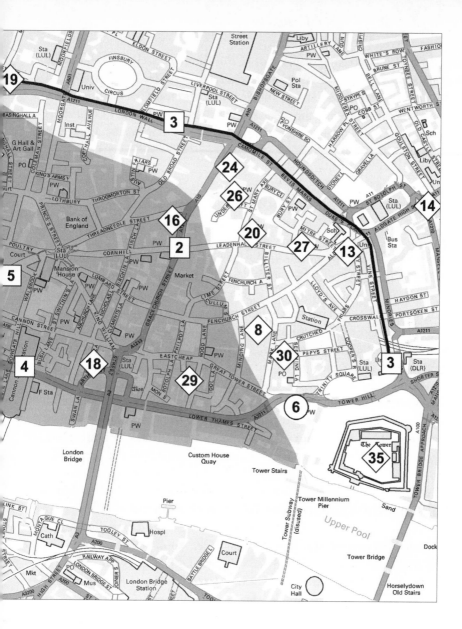

11. 41 Cloth Fair
12. Guildhall
13. Holy Trinity Priory
14. Hoop and Grapes
15. Inner Temple Gatehouse
16. Merchant Taylors' Hall
17. Middle Temple Hall
18. Olde Wine Shades
19. St Alphage

20. St Andrew Undershaft
21. St Bartholomew the Great
22. St Bartholomew the Less
23. St Dunstan-in-the-West
24. St Ethelburga
25. St Giles Cripplegate
26. St Helen

27. St Katharine Cree
28. St Mary Aldermary
29. St Mary-at-Hill
30. St Olave Hart Street
31. St Paul's Chapter House
32. St Sepulchre
33. Temple Church
34. Tipperary
35. Tower of London
36. Whitefriars Monastery

There are also interesting displays of *in situ* Roman tessellated pavements and of associated finds in the crypts of the churches of *All Hallows Barking*, on Byward Street/*Great Tower Street*, and *St Bride*, off *Fleet Street*. *All Hallows Barking* also features a fine dioramic reconstruction of Roman London. A timber from one the Roman wharves stands outside *St Magnus the Martyr* on *Lower Thames Street*.

Anglo-Saxon and Viking London (Lundenburg)

History

Considerably less is known about this period of history than either the succeeding or indeed even the preceding one, such that it is often referred to as the 'Dark Ages'.* What is known is that there was essentially a hiatus in the occupation of London between when the Romans left, in the fifth century, and when the Anglo-Saxons arrived, in numbers, at the turn of the sixth and seventh. By the time the Anglo-Saxons did arrive, the Thames had become tidal and as such navigable well to the west of the Roman city, indeed as far west as *Aldwych* in *Westminster*, such that that was where they established their main settlement, called Lundenwic. By the turn of the eighth and ninth centuries, the Anglo-Saxons had become subject to increasingly frequent and savage raids by the Vikings. In 842, the Vikings attacked Lundenwic, with 'great slaughter', and in around 871, they established a temporary settlement there. Then, in 878, Alfred 'the Great', the King of Wessex, the only Anglo-Saxon kingdom not to have fallen by then to the Vikings, recaptured Lundenwic, and in 886, he reoccupied the old walled City of Londinium, to make use of the old Roman defences (and civic buildings), and renamed it Lundenburg. Edward 'the Elder' took control of the City and essentially the country after Alfred's death, and Edward's son Athelstan became the first recognised King of – all – England after Edward's death, in 924. The Viking raids continued, though, and in 1016 Canute, or Cnut, son of Sweyn Forkbeard, defeated in battle Edmund II, 'Ironside', to become King of England as well as Denmark. Canute was in turn succeeded by his sons Harold I, 'Harefoot', in 1035, and Hardicanute, in 1040. Edward 'the Confessor', generally thought of as Anglo-Saxon, being the son of Ethelred II, 'the Unready', although also descended from the Viking Harold Bluetooth, became king when Hardicanute died, leaving no heir, in 1043; and the ill-fated Harold II, in 1066.

* One of the reasons we know so little is that the Anglo-Saxons appear to have built almost exclusively using perishable materials such as timber, wattle-and-daub, and thatch, which typically leave very little archaeological record.

Building Works

St Paul's Cathedral was founded in 604, by the Kentish king Ethelburg, and the nunnery and later church of *St Mary Overie*, now incorporated into *Southwark Cathedral*, in 606 – shortly after Christian missionaries under St August came to England to convert the pagan Anglo-Saxons in 597. The churches of *All Hallows Barking* and *St Michael Cornhill* were originally built in the Anglo-Saxon period, the former in around 675, and many others are of probable or possible Anglo-Saxon origin. The palace of the Mercian King Offa was originally built in the eighth or ninth century. What is now known as *Queenhithe* was first recorded in 898, as 'Ethelred's Hithe'; and *Billingsgate*, in 949 (Marsden, 1994; Milne, 2003). Further afield, what is now known as *Westminster Abbey* was founded during the reign of Edward 'the Confessor', in 1045.

The Anglo-Saxon street plan, modified after the Roman one, was essentially longitudinal, to allow ready access to the main settlement to the west. *Poultry* and *Cheapside* became established in the centre of the City, and *Eastcheap* and *Cannon Street* slightly to the south, and close to the waterfront. Anglo-Saxon street names were characteristically blunt, often referring simply to available goods or services ('cheap' referring to a market).

Surviving structures and streets are indicated on Map One, and are discussed in a little more detail immediately below, and in the appropriate part of the body of the text.

Essentially nothing now remains of the original Anglo-Saxon fabric in *St Paul's Cathedral, St Mary Overie* or St *Michael Cornhill* (the first St Paul's having been lost in the seventh century; the second, the Church of Paulesbyri, having been destroyed by the Vikings in 962; and the third having been destroyed by fire in 1087). Nothing remains either of the palace of the Mercian King Offa, incorporated into *St Alban Wood Street*, in turn severely damaged by bombing during the Blitz of 1940, and substantially demolished in 1955; nor anything of *Queenhithe* or *Billingsgate*, other than the names.

There are surviving Anglo-Saxon remains in the church of *All Hallows Barking*, on Byward Street/*Great Tower Street*. These include a fine stone arch, incorporating Roman tiles, and, in the exhibition in the crypt, two stone crosses of markedly Celtic appearance, suggesting strong cultural interchange between the Anglo-Saxons and the (Romano-) Britons.

Archaeological Finds

The more important archaeological finds from Anglo-Saxon London are on exhibition in the City's principal museums. The Museum of London on *London Wall* features a reconstruction of a typical Anglo-Saxon dwelling of timber, wattle-and-daub, and thatch. It's really rather cosy inside.

A 'Museum of London Archaeology Service' monograph deals with the finds from and reconstruction of the Saxon site at the Royal Opera House

in *Covent Garden* in the West End. Another deals with finds from Early to Middle Saxon rural occupation and riverside fish-trap sites in the Greater London region, within a twenty-five-kilometre (sixteen-mile) radius of the City. As in preceding times, preferred sites for occupation were on well-drained land on gravel terraces close to rivers. Settlements consisted mainly of small isolated farms and hamlets, with only occasional larger and wealthier estates. The agricultural economy centred on the production of cereal crops, including wheat, barley, oats and rye, and of cattle, presumably for milk as well as meat. Pulses, nuts, fruit and berries were also produced and consumed.

Norman to Stuart London (Londinopolis)

History

This was a time of historical, political, religious and social transformation, not to say turmoil, over six hundred years, and under six royal houses and a Parliamentarian – albeit authoritarian – Commonwealth and Protectorate; of historical events that determined the then-future destiny of the country of England and its capital city. It was a time of war, unending war: war between the English and the Scots, and the Welsh, and the Irish; war between the English and the French, and the Spanish, and the Dutch; and, when there was no-one else willing to fight, war among the English (the War of the Roses, in the mid-fifteenth century, and the Civil War, in the mid-seventeenth). War, and Plague. The defining spirit of the age was one of ebullient confidence, undercut in the dead of night by dread; of 'eat, drink and be merry, for tomorrow we die'.

Norman to Yorkist History

Under the Normans, that is, William I, 'the Conqueror' (1066–87), William II (1087–1100), Henry I (1100–35) and Stephen (1135–54), and their successors the Plantagenets, Henry II (1154–89), Richard I (1189–99), John (1199–1216), Henry III (1216–72), Edward I (1272–1307), Edward II (1307–27), Edward III (1327–77) and Richard II (1377–99), the Lancastrians, Henry IV (1399–1413), Henry V (1413–22) and Henry VI (1422–61), and the Yorkists, Edward IV (1461–83), Edward V (1483) and Richard III (1483–5), it was a time of conquest and oppression; of crusade, and of pilgrimage; of pestilence, and of penitence; of fanfare, and of plainsong.

Under the Normans, and indeed the Plantagenets, the City of London remained outwardly little changed, still largely confined within the Roman walls and laid out according to the Anglo-Saxon street plan. There were, though, sweeping changes to the way the City, and indeed the country, was run, under the king and his place-men, under the feudal system. At the same time, the ruling elite, though powerful, was small, and more than a little wary of the large and potentially rebellious population now nominally under its

control. In consequence, successive Norman and Plantagenet kings made a series of placatory political moves to maintain and even extend the rights and privileges that the City had enjoyed under the Anglo-Saxon King Edward, 'the Confessor'. William I, 'the Conqueror', granted the City a charter in 1067, which read, in translation (from Old English rather than French): 'William King greets William the Bishop and Geoffrey the Portreeve and all the citizens in London, French and English, in friendly fashion; and I inform you that it is my will that your laws and customs be preserved as they were in King Edward's day, that every son shall be his father's heir after his father's death; and that I will not that any man do wrong to you. God yield you.' (The so-called 'William Charter', inscribed on a strip of vellum measuring only six inches by one and a half, is now in the London Metropolitan Archives). Richard I appointed the first Lord Mayor, in effect to run the City, in 1189; and the prestige of the position was such that John invited a later, and by then elected, Lord Mayor to be a signatory to the Great Charter, or *Magna Carta*, which set in motion the train of events that eventually led to our modern system of Parliamentary democracy, in 1215 (the *Magna Carta* is also now in the London Metropolitan Archives). But lest the City go getting ideas above its station, there were everywhere within it and without reminders of the Royal presence, and of where the real power lay: the *Tower of London*, and the gallows and scaffold on *Tower Hill*, in the east; *Castle Baynard*, the *Royal Wardrobe*, the Tower of Montfichet, and the *Fleet Prison*, in the west; and the *Savoy Palace* a little further afield to the west, on the *Strand*.

The City was subject to a series of ravages in the fourteenth century, first by a famine of biblical proportions in 1315, and then by the so-called 'Black Death' in 1348–9, 1361, 1368 and 1375. The 'Black Death' appears to have been an especially virulent and contagious strain of bubonic plague, possibly pneumonic or septicaemic, and hence capable of being passed from person to person; and, moreover, one more than usually resistant to cold, and hence capable of surviving over winter (the spread of the disease is ordinarily significantly slowed by outdoor temperatures of less than ten degrees C) (Callaway, 2011; Sloane, 2011). Around half of the population of the City, or 40,000 people, died in the 1348–9 outbreak, most of whom were buried, with more or less ceremony, in 'Plague pits' in *East* and *West Smithfield*. The horror can only be imagined.

In the immediate aftermath of the 'Black Death', the demand for labour came to greatly exceed the supply, City- and country-wide. At the same time, the work-force had its wages frozen, under the Ordinance of Labourers of 1349; and then became subject to an understandably even more unpopular, and extremely unjustly enforced, Poll Tax in 1377. Civil unrest followed in the Peasants' Revolt of 1381, which came to a head in a confrontation, at

West Smithfield, between on the one side a thousands-strong peasant mob,* and on the other, heavily armed knights and henchmen, officers of the City, and the then boy-King Richard II, as chronicled by Froissart. The revolt also effectively ended then and there, with the death of one of its leaders, Wat Tyler, at the hands of the Fishmonger and Lord Mayor of London William Walworth – whose dagger is to this day exhibited in Fishmongers' Hall. (The other leader of the revolt, incidentally, was Jack Straw, after whom Jack Straw's Castle on Hampstead Heath is named).

Tudor History

Under the Tudors, that is, Henry VII (1485–1509), Henry VIII (1509–47), Edward VI (1547–53), Mary (1553–8) and Elizabeth I (1558–1603), it was above all a time of reformation and dissolution. The Act of Supremacy of 1534 marked the beginning of the English Reformation, and made the then king, Henry VIII, the Supreme Head of the Church in England, and free from the authority of Rome. It was followed by the Dissolution of the Monasteries between 1536 and 1541, which essentially resulted in the appropriation by the Crown of all the assets owned by all the monasteries, priories, convents and friaries in England, Wales and Ireland.

After the Dissolution, the assets of the former monastic houses were disbursed. In London, the change in land ownership and usage is evident in the marked contrast between the map of 1520, from before the event, and the 'Copper Plate' one of 1556–8, the 'Agas' one of 1561–70, and the Braun and Hogenberg one of 1572, from after the event. Many of the former monastic properties evidently became parish churches, hospitals, orphanages or schools, or combinations thereof, or *Inns of Court*, while the former *Black Friars* and *White Friars Monasteries* became play-houses. Many others passed into private ownership.

Stuart History

Under the Stuarts, that is, James I (1603–25), Charles I (1625–49) and Charles II (1660–85), it was a time of bloody civil war, between Royalist and Parliamentarian (1642–9), and of regicide (1649); and of a peculiarly English revolution under the Parliamentarian Commonwealth and Protectorate of Oliver and Richard Cromwell (1649–60), ending with the restoration of the monarchy (1660) – albeit, importantly, a monarchy that could thenceforth only rule with the consent of parliament.

* By this time, the mob had already slaked its blood-thirst by sacking some Establishment buildings in the City, including the aforementioned Savoy Palace and Tower of London, and killing many of their occupants, together with many other innocent bystanders – especially foreigners.

The City of London remained Parliamentarian rather than Royalist in its sympathies throughout the course of the Civil War, with the exception of certain of its churches, most notably *St Helen* and *St Katharine Cree* (Porter & Marsh, 2010). The City's puritan populace even broke its rule against working the Sabbath in order to construct the so-called 'Lines of Communication' that served as its defences. (Incidentally, there is no longer any trace of the 'Lines of Communication', although there is a plaque in Spital Square in *Spitalfields* illustrating where they were located). In 1642, after losing the Battle of Brentford, the Parliamentarians took up a strategic defensive position at Turnham Green, with their left flank protected by the river, and their right by a series of enclosures. There they essentially faced down the Royalists, who found themselves unable to manoeuvre past, in one of the largest-ever confrontations on English soil (albeit a substantially bloodless one), involving some 40,000 troops. It was a decisive moment in the history of the war, the country, and its capital. The war eventually ended with the trial of the king, Charles I, on the charge of treason, and his beheading, in *Whitehall*, in 1649.

London later suffered terribly during an outbreak of bubonic plague – the 'Great Plague' – in 1665, which killed at least 70,000 people, and possibly as many as 100,000 – far more than the 'Black Death' of 1348–9, although far fewer in proportion to the overall population (Collyer, 2003a; Porter, 2008). There had also been outbreaks in 1603, 1625 and 1636. Pepys noted in his diary with mounting dread the advance of the disease across Europe from October 1663, and the vain attempts to stem it by the quarantining of incoming ships, until its eventual arrival in April 1665; and Defoe later wrote a harrowing account of the following 'Plague year'. Plague was, and is, in its non-pneumonic or -septicaemic form, spread to humans by bites from fleas carried by rats infected with the bacterium *Yersinia pestis* – all too easy in the crowded conditions in which people, livestock, pets and vermin lived, cheek-by-jowl, in London in the seventeenth century. At the time, it was thought to be spread by cats and dogs, which were therefore rounded up and killed in large numbers, the resulting reduction in predation ironically allowing the real culprits, the rats, to increase correspondingly in number. It is commonly thought that the plague was only killed off by the Great Fire of September 1666, but the Worshipful Company of Parish Clerks' 'Bills of Mortality' indicates that it had already begun to die out towards the end of 1665, with the onset of winter (the 'Bills of Mortality' are now in the London Metropolitan Archives). The 'Bills of Mortality' also show that of the 70,000 *recorded* Plague deaths in London, only 10,000 were in the ninety-seven parishes within the walls of the City – possibly because a significant proportion of those inhabitants who could afford to do so had fled to the country. The remaining 60,000 Plague deaths were in the sixteen parishes without the walls, the five in *Westminster*, and the twelve in Middlesex and Surrey (*St Giles Cripplegate* was the worst affected, with 5,000 deaths).

Note. The Norman, Plantagenet, Lancastrian and Yorkist periods are commonly collectively thought of by historians as Medieval, and the Tudor and Stuart periods as post-Medieval.

Social History

There are sufficient surviving records of one kind or another to enable us to undertake a reasonably accurate reconstruction of everyday life in London from Norman to Stuart times (Holmes, 1969; Baker, 1970; Hyde *et al*., 1992; Hanawalt, 1993; Weinstein, 1994; Schofield, 1995; Picard, 1997; Griffiths & Jenner, 2000; Thomas, 2002; Picard, 2003; Barron, 2004; Harkness, 2007; Myers, 2009; Tames, 2009; Bastable, 2011; Day, 2011; Porter, 2011a, b; Schofield, 2011a).

These include the Domesday Book of 1086, now in the National Archive in Kew, which was, according to the Anglo-Saxon Chronicle, a sort of inventory undertaken by the Normans of who owned what, and of what taxes they were liable to; and a multitude of court, corporation, ward and parish records, many of which are now in the *Guildhall* Library. Incidentally, the Domesday Book was so known by the Anglo-Saxons,

> for as the sentence of that strict and terrible last account cannot be evaded by any skilful subterfuge, so when this book is appealed to ... its sentence cannot be put quashed or set aside with impunity. That is why we have called the book 'the Book of Judgement' ... because its decisions, like those of the Last Judgement, are unalterable.

More personal contemporary eye-witness accounts include those of William FitzStephen, writing in 1183, John Stow, writing in 1598, James Howell, writing in 1657, and John Evelyn and Samuel Pepys, also writing in the late 1600s (see Latham, 1985 and de la Bedoyere, 1995). The cleric FitzStephen memorably, if gushingly, described London as 'the most noble city', a city that 'pours out its fame more widely, sends to farther lands its wealth and trade, lifts its head higher than the rest', a city 'happy in the healthiness of its air, in the Christian religion, in the strength of its defences, the nature of its site, the honour of its citizens, the modesty of its matrons', a city in which 'the only pests ... are the immoderate drinking of foolish sorts and the frequency of fires'. Perhaps the best known of the chroniclers, though, is Pepys, who kept a diary from 1659 to 1669, when his eyesight finally failed him. Pepys was an establishment figure, well known in official and court circles; and, as such, less an 'everyman' caught up in events than one very much of his time and, particularly, place – that is to say, his place in the prevailing social and class hierarchy. His thoughts and deeds were often to greater or lesser degrees self-serving: he obsessed over his wealth ('To my accounts, wherein ... I ...,

to my great discontent, do find that my gettings this year have been ... less than ... last'); employed sycophancy and deceitfulness to increase the same, or otherwise to get his way; and was not beyond resorting to emotional cruelty, especially towards his wife, Elizabeth, and even to physical violence.* However, his written words were almost always honest and true, and unsparingly and disarmingly so when describing his own shortcomings, or otherwise to his detriment. There was something of a child-like quality to Pepys the man, characteristically beautifully described by Robert Louis Stevenson, in part as follows:

> Pepys was a young man for his age, came slowly to himself in the world, sowed his wild oats late, took late to industry and preserved till nearly forty the headlong gusto of a boy. So, to come rightly at the spirit in which the Diary was written, we must recall a class of sentiments which with most of us are over and done before the age of twelve.

Personally having rather more of a sympathetic regard for Stow, I refer the reader to the admirable biography by Claire Tomalin (2002) for a fully informed and balanced view of Pepys, and of his undoubted accomplishments, especially at the Navy Office where he worked as a civil servant and ultimately Secretary to the Admiralty (it has been said that, 'without Pepys, there could have been no Horatio Nelson').

Population

From various accounts, it appears that the population of London was probably of the order of 10–15,000 at the time of the Domesday Survey in 1086; 40,000 a century later in 1180; 80,000 in 1300; 40,000 in 1377, after the 'Black Death' of 1348; 60,000 in the 1520s; 80,000 in 1550; 120,000 in 1583; 200,000 in 1630; 460,000 in 1665, before the 'Great Plague'; 360,000 in 1666, immediately after the 'Great Plague'; and 500,000 in 1700.

The unprecedented rise in population in the Tudor and Stuart periods made London one of the first great world cities, and was accompanied for the first time by significant growth beyond the old *City Wall*. Interestingly, the death rate in the ancient capital always exceeded the birth rate, significantly so during outbreaks of plague, such that the population could only be maintained and grown by immigration, either from elsewhere in England, or from Europe, for example from Normandy, Gascony, Flanders and Lombardy, or from even further afield.

* He also obsessed over his health, although perhaps understandably, given that as a young man he had survived, somewhat against the odds, a surgical operation to remove a gallstone – the anniversary of which event he celebrated each year rather like a second birthday!

Administration

As noted above, the City became, in essence, at least in part self-governing in Norman to Plantagenet times, under the Corporation and its officials: the Lord Mayor and the aldermen – who were initially appointed and subsequently elected, albeit elected by, and from within, a wealthy and influential elite – and the Sheriff (Shire-Reeve), Bailiff, and Constable.

The Corporation became responsible for, among other things, the prosperity and orderliness of the City, including the *education* of the populace, and the maintenance, if not the establishment, of the *law*.

The Corporation and its benefactors, many of them associated with burgeoning trades guilds or Livery Companies, with vested interests in vocational training, were responsible for founding a number of educational establishments from the fifteenth century onwards, some of which are still running, although none on their original sites. *Christ's Hospital* (Orphanage and School) was founded by the authorities in 1552 on the site of the former conventual buildings of the *Greyfriars Monastery* (and later burnt down in the Great Fire of 1666, rebuilt, and relocated to Horsham in Sussex in 1902). The City of London School was founded through the benefaction of the Town Clerk, John Carpenter, in 1442, on a site adjacent to the *Guildhall* (and later re-founded in *Milk Street* in 1837, and relocated to its present position on reclaimed embankment in Blackfriars in 1986). The Mercers' School was founded through the Mercers' Company in 1542, on the site of St Thomas's Hospital (and later burnt down in Great Fire of 1666, rebuilt in *Old Jewry*, relocated to *Budge Row*, *Watling Street*, and *College Hill*, and closed down in 1959). The Merchant Taylors' School was founded through the Merchant Taylors' Company in 1561, on the site of the former estate of the Dukes of Suffolk (and later relocated to Northwood). Gresham College was founded through the benefaction of the financier Thomas Gresham in 1579 (and later relocated to *Barnard's Inn*). The College of Physicians was founded in 1518, at *Amen Corner* (and later burnt down in the Great Fire of 1666, and rebuilt, and relocated to Regent's Park). Training in the law was provided through the *Inns of Court*, *Gray's Inn*, *Lincoln's Inn*, and *Inner and Middle Temple*, founded on former monastic sites after the Dissolution of the Monasteries in the mid-sixteenth century.

The law was upheld through a judicial system that placed particular emphasis on punishment as a deterrent to crime, although in its defence it also at least attempted to make the punishment fit the crime, with the least serious or petty crimes punishable by fines or corporal punishment, serious ones by imprisonment or, more rarely, deportation to the colonies, and only the perceived most serious, of which it has to be admitted there were scores, by capital punishment (Griffiths, 2008; Brooke & Brandon, 2010). Capital punishment was commuted in the cases of those who could claim the 'benefit

of clergy', by reciting a psalm that came to be known as the 'neck verse' (*'Miserere mei, Deus, secundum misericordiam tuam'*). Corporal punishment included the use of the pillories and stocks, which restrained convicted criminals and allowed them to be harangued or to have missiles thrown at them by the general public (Daniel Defoe, who was perceived to have been unjustly convicted, was garlanded with flowers). Imprisonment was a still more harsh punishment, on account partly of the inhumane conditions under which prisoners were kept, and partly of the brutal treatment meted out to them (see also *Newgate Prison*). Capital punishment took one of a number of forms, for example, hanging, for murderers, and also for common thieves – of any article valued at over a shilling – and other felons; boiling, for poisoners; burning, for religious dissenters of unfortunately unfashionable persuasions; 'pressing' (under a heavy weight), for those accused who refused to confess; beheading, for those of noble birth; and, most gruesomely, hanging, drawing (disembowelling) and quartering, with or without the refinement of castrating, for traitors, that is, those found guilty of high treason. Executions were carried out not only in prison but also in public, in various parts of the city, most famously at *Tower Hill* and *West Smithfield*, and at Tyburn, near the modern Marble Arch, at the western end of Oxford Street. Among those done to death at Tyburn were, in 1499, Perkin Warbeck, for pretending to the throne; in 1534, Elizabeth Barton, for warning King Henry VIII against divorcing Catherine of Aragon and marrying Anne Boleyn, apparently while possessed by spirits (being a ventriloquist, in the original sense of the word); and, in 1660, ritually and grotesquely, the disinterred corpse of Oliver Cromwell, for the regicide of Charles I (Brooke & Brandon, 2004).

Religion

Norman to Stuart Londoners were God-fearing folk, and one could argue that they had cause to be. The sporadic and apocalyptic outbreaks of famine and plague must have seemed to them to have been visited upon them by a vengeful God, or 'Destroying Angel'. Life could also be cut painfully short by other diseases, occupational diseases and accidents, and acts of violence; and the deaths of mother and/or baby in the act of childbirth would have been distressingly common, and infant mortality shockingly high. Faith at least offered hope of life eternal.

The predominant religion of the period was Christianity, and after the Reformation either Catholic or Protestant depending upon royal patronage. Sadly, if not entirely atypically of human history, there was much persecution of the one by the other, such that the fortune and fate of a man could be determined by his faith and allegiance, or by scheme and intrigue, as by the toss of a coin. There was also persecution of believers of other faiths, and of non-believers, by both. A minority Jewish community was established in

London in the reign of William I, 'the Conqueror', in the eleventh century, but was then subject in the twelfth and thirteenth to a series of what in later times would be referred to as purges or pogroms, and eventually expelled under the Edict of Expulsion issued by Edward I in 1290, only returning during the Protectorate of Oliver Cromwell in 1649 (Black, 2007).

There was a major phase of Catholic church-building beginning in the late eleventh and twelfth centuries, perhaps as an act of penance, to assuage the guilt of the conqueror and oppressor, and lasting into the thirteenth to fifteenth. By the twelfth century, there were around 100 churches in the City; some of the associated parishes constituted of only a few streets. Late parishioners' bequests for 'Chantries', or prayers to be chanted for those in purgatory, were often spent on extravagant embellishments. Monastic houses began to be established in and around the City in the twelfth to thirteenth centuries, among them those of the Friar Hermits of the Order of St Augustine of Hippo, or Augustinian or Austin Friars; the Augustinian Friars of the Holy Cross, or Crouched Friars; the Carmelites or White Friars; the Dominicans or Black Friars; the Franciscans or Grey Friars; and the Knights Templar of the Order of St John of Jerusalem (later the Knights Hospitaller). The monastic houses came to dominate not only the religious life, but also the philosophical and indeed even the physical life of the City, becoming wealthy and powerful in the process, and making many enemies as well as friends.

The seeds of the Protestant Reformation may be said to have been sown with the so-called 'Lollardy' of the late fourteenth to fifteenth centuries, which indeed has been referred to as the 'Morning Star of the Reformation', and which similarly sought to restrict the secular wealth and power of the established church, and to return to apostolic poverty and mission. The attempt of the Lollard Revolt of 1413 to overthrow the established church came to nothing when the supporters of the movement, gathered at *St Giles-in-the-Fields* on the western outskirts of the City of London, were betrayed and dispersed, and its local leader, Sir John Oldcastle, was summarily put to death – by hanging, in chains, over a slow fire.

As noted above, the Reformation proper came into effect following the issuing of the Act of Supremacy by Henry VIII in 1534, which made him the Supreme Head of the Protestant Church in England, and free from the authority of the Catholic Church in Rome, and allowed him to hang a large number of Catholic 'heretics' at Tyburn (those martyred during and after his reign are commemorated by a plaque on the nearby twentieth-century Tyburn Convent, and by effigies and a stained glass window in the church of *St Etheldreda*). Henry's successor, Edward VI (1547–53) remained a Protestant, but Edward's successor, Mary (1553–8), also known as 'Bloody Mary', reverted to Catholicism, and burned at the stake a large number of Protestant 'heretics', including, in Oxford, the Anglican Bishops Hugh Latimer, Nicholas

Ridley and Thomas Cranmer, and at *West Smithfield* in London, the common men John Rogers, John Bradford, John Philpot and others (commemorated by a plaque). In turn, Mary's successor, Elizabeth I (1558–1603), the last of the Tudors, reverted once more to Protestantism. James I (1603–25), the first of the Stuarts, remained a Protestant, and saw off the Catholic 'Gunpowder Plot' to blow up the Houses of Parliament in 1605, having Guy Fawkes and the other ringleaders tortured and then hanged, drawn and quartered, and their remains prominently exhibited, as a deterrent to others. Charles I (1625–49), also nominally a Protestant, so abused his supposed 'divine rights' in the eyes of Parliament, and of the population at large, as to trigger the Civil War between supporting Royalists and opposing Parliamentarians.

Trade and Commerce

Commerce prospered alongside religion in Norman to Stuart London, as it always had, always would and no doubt always will, although the relationship between the two was at times strained, like that between an errant child and its parents.

The City had become an important port and trading centre, through which a significant proportion of the entire country's imports and exports were channelled, by Norman to Stuart times (Milne, 2003). The waterfront, the Port of London, much of it then recently reclaimed, bristled with bustling wharves. A prodigious range of comestible and manufactured goods was imported in, including fresh fish to *Queenhithe* and *Billingsgate*, and shellfish to Oystergate (oysters were an important source of protein, especially for the poor, and discarded oyster shells are still a common find on the foreshore of the Thames); wine from Gascony to *Vintry*; dried fish or 'stock-fish', and Baltic goods, furs and timber, to *Dowgate*; and spices, and finished textiles. Wool was the chief export, chiefly to the Low Countries, and the trade in it was enormously lucrative (sheepskins and other animal hides, food-stuffs, and Cornish tin were also exported). The *Custom House* was originally built as long ago as 1275. Fresh fish and shellfish was traded at *Billingsgate* and Oystergate; 'stock-fish' at the *Stocks Market*; meat at the 'Shambles' on *Newgate* and on *Eastcheap*; poultry on *Poultry*; grain at *Cornhill*; bread, milk, honey and a range of general goods at the market on *Cheapside*; and general goods also at the market on *Leadenhall Street*, and at open-air fairs. The *Royal Exchange* was founded in 1565. By Tudor to Stuart times, ultimately immensely important overseas trade links had become forged through the establishment of the Muscovy Company, an outgrowth of the even more venerable 'Company of Merchant Adventurers to New Lands' (or, in full, the 'Mystery and Company of Merchant Adventurers for the Discovery of Regions, Dominions, Islands, and Places Unknown'), in 1555; the Levant Company, in 1581; the (Honourable) East India Company (see *East India House*), in 1600; and the Virginia Company (of London), in 1606.

As time went by, the traders grew rich, in some cases fabulously so, and founded many influential trades guilds or Livery Companies (Lubbock, 1981). The Livery Companies established working practices, trained apprentices and monitored standards, punished workers for poor workmanship, and even controlled commodity prices. The twelve 'Great' Livery Companies, whose coats-of-arms adorn the walls of the Great Hall of the *Guildhall*, are, in order of precedence, the Mercers', Grocers', Drapers', Fishmongers', Goldsmiths', Skinners' and Merchant Taylors' (alternately), Haberdashers', Salters', Ironmongers', Vintners', and Clothworkers'.

Although some working-class people made money by 'bettering' themselves, and becoming artisanal craftsmen, or by supplying the demands of the bourgeois mercantile elite for fancy goods and services, most remained steadfastly poor. There was never an equitable distribution or redistribution of wealth, although there was at least as system for charitable patronage and donation from the rich, from the churches and from the Livery Companies, to the poor. The rich burnt wax candles; the poor, tallow (that is, rendered animal fat). All would appear to have lived rather uneasily together (although there is also a certain amount of evidence from tax records of concentrations of wealth in the wards in the centre and west of the City, and of poverty in the east, especially around *Aldgate*, and without the walls).

Entertainment and Culture

For the entertainment of the many and the edification of the few, there was at *West Smithfield* archery, wrestling and cock-fighting, a weekly horse fair, and the annual Bartholomew Fair every August from the twelfth century, and there were there also jousting tournaments from the fourteenth; at *East Smithfield* a further fair, and on *Undershaft* an annual May Fair; on *Cheapside* further tournaments; on *Moorfields*, in the winter, when the Walbrook froze over, ice-skating; on the Thames, when it froze over, for example in 1410, 1608, and 1683–4, 'frost-fairs'; in the *Tower of London*, from the thirteenth century, bizarrely, a menagerie of elephants, lions, bears and so on (Hahn, 2003); on the South Bank, in *Southwark*, from the mid-sixteenth century, bear-baiting; and everywhere, all the time, football, gambling, 'the immoderate drinking of foolish sorts', and 'stew-houses',* or brothels.

There were also, though, 'miracle plays' performed by City clerks and apprentices at *Clerkenwell*, from at least as long ago as the twelfth century. And enormously popular contemporary plays performed in a range of contemporary play-houses, some of them on the sites of dissolved monasteries, others, such as the *Globe* and *Rose* in *Southwark*, purpose-built, in Tudor, Stuart and Restoration times.

* From the French 'estuier', meaning to stock a fish-pond!

London was the home of Chaucer and Shakespeare, and figured prominently in their famously bawdy and redolent works, and also of Bunyan, Dryden, Donne, Jonson, Marlowe, Milton and Spenser, of Tallis and of Holbein. Chaucer lived in *Aldgate*, and walked to and from his place of work in the *Custom House* in *Billingsgate* (he was the 'Comptroller of the Customs and Subside of Wools, Skins and Tanned Hides'), by way of the church of *All Hallows Barking* and the monastery of the *Crutched Friars*. Shakespeare lived in *Ireland Yard* and in *Silver Street*, as well as in *Southwark*.

The City was also an important centre of publishing, of books, tracts, pamphlets and newsletters; and the centre of the English Enlightenment, a flourishing of learning, and most particularly of what was known as Natural Philosophy and is now known as Science, culminating in the founding of the Royal Society of London for Improving Natural Knowledge in 1660. The Charter of the Royal Society describes one of its objectives as being

> to improve the knowledge of all natural things, and all useful Arts, manufactures, Mechanick practises, Engines and Inventions by Experiments – (not meddling with Divinity, Metaphysics, Moralls, Politicks, Grammar [or spelling, presumably], Rhetorick or Logick).

Food and Drink

The staple foods of the day were those of the butcher and baker, and there was not a lot of fruit and veg eaten, so there was a lot of constipation – in Pepys's day, it was common practice to take relieving purges. As noted above, uncooked meat was sold at the 'Shambles' on *Newgate* and on *Eastcheap*, poultry on *Poultry*, fresh fish and shellfish at *Billingsgate* and Oystergate, dried fish or 'stock-fish' at the *Stocks Market*; bread, and a range of general goods, at the market on *Cheapside*. Cooked meat and other ready-to-eat foods were sold on the street by hawkers ('One cryd hot shepes feete/One cryd mackerel … /One … rybbs of befe, and many a pye'), and in eating establishments or 'ordinaries'. The relationship with meat animals was intimate: people lived with their livestock; and pigs ran wild in the streets, creating a considerable public nuisance. Little of the animal was wasted, everything edible being eaten, the fat being rendered to make tallow, and the hide being tanned to make leather. At the same time, there was no sanitary means of disposing of any waste. Neither was there any means – other than pickling or salting – of preventing food or waste from going off, hence the widespread use in cooking of herbs and spices, to mask 'corrupt savours'.

Water was drawn from the City's rivers, or from springs or wells. In FitzStephen's time, it was pure and clean and sweet and wholesome. Later, though, 'the tide from the sea prevailed to such a degree that the water of the Thames was salt; so much so that many folks complained of the ale tasting

like salt' (and obviously they couldn't have that). And, by the beginning of the thirteenth century, the supply had become so contaminated by waste from ships and from shore as to be not only unpalatable but unsafe to drink, for fear of contracting cholera or typhoid. So, a supply had to be brought in from outside. A so-called Great Conduit was built, by public subscription, in 1236, to bring water from a spring at Tyburn, roughly opposite where Bond Street tube station now stands, to *Cheapside*, about three miles away, by way of a system of lead (!) pipes. Sections have recently been discovered two metres below Medieval street level in *Paternoster Row* and in *Poultry*. The Great Conduit was extended at either end in the fifteenth century so as to run from Oxlese, near where Paddington station now stands, to *Cheapside* and *Cornhill*, about six miles away (water was then either piped directly from the conduit to homes and businesses that could afford the expense of the installation of 'quills', or collected from stand-pipes, and carried there by property owners, or, in buckets suspended from shoulder-yokes, by 'cobs', of whom there were 4,000 by 1600). The so-called Devil's Conduit under Queen's Square probably dated to around the same time; a photograph taken in 1910, shortly before its demolition in 1911–1913, shows it to contain graffiti from 1411. By the sixteenth century, the system had become inadequate to meet the demands of the rising population (it had also become subject to much abuse and over-use by individuals and by commercial and industrial concerns). A short-term solution to this problem was provided by the construction by the Dutchman Pieter Maritz in 1580 of a – rather rickety – apparatus under one of the arches of *London Bridge* that allowed water to be pumped from the Thames into the heart of the City, or, in the case of the original demonstration to City officials, over the spire of the church of *St Magnus the Martyr*! The apparatus was destroyed in the Great Fire of 1666, but thereafter replaced by Maritz's grandson, and continued in use, after a fashion, until the early nineteenth century. A longer-term solution was provided by the construction by the Welshman and wealthy merchant, goldsmith, banker and Member of Parliament Sir Hugh Myddelton or Myddleton in 1609–13 of a ten-foot-wide and 4-foot-deep canal, or 'New River', all the way from springs at Amwell and Chadwell in Hertfordshire into the City, an incredible thirty-seven miles away, which is still in use to this day (parts of it can still be seen, too, along the 'New River' walk in *Islington*, for example in Canonbury Grove). Myddelton had to overcome any number of technological obstacles, and much landowner and political opposition, to see this major civil engineering project through to completion, doing so with a mixture of drive and determination, the financial support of twenty-nine investors or 'adventurers', and the tacit backing of the king. His financial backers had to wait some time until they profited from the enterprise (actually, until 1633, although by 1695 the New River Company ranked behind only the East India Company and Bank of England in terms

of its capital value). The public health benefits of Myddelton's project were immediate, though, and immeasurable, and indeed it has been described as 'an immortal work – since men cannot more nearly imitate the Deity than in bestowing health'. Fittingly, there is a statue to the great man on Islington Green in *Islington*.

Beer, or 'liquid bread' became a staple in the City, as soon as it was unsafe to drink the water – 'small beer' for breakfast, even. Wine was also imbibed in quantity. When King Edward I and his wife Eleanor of Castile were crowned at *Westminster* on the Sunday after the feast of the Assumption in 1274, 'the Conduit in Chepe ran all the day with red and white wine to drink, for all such who wished'. There were a quite literally staggering 1,153 drinking establishments in London in 1656, ranging from basic ale-houses through middling taverns to up-market inns. Among them were the 'Hoop and Grapes' of 1290 on *Aldgate High Street*; the 'Cittie of Yorke' of 1430 on *High Holborn*; the 'Prospect of Whitby' of 1520 on *Wapping Wall*; the '*Belle Sauvage*' of 1452 on *Ludgate Hill* (where the Native American Princess Pocahontas stayed in 1616–7); the 'Olde Mitre' of 1546 on *Ely Place*; the 'Olde Cheshire Cheese' of 1584 on *Fleet Street* (more famous for its literary associations, and its pies and puddings); the 'Tipperary', formerly known as the 'Boar's Head', of 1605, also on *Fleet Street*; the 'Wig and Pen' of 1625 on the *Strand*; and the 'Olde Wine Shades' of 1663 on *Martin Lane*. Of these, the 'Hoop and Grapes', the 'Prospect of Whitby', the 'Olde Mitre', the 'Tipperary', the 'Wig and Pen' and the 'Olde Wine Shades' survived the Great Fire of 1666, and still survive. Perhaps unsurprisingly, drunkenness became something of a social problem. So did the so-called 'dry-drunkenness' caused by smoking tobacco, first introduced from the Americas in the 1570s. (At this time, tobacco was smoked in clay pipes, the remains of which came to litter the City like the cigarette ends of today). More socially acceptable was the consumption of equally addictive, although less harmful, coffee and tea, first introduced from overseas in the 1650s, in coffee- and tea-houses – the first of which was the 'Pasqua Rosee's Head', just off *Cornhill*, whose former site is now marked by a Corporation 'Blue Plaque'.

Sanitation
Which brings us to the indelicate matter of waste, and the disposal thereof. That is to say, human and animal excrement, food waste, and the equally if not even more noxious by-products of the City's cottage industries (butchery, tallow chandlery, tannery, soap manufacture, glass manufacture, from animal horn, and so on). Originally, essentially all of the above was simply dumped in the streets, to be washed downhill in gutters, and into the Thames or one of its tributaries – one of the streets thus coming to be known as Shiteburn Lane – and later, so as to offend one less sensibility, *Sherborne Lane*. To be fair,

some public latrines were built directly over the Fleet and Walbrook, including a 128-seater provided by Dick Whittington, thereby at least cutting out the middle man, so to speak. Eventually, though, this practice was outlawed as the streets became breeding grounds for vermin and disease, not to mention evil-smelling, and exceedingly unpleasant underfoot – whence the invention of the 'patten', the platform sole of the day. After the mid-fourteenth century, waste was compelled to be collected by rakers and carters, and disposed of further afield 'without throwing anything into the Thames for the saving of the body of the river ... and also for avoiding the filthiness that is increasing in the water and upon the Banks of the Thames, to the great abomination and damage of the people', and anyone guilty of any violation was punished by 'prison for his body, and other heavy punishment as well, at the discretion of the Mayor and the Aldermen'. Some was carried down the Thames, in 'dung-boats' to be dumped, some deposited in land-fill sites outside the City, and some spread as fertiliser on surrounding fields. Nonetheless, a considerable amount of damage had already been done to the environment and to public health, and the Fleet and Walbrook had effectively become dead rivers, the post-Anglo-Saxon history of the former being described as 'a decline from a river to a brook, from a brook to a ditch, and from a ditch to a drain'. Environmental archaeological examination of Medieval Fleet deposits from a site in *Tudor Street* revealed the existence of 140 species of mainly micro-organisms in one early layer, indicating – apart from nematode worms from human faeces – a generally healthy condition; but only two stress-tolerant and opportunistic species in a second, later layer, indicating increasing toxicity; and none at all in the third, latest layer, indicating the total eradication of all life, as described in the archive records for 1343 (Boyd, 1981).

All in all, Norman to Stuart London was a City of crowding and clamour and squalor and stench. Oh, the humanity!

Building Works

The first stone buildings in the City for well over six hundred years were built by the Normans, including those intended to symbolise their sovereign authority over the Anglo-Saxons: the *Tower of London*, built out of French limestone, from 1067 onwards; *Castle Baynard*; and the Tower of Montfichet (Schofield, 1995, 2011a). The *Royal Wardrobe* and *Savoy Palace* were built by the Plantagenets, essentially to the same end.

The Normans also initiated a major phase of church-building in the City, and beyond, beginning in the late eleventh and early twelfth centuries, in the Norman or Romanesque style, that continued, under the Plantagenets, Lancastrians and Yorkists, into the late twelfth to early fifteenth, in the Gothic style. Particularly notable new religious building works of this period included 'Old *St Paul's*', *St Bartholomew the Great*, *Holy Trinity Priory* and

the *Priory of St John*, originally in the Norman or Romanesque style; *Temple Church*, in a part-Norman or Romanesque, and part-Early (English) Gothic, style; and *All Hallows Staining*, the *Bishop of Winchester's Palace*, *Blackfriars Monastery*, the *Charterhouse*, *St Andrew Undershaft*, *St Bartholomew the Less*, *St Ethelburga*, *St Etheldreda*, *St Giles Cripplegate*, *St Helen*, *St Mary Aldermary*, *St Mary-at-Hill*, *St Mary Spital*, *St Olave Hart Street*, *St Sepulchre* and *Whitefriars Monastery*, and extensions to 'Old *St Paul's*' and to *St Mary Overie*, or *Southwark Cathedral*, in the Gothic style, either Early and simple, or Late and decorated, although never as ornate as on the Continent (also the synagogues on *Old Jewry*, *Threadneedle Street*, *Gresham Street*, *Coleman Street* and *Ironmonger Lane*, and the Jewish ritual baths or mikva'ot in the precinct of the *Guildhall* and in *Milk Street*).

New public building works included the *Guildhall*, built to rival *Westminster Hall*; and the first stone incarnation of *London Bridge*. New private buildings included a number of what were to become *Inns of Court*, and Livery Company Halls, some of which latter, such as the *Merchant Taylors'*, were particularly grand, including gardens, grounds and alms-houses – for 'decayed' members of the company – as well as Great Halls (and kitchens), offices and private chapels. New private residences included that of the wealthy grocer and twice Lord Mayor Stephen Browne, in *Billingsgate*, which was evidently sufficiently grand as to have included its own quay. The cheaper ones of the common man, such as those recently excavated on *Poultry*, continued to be built largely of timber and thatch, although thatch was officially outlawed as a building material in the twelfth century, on account of its combustibility, and the use of brick had become much more prevalent by the end of the fourteenth.

New building activity continued in the City, and especially in *Westminster* and the West End beyond, into the late fifteenth to early seventeenth centuries, in the Tudor, including Elizabethan, and in the Stuart, including Jacobean, and (English) Renaissance or Neoclassical, styles. *Bridewell Palace* was built by Henry VIII in the Tudor period and style (and further afield, St James's Palace and Hampton Court Palace were also built by Henry VIII). Notable new religious building works of the Stuart period included the renovations to *St Katharine Cree*, undertaken in 1628–31, and those to 'Old *St Paul's*', undertaken by Inigo Jones in 1633, both of which were in the Neoclassical style (also a Sephardic – or Spanish and Portuguese – Jewish synagogue on *Creechurch Lane*). New private buildings included further numbers of *Inns of Court*, and Livery Company Halls (including the *Apothecaries'*). New private residences included that of the wealthy grocer John Crosby, on *Bishopsgate*, later owned by Thomas More, which Stow described as 'very large and beautiful'; and that of the merchant trader and ambassador to the Ottoman court Paul Pindar, also on *Bishopsgate*, which would appear from surviving drawings and a photograph taken in around 1885 to have been if

anything even more extravagant and flamboyant. The town houses of the men of wealth and perceived substance typically had cellars and storehouses for merchandise attached to them, as well as well-appointed living quarters and other rooms upstairs, and long galleries on the projecting uppermost, third or even fourth, storey (after all, they had to accommodate not only the owner and his extended family, but also his apprentices, and his many servants).

By the time of the Great Fire of 1666, there were over a hundred churches and other places of worship within and immediately without the walls of the City,* many of them lovingly embellished with bell- and clock-towers and spires by their parishioners, as can be clearly seen in contemporary drawings, paintings and maps, and some also with churchyards and gardens, splashing colour onto an otherwise drab canvas (that of *St Andrew Hubbard* was sown with hemp, which would probably be an arrestable offence these days); and numerous *Inns of Court* and Livery Company Halls, and grand royal and other private residences and places of business besides. Important drawings and paintings of the City of the time include those of Bol, Briot, de Jongh, Hogenberg, Hollar, Marian, Norden, Picart, Rembrandt, Salmincio, Schut, Smith, Valeggio, van den Wyngaerde, Visscher, and various anonymous artists (Hyde, 1999; Warner, 2000; Pearson, 2011); and important maps or 'pictorial surveys' include the one of 1520, the 'Copper Plate' one of 1556–8, the 'Agas' one of 1561–70, the Braun and Hogenberg one of 1572, the Treswell ones of 1585–1611, the Norden one of 1593, the Agas one of 1633, the Newcourt and Faithorne one of 1658, and the Moore one of 1662 (Lobel, 1989; Whitfield, 2006; Foxell, 2007; Sinclair, 2009).

The Norman to Stuart street layout, so organically developed or evolved, and so modified after the Roman and Anglo-Saxon ones as to be unrecognisable, was less in the form of a grid, although there were many streets parallel and many perpendicular to the river, than of an intricate, almost beguiling, maze or web. By the end of the period, around a hundred yards of land had been reclaimed from the river, and there was a dense network of quays, wharves, steps, alleyways, passageways and lanes along the foreshore. The intricately intermingled alleyways and courtyards there and elsewhere were the capillaries and alveoles of the City, where persons might pause, albeit fleetingly among

* To be precise, as recorded in the Worshipful Company of Parish Clerks' 'Bills of Mortality', there were ninety-seven parish churches within the walls of the City, and sixteen without, making a total of 113. There was also one cathedral, Old St Paul's within the walls, and a number of conventical churches and private chapels within and without, including St Etheldreda and Temple Church. In addition, there were five parish churches in the City and Liberties of Westminster, namely, St Clement Danes, St Paul Covent Garden, St Margaret Westminster, St Martin in the Fields and St Mary Savoy; and twelve in the out-parishes of Middlesex and Surrey, including St Giles in the Fields.

the seething, and rest and refresh body and soul; the lanes and thoroughfares its veins and arteries, moving people and trade far and wide.

Surviving structures and streets are indicated on Map One, and are discussed in a little more detail immediately below, and in the appropriate part of the body of the text.

Essentially nothing now remains of the overwhelming majority of the predominantly Norman to Stuart churches and other places of worship, *Inns of Court* and Livery Company Halls, and royal and other private residence buildings that stood within and immediately without the walls of the City before the Great Fire of 1666.

Of the ninety-seven parish churches within the walls, only seven, namely, *All Hallows Barking*, *All Hallows Staining*, *St Andrew Undershaft*, *St Ethelburga*, *St Helen*, *St Olave Hart Street*, and the part-Stuart, or Renaissance or Neoclassical, *St Katharine Cree*, were undamaged by the Great Fire and still survive, with at least some pre-Great Fire structures standing, above ground (although note that *St Mary Aldermary* and *St Mary-at-Hill* were rebuilt after the fire incorporating into their designs significant portions of pre-fire structure). Thirty-five were burnt down and never rebuilt, forty-eight were burnt down and rebuilt by Wren and his office in the immediate aftermath, and seven were undamaged in the fire but either demolished or rebuilt some time afterwards. 'Old *St Paul's Cathedral*' was also burnt down, and rebuilt by Wren (Saunders, 2011b). Without the walls, *St Bartholomew the Great*, *St Bartholomew the Less*, *St Etheldreda*, *St Saviour*, or *Southwark Cathedral*, *St Sepulchre* and *Temple Church* were undamaged, and still stand, but *St Bride* was burnt down, and rebuilt by Wren (alongside *St Andrew Holborn*, which was according to most accounts actually undamaged by the fire). Within or without, parts of the *Bishop of Winchester's Palace*, *Blackfriars Monastery*, the *Charterhouse*, *Holy Trinity Priory*, the *Priory of St John* and *Whitefriars Monastery* also still stand.

Of the *Inns of Court*, only the Medieval Hall survives in *Barnard's Inn*, the Henrician 'Old Hall' and 'Old Buildings' and Jacobean Chapel in *Lincoln's Inn*, the Elizabethan Buildings and Hall in *Staple Inn* and *Middle Temple*, respectively, and the Jacobean gatehouse, also known as 'Prince Henry's Room', after Henry, the son of James I, in *Inner Temple*, all immediately without the walls. Of the Livery Company Halls, only parts of the *Merchant Taylors'*, and the *Apothecaries'*, within. Of the royal residences, only the *Tower of London*, within. Of the private residences, only Crosby Hall, although not in its original location on *Bishopsgate*, but at a new one near Battersea Bridge in Chelsea, and 41 *Cloth Fair*, and 59/60 *Lincoln's Inn Fields*, immediately without. And of the places of business, only the 'Olde Wine Shades' on *Martin Lane* within, and the 'Hoop and Grapes' on *Aldgate High Street*, the 'Tipperary' on *Fleet Street*, and the 'Wig and Pen' on the

Strand, immediately without. Parts of the *Guildhall* also survive, within. As noted above, the best-preserved sections of the Roman and Medieval *City Wall* are on *London Wall* to the west, and around *Tower Hill* to the east. The remains of the Medieval *Postern Gate* can also be seen on *Tower Hill*.

Archaeological Finds

The more important archaeological finds from Norman to Stuart London are on exhibition in the City's principal museums. The salvaged carved oak façade from Paul Pindar's house, once on *Bishopsgate*, is one of the largest exhibits in the Victoria and Albert Museum in South Kensington. A series of 'Museum of London Archaeology Service' monographs and other publications describe in detail the findings of archaeological excavations at various Norman to Stuart sites around the City, and south of the river in *Southwark*, *Bermondsey* and *Rotherhithe*.

Small finds include such essentially everyday items as coins and tokens, and discarded oyster shells and clay pipes; and such rare curiosities as shoe leather and textiles preserved in anaerobic mud on the foreshore of the Thames, and makeshift ice-skates made by tying animal bones to shoes.

The Great Fire of 1666

On the evening of Saturday 1 September 1666, the king's baker Thomas Farriner or Faryner or Farynor, whose premises were on *Pudding Lane*, went to bed leaving the fire that heated his oven still burning, in contravention of the curfew law passed 600 years previously by William I, 'the Conqueror' (the word curfew deriving from the Norman French '*cover-feu*', meaning, literally, 'cover fire'). In the early hours of the following morning, a spark from the fire settled on a pile of firewood stacked nearby for use on the following working day, and set it alight (Hanson, 2001; Collyer, 2003b; Tinniswood, 2004; Porter, 2009). Flames soon engulfed the house, and although Farriner and his family were able to escape by climbing through an upstairs window and along the outside of the building to a neighbouring one, his unfortunate maid-servant stayed put, and burned to death, becoming the first of, reportedly, mercifully few to die in what was still yet to become the *Great* Fire (considering that around 3,000 people lost their lives in a fire in 1212). Her name was Rose.

The fire soon spread from Farriner's bakery to nearby *Fish Street Hill*, burning down the 'Star Inn', where flammable faggots and straw were stacked up in the yard, and the church of *St Margaret Fish Street Hill*, the first to be destroyed; and thence on to *Thames Street*, where wood, cloth sails, rope, tar, coal and other flammable materials were stacked up on the river-front. It went on to take a firm hold of the City, largely built of wooden houses,

weatherproofed with pitch, and separated by only a few feet at ground level, and even less at roof level (on account of the construction of successive storeys further and further out into the street, affording more space, a practice known as jettying), allowing flames to leap from one to another with ease. The spread of the fire was further facilitated by the weather, with the strong easterly wind that had been creaking and rattling shop signs on their hinges now fanning it and carrying it towards the heart of the City; and everything in its path tinder-dry from the preceding exceptionally long, hot, dry summer (which also meant that the supply of water with which to fight it was short). Fortunately, its spread across the river to *Southwark* was halted at a gap in the buildings on *London Bridge* that formed a natural fire-break – ironically, the result of another fire some thirty years previously. Nonetheless, Pepys* wrote that he 'did see the houses at the end of the bridge all on fire', and

> rode down to the waterside ... and there saw a lamentable fire ... Everybody endeavouring to remove their goods, and flinging into the river or bringing them into lighters that lay off; poor people staying in their houses as long as till the very fire touched them, and then running into boats, or clambering from one pair of stairs by the waterside to another.

On seeing this, he travelled to *Westminster* to advise the king that the situation was getting out of hand, later recalling:

> Having stayed, and in an hours time seen the fire rage every way, and nobody to my sight endeavouring to quench it ... to Whitehall and there up to the King's closet in the Chapel, where I did give them an account that dismayed them all, and the word was carried to the King. So I was called for, and did tell the King ... what I saw; and that unless His Majesty did command houses to be pulled down, nothing could stop the fire. They seemed much troubled, and the King commanded me to go to my Lord Mayor from him, and command him spare no houses.

And at the King's behest, he returned to the scene, and

* Aside from Pepys's vivid eye-witness account, for which we can perhaps forgive him the infamous 'parmazan' episode, there are a number of contemporary paintings of the fire at its height, one of which, attributed to Waggoner, survives, in the Guildhall Art Gallery (Hyde, 1999; Pearson, 2011); and another, by an anonymous artist, in the Museum of London. A panorama of the aftermath of the fire, by Hollar, survives in the British Museum. Other graphic images of the fire and its aftermath also survive, although mainly outside London. A significant proportion are by Dutch artists, one of whom entitled his work '*Sic Punit*', or 'Thus He Punishes' – remember that England was at war with Holland at the time of the fire.

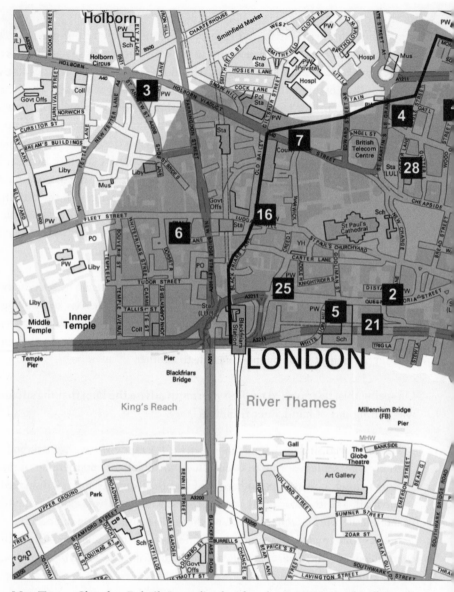

Map Two – Churches Rebuilt Immediately After the Great Fire and Still Standing
Contains Ordnance Survey data © Crown copyright and database right (2012)
Shaded area indicates that affected by Great Fire of 1666
Churches rebuilt by Wren unless otherwise stated

1.	St Alban (part only still standing)	6.	St Bride	10.	St Edmund the King
2.	St Andrew by the Wardrobe	7.	Christ Church Newgate Street (part only still standing)	11.	St James Garlickhythe
3.	St Andrew Holborn	8.	St Clement Eastcheap	12.	St Lawrence Jewry
4.	St Anne and St Agnes	9.	St Dunstan-in-the-East (part only still standing)	13.	St Magnus the Martyr
5.	St Benet Paul's Wharf (by Hooke and Wren)			14.	St Margaret Lothbury

15. St Margaret Pattens
16. St Martin Ludgate
17. St Mary Abchurch
18. St Mary Aldermary
19. St Mary-at-Hill
20. St Mary–le-Bow
21. St Mary Somerset (part only still standing)
22. St Mary Woolnoth (by Hawksmoor)
23. St Michael Cornhill
24. St Michael Paternoster Royal
25. St Nicholas Cole Abbey
26. St Peter Cornhill
27. St Stephen Walbrook
28. St Vedast alias Foster

At last met my Lord Mayor in Canning Streete … with a hankercher about his neck. To the King's message, he cried like a fainting woman, 'Lord, what can I do? I am spent! People will not obey me. I have been pull[ing] down houses. But fire overtakes us faster than we can do it.'

Pulling down or even blowing up buildings to create further fire-breaks did indeed prove a partially successful strategy in fighting the fire, saving the churches of *All Hallows Barking* and *St Olave Hart Street*, but unfortunately it was also one that was implemented too late to make much of a difference to the eventual outcome (possibly for fear of law-suits from property owners). The fire eventually essentially halted in its own tracks, spent, after the wind dropped on the fourth day.

Recriminations rapidly followed, with the Lord Mayor Sir Thomas Bloodworth or Bludworth singled out for criticism over his initial complacency and subsequent indecisiveness; when first informed of the fire, he is reported to have remarked that a woman might have pissed it out, which indeed she might, if she had acted promptly, but she did not, and must soon have come to rue his rash words. The rudimentary fire brigade was also criticised, for acting in an uncoordinated fashion, and, in its desperation, digging up roads and cutting pipes to get at the water to fill its buckets, in so doing cutting off the supply to others. However, given the chaotic situation they found themselves confronted with, and the tools at their disposal with which to deal with it, including primitive fire engines that looked and likely handled more like tea trolleys, they would appear to have performed perfectly admirably. In the end, everything was essentially ascribed to an act of God, albeit one that the wit and hand of man would attempt to ensure was never repeated. Many, though, falsely believed the fire to have been deliberately set, by a fanatical Papist or Dissenter, or by a Dutch or French saboteur; and indeed a Frenchman, Robert Hubert, was executed for having set it, after a confession obtained under duress, and a 'show trial' presided over by members of Farriner's family – who had their own reasons to attach the blame to such a convenient scapegoat.

The stark fact remained that the fire had largely destroyed the City that had witnessed so much history in the making. Eighty per cent of the area within the walls was more or less completely burnt out, and only the extreme north and east had survived substantially intact (the walls had essentially confined the fire to the City within, although some areas without to the west had also been affected). Around 13,000 private residences and places of business within and immediately without the walls of the City were either essentially or entirely destroyed, alongside eighty-four parish churches and *St Paul's Cathedral*, forty-four Livery Company Halls, the *Custom House*, the *Guildhall*, the *Royal Exchange*, the *Royal Wardrobe* and *Castle Baynard*. The heat of the fire had been sufficiently intense as to melt the lead on the roofs of the churches, and

apocryphally also the bells – it was apparently molten lead setting fire to the wooden supports of the otherwise stone-built *St Paul's* that caused its downfall. Damage to property and trade was on an entirely unprecedented scale, as was associated homelessness and loss of livelihood. Around 100,000 persons were made homeless, and had to be temporarily rehoused in camps, like the one on *Moorfields*, or in those still substantial parts of what we might think of as Greater London that were not affected by the fire. There would appear to have been a certain amount of profiteering by landlords at this time, and a little later, as rebuilding work began, by builders' merchants, although the general mood would appear to have been one of shared hardship and public-spiritedness, somewhat akin to that of the Blitz of the Second World War.

Aftermath

Would the City ever be rebuilt, or be the same again?

Well, of course it would, not least because the prosperity of the City was essential not only to that of the country as a whole but also to that of powerful men with vested interests, watching anxiously from the sidelines as 'day by day the City's wealth flowed out of the gate' to other boroughs.

The Lord Mayor initiated the process essentially straight away, within weeks commissioning a detailed survey of the fire-damaged area of the City to assist with the assessment of compensation claims, and to use as a template for reconstruction plans. The survey was undertaken by the Bohemian Wencesla(u)s Hollar (1607–77), who had travelled widely before eventually settling in London, and earning a reputation as an engraver and print-maker of some skill, specialising in landscape scenes (Griffiths & Kesnerova, 1983; Tindall, 2003). Other surveys were undertaken, and maps made, by Doornick, Leake, and Ogilby and Morgan (Whitfield, 2006; Foxell, 2007; Sinclair, 2009).

A number of revolutionary reconstruction plans for the City were submitted by, among others, Christopher Wren, Robert Hooke and John Evelyn, any one of which, if implemented, would have given it a radically new look and feel, much more like that of the great European cities of the day, and indeed of today, with their uniform architecture, broad boulevards and open piazzas. (Evelyn wrote that 'in the disposure of the streets, due consideration should be had, what are the competent breadths for commerce and intercourse (!), cheerfulness and state'). But these plans were over-ambitious, apart from anything else, and were abandoned on the grounds of practicality in favour of one requiring much less groundwork, and much more like the old one – although allowing of at least one concession to modernity, in the widening, and freeing from encumbrance to the flow of traffic, of the streets. The City that might have been never came to be, and that that had been would come to

be again: for the most part neither particularly beautiful nor harmonious; but, rather, disorganised and fractious; and yet, familiar and loved.

The man selected to oversee and implement the chosen reconstruction plan was Christopher Wren (1632–1723), an architect and a member of an aristocratic family who had finally found favour in the Restoration, after years in the wilderness during the Protectorate and Commonwealth (Whinney, 1971; Beard, 1982; Downes, 1988; Tinniswood, 2001): his assistants, the aforementioned brilliant but curmudgeonly Robert Hooke, described by Pepys as 'the most, and promises the least, of any man in the world that I ever saw' (Cooper, 2003); and the young and prodigiously gifted Nicholas Hawksmoor (Downes, 1970; de la Ruffinière du Prey, 2000). Incidentally, Wren was an anatomist and astronomer as well as an architect (one wonders whether he, like Sartre's autodidact, acquired his learning by reading an encyclopaedia, starting with the letter 'A'); a follower of the 'New Philosophy' of Francis Bacon (1561–1626); and a founder member of the Royal Society. He was, in short, an archetypal (English) Renaissance Man, and, most definitely, the right man, in the right place, at the right time – an unusually happy conjunction in the history of the City.

Wren and his office set about their reconstruction work as hastily, or rather speedily, as practicable, so as to provide the City with the opportunity of re-establishing itself with the minimum of delay and loss (Baker, 2000; Hollis, 2008). In all, they rebuilt fifty parish churches within and immediately without the walls, that is, around half of those that had been destroyed in the Great Fire,* together with *St Paul's Cathedral*, and also rebuilt numerous other public and private buildings, many in the High (English) Renaissance or Early

* Of these fifty churches, only twenty-eight, that is, around half, are still standing, together with St Paul's Cathedral, and twenty-two are not (see Map Two). Of the twenty-two that are no longer standing, seventeen, far more than one might have hoped, were demolished by our own over-zealous town planners and engineers in the pell-mell expansion of London following the Industrial Revolution – in some cases, at least marginally justifiably, to allow for development, but in many others simply because they were deemed, under the incomprehensibly philistine Union of Benifices Act of 1860, to be surplus to requirements! Only five, far fewer than one might have feared, were completely destroyed by German bombing during the Blitz of the Second World War. However, a number of others were also damaged to varying extents, some of which were subsequently restored, and some left as empty shells. Two, St Mary Aldermanbury and St Stephen Coleman Street, were destroyed, and eight, Christ Church, St Alban, St Andrew by the Wardrobe, St Anne and St Agnes, St Augustine, St Bride, St Lawrence Jewry and St Vedast alias Foster, damaged, on a single, fateful night, Sunday 29 December 1940, when thousands of incendiaries were dropped on an essentially unguarded City (All Hallows Barking and St Giles Cripplegate were damaged on the same night, each for the second time).

At least many of the original plans of these recently lost churches still survive, as do some later paintings and photographs.

Baroque style (Jeffery, 1996; Christopher, 2012). The most glorious of Wren's many glorious achievements was undoubtedly *St Paul's Cathedral*, which he built out of 66,000 tons of plain yet imposing Portland Stone (quarried in Dorset and brought round the coast and up the Thames to London in barges), and crowned with a wonderful and iconic dome, making it unique among all the cathedrals of England (Campbell, 2007). Wren's simple epitaph inside the cathedral reads '*Lector, si monumentum requiris, circumspice*', meaning 'Reader, should you seek his memorial, look about you'. On the pediment above the south door is a stone bearing the image of a phoenix rising from the ashes, and the inscription of the single word '*Resurgam*', meaning 'I shall rise again' (the inscription repeating that on another stone found by one of Wren's workmen among the debris of the old, burnt-out cathedral – a positive portent if ever there was one).

And so, out of the ashes arose a new London. And England was reborn.

SURVIVING STRUCTURES
AND STREETS

The following structures and streets, or reminders of them, survive to this day (see also Map One). Many of the street names and their inferred meanings have changed over the centuries. Among the now sadly lost street names are Berelane, Cow Face, Do Little Lane, Dunghill Lane, Grope Countlane (*sic*) and Harebrain Court.

Abchurch Lane (first recorded in 1274 as *Abechirchelane*). Named after the church of *St Mary Abchurch*. Site of a preserved fourteenth-century undercroft. Thus also *Abchurch Yard*.

Adams Court. Named after Thomas Adams (1586–1668), who lived here in the 1640s, when he was Master of the Drapers' Company, and went on to become Lord Mayor in 1645. Adams was arrested here for his Royalist sympathies during the Civil War.

Addle Hill (first recorded in 1244 as *Adhelingestrate*). Takes its name from the Old English '*atheling*', meaning noble or prince.

Addle Street (first recorded in 1304 as *Addelane*). Takes its name from the Old English '*adela*', meaning a dirty, muddy place. The junction between Addle Street and *Wood Street* was the site of the office of the Roman *aedile*, or public health and sanitation inspector, one of whose tasks was 'interviewing' women regarding their suitability as prostitutes.

Aldermanbury (first recorded in around 1124 as *Aldremanesburi*). Takes its name from the Old English '*earldormann*', meaning Alderman, and '*burh*', meaning manor, in reference to this being the place where the elder statesmen of the wards once met, before the *Guildhall* was built.

Alderman's Walk. Took its former name of Dashwood Walk from Sir Francis Dashwood, whose house and gardens were nearby in the seventeenth century.

Aldersgate Street, also *Ward* (first recorded in 1266 as *magnus vicus de Aldredesgate*). Takes its name from one of the ancient (fourth-century) gates to the City that once stood here, referred to in the Saxon period as 'Ealdredesgate', or Ealdred's Gate. The gate was damaged in the Great Fire of 1666, and demolished in 1761. Photographs show that pre-Great Fire houses stood on the street until comparatively recently.

Aldgate, also *Aldgate High Street*, and *Ward* (first recorded in the thirteenth century as *Alegatestrete*). Takes its name from another of the ancient (second-century) gates to the City that once stood here, referred to in the Saxon period as '*Aestgeat*' or East Gate, and as '*Alegate*', no doubt in reference to 'weary travellers from Essex ... in need of refreshment on entering the City', which need they would have been able to meet at the '*Saresynshede withynne Algate*' or 'Saracen's Head'. The gate survived the Great Fire of 1666, but was demolished in 1760. The originally thirteenth-century timber-framed 'Hoop and Grapes' on adjacent Aldgate High Street also survived the Great Fire, and, remarkably, parts of it survive still. Seventeenth-century Corinthian pilasters, salvaged from the 'Saracen's Head' when it was demolished, are now housed in the *Guildhall* Museum.

Aldwych (first recorded in 1211 as *Aldewic* or *Aldewich*). Takes its name from the Old English '*ald*', meaning old, and '*wic*', meaning trading settlement.

Alie Street. Named after the Alie family, related by marriage to the Lemans, who gave their name to *Leman Street*.

All Hallows Barking, also known as *All Hallows-by-the-Tower*, Byward Street/Great Tower Street. Originally built in the Saxon period, and considerably added to in the Middle Ages. Undamaged in the Great Fire of 1666, thanks to the action of Admiral General Sir William Penn Senior, who ordered the blowing-up of some surrounding buildings to create a fire-break, although nonetheless rebuilt by Pearson in the late nineteenth century. Gutted by bombing in the Blitz of 1940–1, when 'the tower of the church acted like a chimney, drawing the flames upwards and intensifying them' and 'wood blazed, stones calcinated, lead poured down walls and the bells melted', and rebuilt again by Lord Mottistone in a 'happy blend' of Ancient and Neo-Perpendicular styles, and rededicated in 1957 (a photograph taken after the war clearly shows the extent of the bomb damage sustained by the church). A fine Saxon arch of around 675, incorporating Roman tiles, survives *in situ*; and two Saxon crosses, once incorporated into a Norman column, in an interesting exhibition in the crypt, which is itself Saxon to Medieval. Among the many surviving

Medieval features are substantial sections of tiled floor; an altar table of stone from the Crusaders' castle at Atlit below Mount Carmel in the Holy Land; a fine Flemish painted panelled altar-piece, known as the Tate Panel, dating to at least the fifteenth century; numerous sculptures, including a carved wooden one of St James of Compostella, dating to the fifteenth century; numerous monuments, including the Croke chest, dating to around 1477, and various brasses; and the seventeenth-century tower, from which Samuel Pepys watched the Great Fire of 1666, later noting in his diary entry for Wednesday 5 September, 'I up to the top of Barkinge steeple, and there saw the saddest sight of desolation I ever saw'. Also of note are the exquisitely intricately carved lime-wood font-cover by Grinling Gibbons, dating to 1682; the pulpit, originally from *St Swithin London Stone*, also dating to 1682; a series of ornamental sword-rests, dating to the eighteenth century; and, among the curiosa, numerous large model ships suspended in the south aisle. On a macabre note, many prisoners executed at the nearby *Tower of London* are buried here, including Thomas More, Archbishop William Laud and Bishop John Fisher. William Penn Junior, the founder of Pennsylvania, was baptised here.

All Hallows Bread Street. Originally built in the thirteenth century. John Milton was christened here in 1608. Burnt down in the Great Fire of 1666, and rebuilt by Wren in 1681–98, only to be demolished to make way for warehouses in 1877, when the parish was merged with *St Mary-le-Bow*. A plaque on the wall of *St Mary-le-Bow* and some parish boundary markers survive at its former site. The salvaged pulpit also survives, in *St Vedast, Foster Lane*.

All Hallows Honey Lane, Milk Street, off Cheapside. Originally built in around 1235, the church was burnt down in the Great Fire of 1666 and never rebuilt, and the parish was merged with that of *St Mary-le-Bow*. Only parish boundary markers survive at its former site (although an alms-dish survives in the treasury of *St Paul's*).

All Hallows Lombard Street. Originally built in around 1053, and rebuilt between 1516 and 1544. Burnt down in the Great Fire of 1666, and rebuilt by Wren in 1686–94, only to be demolished in 1938–9, when the parish was merged with *St Edmund the King*. Only parish boundary markers survive at its former site. Some of the fabric and furnishings survive in a church in Twickenham.

All Hallows London Wall. Originally built around 1130. Undamaged in the Great Fire of 1666, but rebuilt by George Dance the Younger in 1765–7, and

further modified in the late nineteenth century, only to be badly damaged by bombing in the Second World War, and rebuilt again, by David Nye, in 1960–2. Also damaged by and further restored following an IRA bomb in 1993. The font was salvaged from *St Mary Magdalen, Old Fish Street*.

All Hallows Staining, Mark Lane. Originally built around 1177, and added to in the fifteenth century. Undamaged in the Great Fire of 1666, most of the church fell down in 1671, due to undermining of the foundations by plague burials, and it had to be rebuilt in 1674–5, before being substantially demolished in 1870, when the parish was merged with *St Olave Hart Street*. The fifteenth-century tower still stands, thanks to the initiative of the Clothworkers' Company, who were also responsible for restoring it in 1873. The foundations are original, twelfth-century. The crypt is also twelfth-century, although it has been moved from its original position. Two sword-rests salvaged from the church can be seen in *St Olave Hart Street*, a third in *St Andrew Undershaft*.

All Hallows the Great, Upper Thames Street. Originally built in around 1235. Burnt down in the Great Fire of 1666, and rebuilt by Wren in 1677–84, only to be demolished, to allow for road-widening and development, between 1876 and 1894, when the parish was merged with *St Michael Paternoster Royal*. Essentially nothing now remains of the church at its former site, other than the name, which lives on in that of *Allhallows Lane* (the last vestige, the churchyard, having been lost during the construction of the City Fire Station). Salvaged statues of Moses and Aaron, and a carved figure of Charity, survive in *St Michael Paternoster Royal*. A salvaged chancel screen also survives, in *St Margaret, Lothbury*.

All Hallows the Less, Upper Thames Street. Originally built sometime during the long reign of Henry III (1216–72). Burnt down in the Great Fire of 1666 and never rebuilt, and the parish was merged with that of *All Hallows the Great*. Essentially nothing now remains of the church at its former site, other than the name, which lives on in that of *Allhallows Lane*, although a salvaged alms-dish survives in the treasury of *St Paul's*. A photograph of the church taken in around 1910 also survives. The former site was occupied by Mondial House, a bomb-proof telephone exchange clad in glass-reinforced polyester, from 1975 until its demolition in 2006. Photographs of Mondial House on nothingtoseehere.net reveal it to have been a rather striking building, with each storey set back a little further than the last so as not to obstruct the view of *St Paul's* (which is what prompted that self-appointed arbiter of the nation's tastes Prince Charles to describe it as 'redolent of a word-processor').

Allhallows Lane (indicated on map of 1520 as *All Hallows Lane*). Takes its name from the church(es) of *All Hallows*, which once stood nearby.

Amen Corner (first recorded on map of 1520 as *Amen Lane*). Takes its name from the prayers recited here on the processional route towards *St Paul's*.

(Roman) Amphitheatre, Guildhall. Originally built in timber in the late first century, around 75, rebuilt in stone in the second, and renovated in the late second to third, before being abandoned in the fourth, and only coming to light again during excavations on the site of the Medieval *Guildhall* in 1987. A 'Museum of London Archaeology Service' monograph describes in detail the findings of subsequent archaeological excavations at the Roman site (Bateman *et al.*, 2008; see also Bateman, 2000 and Bateman, 2011). The surviving structures and associated artefacts can be viewed on site, in the basement of the *Guildhall*.

Angel Court. Takes its name from the 'Angel' Tavern that once stood here.

Angel Passage. Takes its name from another 'Angel' Tavern. One of the remaining few of the formerly many passageways linking the river and *Upper Thames Street*, 'today … it has little to recommend it'.

Apothecaries' Hall, Blackfriars Lane. Originally built in 1633, on part of the site of the former Black Friars Monastery, which was dissolved in 1538. Substantially burnt down in the Great Fire of 1666, and rebuilt by Thomas Lock in 1668. The walls of the original building survive.

Artillery Lane (first recorded in 1600 as *Artyllerye lane*). Takes its name from the Tasel Close Artillery Yard that stood here from the Dissolution in the time of Henry VIII in the sixteenth century until it was sold at the end of the seventeenth. The artillery yard was used for shooting practice by trained bands, or 'Fat Hal's Militia', by the forerunner of the Honourable Artillery Company, the 'Guild of St George' or 'Gentlemen of the Artillery Garden' or 'Fraternyte or Guylde of Artyllary of Longebowes, Crossbowes and Handegonnes', and by gunnery officers of the Tower Ordnance. As Stow wrote, 'serveth to be an artillery yard, whereunto the gunners of the Tower do weekly repair … and there levelling certain brass pieces of … artillery against a butt of earth, made for that purpose, they discharge them for their exercise'. Thus also *Artillery Passage*. Tasel Close took its name in turn from the teasels that once grew here, and proved of great use to the Huguenot silk-weavers of nearby *Spitalfields*.

Arundel House, Arundel Street, off the Strand. The former town house of the Bishops of Bath and Wells came into the possession of the Earls of

Southampton, and later the Earls of Arundel, after the Dissolution of the Monasteries in 1545, whereupon it became known as Arundel House. The house was undamaged in the Great Fire of 1666, and the Royal Society, which had lost its former meeting place in the fire, met here from 1666–74. It was demolished in 1678, when Arundel Street was built. Philip Howard, Earl of Arundel, who was born in the house in 1557, was later imprisoned in the *Tower of London* for his Catholic religious beliefs in 1585, which he steadfastly refused to renounce, and died of dysentery there in 1595. He was canonised by Pope Paul VI in 1970, as one of the Forty Martyrs of England and Wales.

Ashentree Court. Named after the ash trees that once stood here, when the site belonged to the Carmelite Order of White Friars. See also *Carmelite Street* and *Whitefriars Monastery* and *Street*.

Austin Friars (indicated on map of 1520 as *Austin Friary*). Named after one of the many old monastic orders of the City, the Augustinian or Austin, established here under Humphrey de Bohun, Constable of England, in around 1253. Site of the *Dutch Church*.

Ave Maria Lane (first recorded in around 1510 as *Ave-maria aly*). Takes its name from the 'Hail Marys' recited here on the processional route towards *St Paul's*.

Back Alley. One of the remaining few of the formerly many 'back alleys' of the City, in Aldgate.

Bakers' Hall Court. Takes its name from the Worshipful Company of Bakers' Hall, on *Mark Lane*. The original hall was burnt down in the Great Fire of 1666.

Bankside see *Southwark*.

Barbican (first recorded in around 1260 as *Barbikan*). Takes its name from the Old French *'barbacane'*, meaning an outer fortification of a city or castle, usually with a watch-tower.

Barley Mow Passage. Takes its name from the 'Barley Mow' Tavern that once stood here.

Barnard's Inn (Gray's Inn) see *Inns of Court*.

Bartholomew Close and *Passage*. Named after the church of *St Bartholomew the Great*.

Bartholomew Lane (first recorded in around 1350 as *Seynt Bartilmew lane*). Named after the church of *St Bartholomew-by-the-Exchange*.

(Roman) Basilica and Forum. The original Roman buildings on the site, which may or may not have included a Basilica and Forum, were put up in the first decade of Roman occupation in the mid-first century, around 50–60, and substantially burnt down during the Boudiccan Revolt of 60 or 61. The first undoubted Basilica and Forum were built around 70, and rebuilt and considerably extended around 100–130, before being substantially demolished around 300, only coming to light again during excavations at 168 *Fenchurch Street* in 1995–2000. A 'Museum of London Archaeology Service' publication describes in detail the findings of recent archaeological excavations at the site (Dunwoodie, 2004). A pier base can be seen in the basement of No. 90 *Gracechurch Street*.

Basinghall Street (first recorded in 1279 as *the street of Basingeshawstrete*). Named after the Hall of the Basing family, which stood here in the Middle Ages. Solomon Basing was Mayor of London in 1216. Thus also *Bassishaw Ward*.

Bath Street. Takes its name from the nearby Peerless – also known as Parlous or Perilous – Pool, filled in and built over in 1850. Took its previous name of *Pest House Row* from the presence there of a so-called 'pest house', where people infected with the Plague were sent in the sixteenth and seventeenth centuries (most of them doubtless ending up in the nearby burial ground at *Bunhill*). A plaque marks the former site of the pest house.

Bear Alley. Thought to take its name from a 'Bear' Tavern.

Bear Gardens, Southwark. Takes its name from the bear-baiting that used to take place here. This barbaric practice was introduced to London from Italy in around 1546, and only outlawed as recently as 1835.

Bear Street. Takes its name from the bear that appears, with a ragged staff, on the coat-of-arms of the Neville family, who owned land and property here in the Middle Ages. The same Neville family, which included Warwick the king-maker, built Lord Leycester Hospital in Warwick, which still stands today.

Bedford Street. Named after John Russell, First Earl of Bedford, who was presented with land in the area by Charles II, and who commissioned Inigo

Jones to design the street layout and build the houses, in 1633–40. Thus also *Bedfordbury*.

Bedlam. Originally founded as the Priory of the Order of the Star of Bethlehem just outside *Bishopsgate* in 1247, becoming a hospital in 1337, and a mental hospital of a sort in 1357, and becoming infamous less for the disorganised behaviour and din of its inmates than for their shameful ill-treatment by all and sundry (Arnold, 2008). Rebuilt in *Moorfields* in 1675, by Robert Hooke, as 'The Palace Beautiful'. Relocated to *Southwark* in 1815, and to Bromley in Kent in 2008. Corporation 'Blue Plaques' mark its former sites just outside *Bishopsgate* and on *Moorfields*.

Beech Street (first recorded in 1279 as *le Bechlane*). Thought to take its name either from the Old English '*bece*', meaning either a beech tree or possibly a stream, or from a strip of land known as the '*beche*' that lay alongside. Stow had an alternative explanation, that it was named after one Nicholas de la Beech, the Lieutenant of the *Tower of London* in the reign of Edward III, from 1327–77. Note, though, that usage of the name from the late thirteenth century probably pre-dates Beech's time, which would have been at least mostly fourteenth.

Bell Inn Yard. Takes its name from the 'Bell Inn' that stood here from the fourteenth century until the seventeenth, when it was burnt down in the Great Fire.

Bell Yard, off *Carter Lane*, EC4. Takes its name from another 'Bell Inn', that stood on *Carter Lane* from 1424 until around 1708. One Richard Quiney or Quyney wrote the only surviving letter to Shakespeare from the inn in 1598.

Bell Yard, off the *Strand*, WC2. Takes its name from yet another 'Bell Inn', that stood here from early Medieval times, and was frequented by the Knights Templar.

Bermondsey (first recorded as *Vermundesei* in around 712, and as *Bermundesye* in the Domesday Book of 1086). Takes its name from the Old English personal name 'Beornmund' and '*eg*', meaning island, or area of high and dry ground surrounded by low marsh. The Cluniac Priory and Abbey of St Saviour, or Bermondsey Abbey, was established here in 1082, dissolved by Henry VIII in 1538, and substantially demolished by Thomas Pope, Treasurer of the Court of Augmenations in 1541, to allow for the construction of Bermondsey House, which itself stood until the early nineteenth century. A plaque marks the site of the abbey church. A 'Museum of London Archaeology Service' monograph describes in detail the findings of archaeological excavations there (Dyson *et*

al., 2011). The church of St Mary Magdalen also had its origins before the Great Fire of 1666.

Bethnal Green (first recorded as *Blithehale* in the thirteenth century, as *Blethenalgrene* in 1443, and as *Bethnal Greene* in 1657). Takes its name from the Old English personal name 'Blitha' or word '*blithe*', meaning pleasant, the Old English '*halh*', meaning land, and the Middle English 'grene'. Would appear to have been a leafy suburb until Victorian times.

Bevis Marks (first recorded in 1372 as *Bewesmarkes*). Corrupted from *Bewesmarkes* or *Burysmarkys*, which marked the limit of the estate of the Abbots of Bury St Edmunds in Medieval times.

Billingsgate (first recorded in around 1000 as *Billingesgate*), also *Billingsgate Ward*. Thought to be named after one Billing, an ancient Briton. Billingsgate became a by-word for foul language in the seventeenth and eighteenth centuries, when it was the site of a bustling, jostling fish market. Malcolm wrote of the area in his *Londonium Redivivium* of 1807 that 'the narrow streets and alleys and their wet slippery footways will not bear description or invite unnecessary visits'. An excavation in what is now Billingsgate Lorry Park in 1982 yielded many finds, including fragments of sixteenth-century stoneware imported from the Rhineland (Schofield & Pearce, 2009).

Billiter Street (first recorded in 1244 as *Belyetereslane*). Takes its name from the 'belleyeteres' or bell-founders who made bells here in the Middle Ages. Thus also *Billiter Square*.

Birchin Lane (first recorded in 1193 as *Bercheruere lane*). Thought to be corrupted from the Middle English '*berdcherver*', meaning beard-shaver or barber, in reference to such once working here.

Bishop of Winchester's Palace, Clink Street, Southwark. Originally built in the twelfth century by Bishop Henry de Blois, the brother of King Stephen. Remained in use as the Bishop's private retreat, replete with a tennis court, bowling alley and 'pleasure garden', throughout the Middle Ages. A 'Museum of London Archaeology Service' monograph describes in detail the findings of recent archaeological excavations at the site (Seeley *et al.*, 2006). Another deals with excavations at the unconsecrated 'Crossbones Graveyard' on Redcross Way, where prostitutes who worked in the brothels licensed by the bishops – 'Winchester Geese' – were buried (Brickley *et al.*, 1999). The skeleton of one was found to exhibit pathological indications of syphilis.

Bishop's Court, EC4. Thought to take its name from the 'Bishop's Head' Tavern that once stood here.

Bishop's Court, WC2. Named after the Bishops of Chichester, whose mansion stood nearby in the early Medieval period. Thus also *Chichester Rents*.

Bishopsgate (first recorded in 1086 – in the Domesday Book – as *Portam Episcopi*), also *Bishopsgate Ward*. Named after Eorconweald or Erkenwald, the Bishop of London from 675–93, who, according to tradition, built a gate here, on the site of the earlier, second-century one, and exacted a tax of one stick from all carts bringing wood into the City through it. The gate survived the Great Fire of 1666, but was demolished in 1760. Photographs taken in the late nineteenth and early twentieth centuries show that at these times a number of pre-Great Fire houses still stood on the street, including those of John Crosby and Paul Pindar. Amazingly, Crosby's, dating to 1466–75, still survives, although at a new location near Battersea Bridge in Chelsea. The façade salvaged from Pindar's also survives, in the Victoria and Albert Museum in South Kensington.

Blackfriars Lane (indicated on map of 1520 as *Water Lane*). Named after the Dominican, or Black, Friars, who once had a monastery here. Thus also *Blackfriars Court* and *Passage*, and *Friar Street*.

Blackfriars Monastery. Built in 1278, and dissolved in the reign of Henry VIII in 1538, whereupon the site became that of a play-house, used by Shakespeare's Players, in turn closed down by the Puritans in 1642, and demolished in 1655. A Corporation 'Blue Plaque' marks the former site. Part of the wall of the monastery can still be seen in the churchyard of *St Ann Blackfriars* in *Ireland Yard*. A copy of the dissolution document can be seen in *St Andrew-by-the-Wardrobe*.

Blackwall (first recorded as *Blakewale* in 1377). Takes its name from the Old English '*blaec*', meaning black, and '*wall*', in reference to an artificial embankment put up here to hold back the waters of the Thames. The Citizen and Cordwainer Captain John Smith (1580–1631) left from here in 1606 to establish the first English colony in America, at Jamestown in Virginia ('from which began the overseas expansion of the English-speaking peoples'); and the East India Company established its first docks at Blackwall Yard in 1614. Smith is buried in the church of *St Sepulchre*, and there is also a statue of him in the churchyard of *St Mary-le-Bow*. Incidentally, the Native American Princess Pocahontas saved his life in America, and later visited London, staying at the 'Belle Sauvage' on *Ludgate Hill*.

Bleeding Heart Yard. According to legend, named after Lady Elizabeth Hatton, who was found in the yard, 'torn limb from limb, but with her heart still

beating' in 1626, after reneging on an earlier pact with the devil entered into in order to obtain favours for her husband, Christopher Hatton, from the then queen, Elizabeth I. In an alternative version, Lady Elizabeth was murdered after a tryst with one Diego Sarmiento de Acuna, the Spanish Ambassador to the Court of King James, although as Long put it, 'the end result was much the same'. The spot is reputedly haunted by the ghost of Lady Elizabeth, 'pumping the imaginary handle of an imaginary pump which never draws a drop even of ghostly water'.

Bloomsbury (first recorded as *Soca Blemund* in 1242). Takes its name from a corruption of Blemondesberi, meaning the manor of (William) Blemond or Blemund, who owned land here in the thirteenth century. Thus also *Bloomsbury Place, Square, Street* and *Way*. *Bloomsbury Square*, originally named Southampton Square, after Robert Wriothesley, Fourth Earl of Southampton, was originally laid out in the early 1660s. *Bloomsbury Place* allowed residents of the square access to *Southampton Row*. *Bloomsbury Street* and *Way* are later.

Bolt Court. Takes its name from the 'Bolt-in-Tun' Tavern. The bolt-in-tun was the rebus of the Bolton family. William Bolton was the Prior of *St Batholomew the Great* during the reign of Henry VII, hence the rebus on the oriel window in the interior thereof.

Bond Court. Named after William Bond, who was Alderman of the Walbrook Ward in 1649.

Borough (first recorded as *Southwarke borrow* in 1559). Takes its name from the Old English '*burh*'. Thus also *Borough High Street* and *Market*. *Borough High Street* is part of, and was once known as, *Stane Street*, the Roman road to Chichester and the south, and *Borough Market* was first established in the thirteenth century. Famously, there were some fifty inns and other drinking establishments on and around *Borough High Street* at the time of the Great Fire of London in 1666, including the 'Tabard' and 'White Hart', which were known to and written about by Chaucer and Shakespeare. They all survived that fire, but many were burnt down in the later Great Fire of *Southwark* in 1676. The magnificent, galleried 'George', which was rebuilt in 1677, is still standing.

Botolph Lane (first recorded in 1349 as *Seyntbotulfeslane*). Named after the church of *St Botolph Billingsgate* that one stood hereabouts. Thus also *Botolph Alley*. Botolph was the patron saint of travellers, and had churches dedicated to him at *Aldgate, Aldersgate* and *Bishopsgate* as well as *Billingsgate*.

Bouverie Street (indicated on map of 1520 as *Crokers Lane*). Named in 1799 after the Bouverie family, who acquired nearby land formerly owned by the White Friars after the Dissolution of the Monasteries.

Bow (first recorded in 1177 as *Stratford*, and in 1279 as *Stratford atte Bowe*). Takes its name from the Old English '*boga*', meaning an arched bridge. Bow church was built in 1311.

Bow Lane (first recorded in 1485 as *Bowlane*). Named after the church of *St Mary-le-Bow*. Thus also *Bow Churchyard*.

Bread Street (first recorded in around 1165 as *Bredstrate*), also *Bread Street Ward*. 'So called of bread in old time there sold' (Stow). The name first appears in the late twelfth century. The Bread Street Compter stood here until the *Wood Street* Compter was built in 1555. The 'Mermaid' Tavern stood here from 1411 until it was burnt down in the Great Fire of 1666. John Milton was born here, at the sign of the 'Spread Eagle', in 1608.

Brewhouse Yard. Takes its name from the many brew-houses that once stood nearby, drawing water from the Thames.

Brick Lane (first recorded as *The Brick Lane* in 1542). Takes its name from the brick-earth workings and brick manufactories that stood here in the sixteenth century. Home to successive waves of immigrants: Huguenot, Jewish, and Bengali. What is now the Jamme Masjid at the corner of Brick Lane and Fournier Street was once the Machzike Adass or Spitalfields Great Synagogue, and before that a French Protestant church.

Bride Lane (first recorded in 1205 as *vico Sancte Brigide*). Named after the church of *St Bride*. Thus also *Bride Court*.

Bridewell Palace. Built by Henry VIII in 1520, and granted by Edward VI in 1553 to the City of London to house a hospital, hostel, workhouse and prison. Burnt down in the Great Fire of 1666, rebuilt in 1667, and demolished in 1864. The new building on the old site bears a commemorative plaque. It was here that Henry VIII argued the case for his divorce from Catherine of Aragon with the Papal Legate; and here in 1553 that Holbein painted *The Ambassadors*.

Bridge Ward. Named after *London Bridge*.

Broad Street Ward see *Old Broad Street*.

Broken Wharf. Takes its name from a wharf that stood here in the thirteenth century that was allowed to fall into disrepair during a long-running dispute between the co-owners, the Abbots of Chertsey and the Abbots of Ham(me), over who was responsible for its maintenance.

Bromley-by-Bow (first recorded as *Braembelege* in around 1000, and as *Bromley-by-Bow* in 1786). Takes its name from the Old English for a woodland clearing or *'leah'* where brambles grew. The home of a Benedictine Convent dedicated to St Leonard, founded in around 1100, although now no longer standing. Also of Bromley Palace, originally built for James I in around 1606, although also now no longer standing. And of Bromley Hall, originally built around 1500, and still standing, on what is now part of the *Blackwall* Tunnel Approach Road.

Bucklersbury (first recorded in 1270 as *Bukerelesbury*). Named after the Buckerel family, thought to be originally of Italian extraction, who lived here at least as long ago as the twelfth century. Thomas More lived here from 1505–11.

Budge Row (first recorded in 1342 as *Bogerowe*). Takes its name from the 'budge', a kind of lambskin, once sold here. 'Budge' takes its name in turn from the Middle English *'boge'*.

Bull's Head Passage. Takes its name from the 'Bull's Head' Inn that stood here in the sixteenth century.

Bunhill Fields, Row (first recorded in 1544 as *Bonhilles*). Corrupted from 'Bonhilles' or 'Bonhil', meaning bone hill, in reference to the nearby cemetery. The visionary poet and artist William Blake and the writers John Bunyan and Daniel Defoe are among those buried in the cemetery, alongside many victims of the 'Great Plague' of 1665 (which Defoe wrote a harrowing account of in his journal), and many religious dissenters. Touchingly, Blake's grave was adorned with trinkets when I last visited it.

Bury Street (indicated on map of 1520 as part of *Burye street*). Named after the Abbots of Bury St Edmunds, who had a town house here up until the time of the Dissolution of the Monasteries. Thus also *Bury Court*.

Bush Lane (first recorded in 1445 as *Le Busshlane*). Takes its name from the 'Bush' Tavern that stood here in the fifteenth century. The sign at the entrance to the tavern was apparently actually in the form of a bunch of ivy, and would have been recognisable even to those who could not read.

Camomile Street (indicated on map of 1512 as part of *Bevesmarks*). Takes its name from the herb camomile, grown here in the twelfth and thirteenth centuries for use as an ingredient in remedies for fevers, agues and other ailments. Thus also *Camomile Court.*

Cannon Street (first recorded in 1183 as *Candelewrithstret*). Corrupted from the Middle English '*candelwricht*', meaning candle-wright or chandler, in reference to such working here in the Middle Ages. Thus also *Candlewick Ward.* The smell associated with the rendering of the animal fat to make the tallow for the candles caused so many complaints from the neighbouring populace that the manufactories eventually had to be moved into the surrounding countryside! A 'Museum of London Archaeology Service' monograph describes in detail the findings of archaeological excavations at the site of a substantial Roman town house immediately adjacent to the *Governor's Palace*, substantially under Cannon Street Station, the site appropriately now known as 'Governor's House' (Brigham & Woodger, 2001); another MoLAS archaeology study with the findings of archaeological excavations at No. 25 (Elsden, 2002). Incidentally, it is likely that the so-called '*London Stone*', first recorded at least as long ago as the twelfth century, is a relic of the *Governor's Palace* itself (see also *St Swithin London Stone*).

Capel Court. Named after the Capel family. William Capel was Lord Mayor of London in 1503.

Cardinal Cap Alley, Southwark. Named after the insalubrious tavern with the 'Cardinal's Cap' as its sign that stood here in Medieval times, serving also as a 'stew-house' or brothel (there was a proliferation of such establishments on Bankside at the time). Previously known as Cardinal's Tart Alley, it being rumoured that Cardinal Beaufort, Bishop of Winchester from 1405–47, kept a mistress here.

Carey Lane (first recorded in 1234 as *Kyrunelane*). Thought to take its name from a corruption of the Old English woman's name 'Cynerun'.

Carlisle Lane, Lambeth. Named after the Bishops of Carlisle, who took possession of the twelfth-century town house formerly owned by the Bishops of Rochester here in 1539. In 1531, an attempt was made here by Richard Rose to poison the Bishop of Rochester, John Fisher. Fortunately for him, 'the Bishoppe eate not pottage that daie, whereby hee escaped'. Unfortunately for them, though, fourteen others did partake, and died. The dreadful deed also cost Rose his life: he was boiled alive at *West Smithfield*. Carlisle House was demolished in 1827.

Carter Lane (first recorded in 1295 as *Carterestrate*). Thought to take its name either from the brothers Stephen and Thomas le Charatter or le Charetter, who, tax records indicate, lived in *Castle Baynard Ward* at least as long ago as 1319, or from the carters who once lived or worked here. The headquarters of Worshipful Company of Carmen, formerly the 'Fraternyte of Carters', is in Painters' Hall in nearby *Little Trinity Lane*. Guy Fawkes and his co-conspirators in the Gunpowder Plot of 1605 held clandestine meetings in the 'Hart's Horn' Tavern in *Carter Lane*.

Castle Baynard. Originally probably built a little to the south-west of *St Paul's Cathedral* by Ralph Baynard, one of William I's noblemen, in the eleventh century, and rebuilt in a river-front location in the early fifteenth, becoming much used by a succession of kings and queens in the late fifteenth to early seventeenth, before being essentially completely destroyed in the Great Fire in 1666. A Corporation 'Blue Plaque' on the Embankment marks the site of the second, river-front castle. Essentially nothing else remains of either castle, other than, arguably, part of the outline of the moat of the first, traced by the curved northern end of *St Andrew's Hill*. However, numerous archaeological finds have been made in the vicinity over the years, some of them dating back to the Saxon period. My favourite is the fourteenth-century 'winkle-picker' shoe.

Castle Baynard Street (indicated on map of 1520 as part of *Thames Street*), also *Ward*. Takes its name from *Castle Baynard*.

Castle Court. Presumably named after a drinking establishment, there having been a range of such here since at least the fifteenth century. The 'George and Vulture' at No. 3 was much frequented by Dickens in the nineteenth.

Cavendish Court. Named after the Cavendishes, the Earls and Dukes of Devonshire, who had a house here until the late seventeenth century. Thus also *Devonshire Row* and *Square*.

Chancery Lane (first recorded in 1338 as *Chauncelerslane*). Takes its present name from the Middle English '*Chauncerie*', a contraction of '*Chauncelerie*', in reference to office of the Master of the Rolls of the Court of Chancellory, established here in the fourteenth century. Previously known in the late thirteenth century as 'Converslane', in reference to a house for Jewish converts to Christianity built here in around 1231; and in the early thirteenth century as 'Newestrate'.

Chandos Place. Built in the 1630s and named after Lord Chandos, the father-in-law of the land-owner, the Fourth Earl of Bedford.

Change Alley. Takes its name from the nearby *Royal Exchange.* Jonathan's Coffee House, famous for being where the Stock Exchange was founded, stood here. Garraway's Coffee House, which ought to be even more famous for being the first place in the City to sell tea, stood next-door to it. Tea and coffee first became readily available in the sixteenth century, although at that time they were almost prohibitively expensive, and most certainly the exclusive preserves of the higher echelons of society.

Charing Cross (first recorded as *The stone cross of Cherrynge* in 1334, and as *La Charryngcros* in 1360). Takes its name from the cross set up here by Edward I in 1291 to mark one of the places through which the body of his late wife, Eleanor of Castile, passed on its final journey from Nottinghamshire, where she died, to London, where she was buried. The equestrian statue of Charles I by Hubert le Sueur dates to 1632. It was taken down after the Civil War, whereupon an unscrupulous entrepreneur named Rivett sold as souvenirs what he claimed were parts of it, which were not. Charing was the village that stood at the site previously, at least as far back as the end of the eleventh century.

Charterhouse, Charterhouse Square. Built in 1371 as a 'Chartrouse', or Carthusian monastery, by Sir Walter Manny, 'a stranger born, lord of the town of Manny, in the diocese of Cambray, beyond the seas, who for service done to Edward III was made Knight of the Garter' (Stow). In fact, the site was first consecrated as a burial ground for victims of the 'Black Death' in 1348–9 (as Stow put it, 'A great pestilence ... overspread all England, so wasting the people that scarce the tenth person of all sorts was left alive, and churchyards were not sufficient to receive the dead, but men were forced to choose out certain fields for burial'). After the Dissolution of the Monasteries in 1538, the site eventually became that of a charitable hospital and school, and is in part now that of St Bartholomew's School of Medicine and Dentistry. A few original Medieval parts of buildings remain. Although a 'Museum of London Archaeology Service' monograph describes in detail the findings of recent archaeological excavations at the site, unfortunately the Elizabethan Great Chamber was destroyed in the Second World War (Barber & Thomas, 2002).

Charterhouse Street (indicated on map of 1520 as *Charterhouselane*). Takes its name from the *Charterhouse.* Thus also *Charterhouse Mews* and *Square.*

Cheapside (first recorded in around 1100 as *Westceap*), also *Ward of Cheap.* Takes its name from the Old English 'ceap', meaning market. A great open-air market was situated here, in what was in effect the High Street of the City, in Medieval times, where all manner of goods could be procured. The space was also used for pageants, tournaments and other festivities. Photographs taken in

the 1900s show that at this time a number of seventeenth-century houses still stood on the street, including No. 37, which was one of the first to be rebuilt after the Great Fire of 1666, on the site of the 'Chained Swan' Tavern. All were destroyed during the Blitz of 1940–41. A 'Museum of London Archaeology Service' publication describes in detail the findings of recent archaeological excavations at Nos 72–78 (Hill & Woodger, 1999). A Roman bath-house once stood where Nos 110–116 now stand.

Chicheley Street, Southwark. Named after Henry Chicheley, the Archbishop of Canterbury in the fifteenth century.

Chichester Rents. Named after the Bishops of Chichester, whose mansion stood nearby in the early Medieval period. Thus also *Bishop's Court* (WC2).

Chiswell Street (first recorded in the thirteenth century as *Chysel strate*, and indicated on the map of 1520 as *Cheselstrete*). Takes its name from the Middle English '*chysel*', meaning gravel.

Christ Church Newgate Street. Originally founded as a Franciscan or *Greyfriars Monastery* in around 1225, and re-founded in 1552 after the Dissolution of the Monasteries as a parish church, also incorporating the former parishes of *St Audouen or Ewen* and – get this – *St Nicholas Shambles* (Kingsford, 1915). Badly damaged in the Great Fire of 1666, although the glazed windows were 'very little damnified', and rebuilt by Wren in 1677–1704, only to be gutted by incendiary bombing on 29 December 1940. The tower with its impressive steeple, restored by Lord Mottistone in 1960, still survives, as does the still-impressive partial shell of the rest of the building. The former nave was made into a city garden in 1989. A 'Museum of London Archaeology Service' monograph describes in detail the findings of recent archaeological excavations at the site (Lyon, 2007). Three queens, Edward I's Margaret, Edward II's Isabella, and Joan de la Tour of Scotland, and the heart of a fourth, Henry III's Eleanor of Provence, were buried here, along with a total of 663 nobles. After the Dissolution, the majority of their tombs and memorials were sold for as little as £50. The library presented by Dick Whittington in 1425, valued at £400, was lost in the Great Fire. Some reportedly rather beautiful choir stalls, built with timber salvaged from a Spanish warship of the Armada of 1588, were destroyed in the Blitz.

Christ's Hospital (Orphanage and School), Newgate Street. Originally founded by the City of London authorities on the site of the former conventical buildings of the aforementioned *Greyfriars Monastery* in 1552. Badly damaged in the Great Fire of 1666, and rebuilt, only to be substantially destroyed by bombing

during the Blitz. A photograph taken in around 1906 still survives. A 'Museum of London Archaeology Service' monograph describes in detail the findings of recent archaeological excavations at the site (Lyon, 2007). Christ's Hospital School, also known as 'Bluecoats', which numbers among its alumni Charles Lamb (1775–1834), 'a Bluecoat boy ... for seven years' (who, incidentally, is commemorated in a bust on *Giltspur Street*), and Samuel Coleridge (1875–1912), relocated to Horsham in Sussex in 1902, but still participates in many ancient City traditions, including the St Matthew's Day celebrations, held each year on or around 21 September, the 'Spital Sermons', held on or around the second Wednesday after Easter, and the Lord Mayor's parade. A Corporation 'Blue Plaque' marks its former site.

Church Entry. Takes its name from the church of *St Ann Blackfriars*.

City Wall. Originally built by the Romans in the early second century, after Londinium was essentially razed to the ground during the Boudiccan Revolt of the late first, and strengthened and extended by them in the third and again in the fourth, and by the succeeding inhabitants of the City in the Middle Ages. The best-preserved sections are near the Museum of London on *London Wall* to the west, where battlements and substantially intact bastions can be seen, and around *Tower Hill* to the east.

Clement's Lane (first recorded in 1241 as *vicus sancti Clementis*, and in 1348 as *Seint Clementeslane*, and indicated on map of 1520 as *Seynt Clementes Lane*). Named after the church of *St Clement*, of nursery-rhyme fame. Thus also *St Clement's Court*.

Clerkenwell (first recorded in around 1150). Takes its name from the Clerk's Well, where the Worshipful Company of Parish Clerks of the City of London used to make pilgrimages, and to perform mystery plays, from at least as long ago as the twelfth century, as noted by FitzStephen. The well provided a source of fresh water for the local inhabitants until the nineteenth century. It can still be seen through the window in the front of a building on Farringdon Road immediately north of the junction with *Clerkenwell Road*. In addition to the *Priory of St John*, the Priory of St Mary was founded as an Augustinian convent here in around 1145. The church of St James also had its origins before the Great Fire of 1666.

Clink Street, Southwark (first recorded as *le Clynke* in 1524). Thought to be named either after the noise made by the chains in which inmates in the nearby prison were kept, or from the French '*clinque*', meaning a catch on the outside of a door.

Cloak Lane (indicated on map of 1520 as *Horshew Bridge Streete*). Thought to take its name from the Italian or Latin '*cloaca*', meaning open sewer. There once was one here, flowing into the Walbrook.

Cloth Fair. Takes its name from the cloth fair held here from the twelfth century until the nineteenth. In Medieval times, the fair attracted clothiers, drapers and wool merchants from far and wide (members of the Mercers' and Merchant Taylors' Companies also attended to ensure fair trading, and there was even a peripatetic 'Pie Powder' Court that took its name from a corruption of the French '*pieds poudres*', meaning dusty feet). By the beginning of the Victorian era, it had become more of an 'entertainment', marked by increasing levels of violence, such that it was finally discontinued in 1855. Remarkably, No. 41, which was built in 1597–1614, still stands. Photographs taken in the early 1900s show that at that time several other pre-Great Fire houses were also still standing on the street. Among them was the 'Dick Whittington' Inn, reputedly the oldest in London, which was demolished in 1916. Two carved wooden satyrs from its corner posts were salvaged, and are now in the Museum of London. Thus also *Cloth Court* and *Street*.

Cock Lane (first recorded in around 1200 as *Cockeslane*). Thought to takes its name either from cocks reared or sold or fought here in Medieval times, or from its being the only licensed walk for prostitutes in the fourteenth century.

Coleman Street (first recorded in around 1182 as *Colemannestrete*), also *Coleman Street Ward*. Thought to be take its name either from one Coleman, or from the coal men, or charcoal burners and sellers, who worked here in Medieval times. In the fifteenth century, Coleman Street was the home of one John Sokelyng's 'Le Cokke on the hoop' brewery, and in remembrance of Sokelyng's benefaction, both *St Stephen Coleman Street* parish boundary markers and *Coleman Street* Ward plaques bear his insignia of an encircled cockerel.

College Hill, Street (indicated on map of 1520 as *Le Riall*). Takes its name from Dick Whittington's College of St Spirit and St Mary, set up here in the early fifteenth century.

College of Arms, Queen Victoria Street. Originally founded in Coldharbour on *Thames Street* in 1484, moved to a new location on what was then Derby Place in 1555, burnt down in the Great Fire of 1666, and rebuilt in the 1670s. In Medieval times, the college was the home of the so-called heralds who organised and proclaimed knightly tournaments, marshalled and announced contestants, and kept records of the coats-of-arms they wore on their shields

and helmets. It is now concerned with genealogical as well as ceremonial activity.

Compton Passage. Named after Lord Compton, Bishop of London from 1675. The passage runs alongside the 'Plague pit' formerly known as Pardon Churchyard.

Coopers Row (indicated on map of 1520 as *Woodroffe Lane*). Took its previous name of Woodroffe Lane from the some-time landowner. The site of a well-preserved section of Roman and Medieval *City Wall*.

Copthall Avenue. Takes its name from Copped Hall or Copthall, a house that stood on nearby *Dowgate Hill* in the thirteenth and fourteenth centuries. The remains of a Roman wharf beside the Walbrook have been found here.

Cordwainer Ward (first recorded in 1217 as *Corueirestrate*, and in 1230 as *Cordewanerestrete*). Takes its name from the Middle English '*cordewaner*', meaning worker in Cordovan leather, or more specifically shoe-maker, in reference to such working here in the Middle Ages.

Cornhill (first recorded in around 1100 as *Cornehulle*), also *Cornhill Ward*. Thought to take its name either from the hill on which corn was grown, or 'of a corn market time out of mind there holden' (Stow).

Cousin Lane (first recorded in 1283 as *Cosinelane*). Named after the Cosin or Cosyn or Cousin family, who lived here or nearby in the late thirteenth to early fourteenth centuries. William Cousin was Sheriff of London in the early fourteenth century.

Covent Garden (first recorded as *Covent Gardyn* in 1491). Takes its name from the garden of the convent or monastery that stood here up until the Dissolution of the Monasteries under Henry VIII in the mid-sixteenth century. After the Dissolution, the area was given over initially to Protector Somerset, and subsequently to John Russell, Earl of Bedford, who, in 1631, commissioned Inigo Jones to lay out the square and surrounding streets.

Cowcross Street (indicated on map of 1520 as *Cowcross*). Takes its name from the place where cattle crossed the River Fleet on their way to slaughter at the market in nearby *West Smithfield*.

Crane Court. Takes its name from the 'Two Cranes' Tavern, which once stood here.

Creechurch Lane (indicated on map of 1520 as part of *Burye street*). Takes its name from a corruption of Christ Church, the alternative name for *Holy Trinity Priory, Aldgate*. Thus also *Creechurch Buildings*. Creechurch Lane was the site of the first synagogue of the Jewish resettlement, built in 1657. The synagogue survived the Great Fire of 1666, and was then enlarged in 1673, and later rebuilt at a new site on *Heneage Lane*, just off *Bevis Marks*, in 1700–01.

Creed Lane (first recorded in 1548 as *Crede Lane*). Takes its present name either from the religious manuscripts, known as 'creeds', once written here, or from the public statements of faith, also known as 'creeds' or as 'credos', once chanted here by the faithful processing towards *St Paul's*. Took its previous name of Sporyer Row or Rowe from the spurriers or spur-makers who worked here in the fourteenth and fifteenth centuries.

Cripplegate Street, also *Ward*. Takes its name from the ancient (second-century) gate to the City that once stood here, referred to in the Saxon period as 'crepyl-geat', meaning a low gate, literally for creeping through. The name is now popularly understood to refer to a later legend that cripples could be cured by sleeping in the gateway. The gate survived the Great Fire of 1666, but was demolished in 1760.

Crosswall. Takes its name from its crossing the old *City Wall*. The remains of a Roman bastion have been found here.

Crown Court. Named after Edward III, who built a substantial stone grand-stand here from which to view jousts taking place on the nearby tilt-yard in Crown Fields, immediately to the east of *St Mary-le-Bow*. Stow wrote that the grand-stand 'greatly darkeneth the said church'.

Crown Office Row. Takes its name from the Crown Office that stood here until being relocated to King's Bench Walk in *Temple* in 1621, and then to the *Strand*. The office was responsible for the issuance of bills of indictment.

Crutched Friars (first recorded in 1405 as *Crouchedfrerestrete*). Named after the Augustinian Friars of the Holy Cross, also known as the '*cruciati*' or, in Middle English, '*crouched*' or crossed '*freres*' or brothers or friars, because they wore red crosses on their blue habits, established here under Ralph Hosiar and William Sabernes in the late thirteenth century. Thus also *Friary Court*.

Cullum Street (indicated on map of 1520 as *Culver Alley*). Named in the late seventeenth or early eighteenth century after John or Thomas Cullum.

Cursitor Street. Takes its name from the '*clerici de cursa*', or clerks or cursitors, who worked in the Court of Chancery in Medieval times.

Custom House, Lower Thames Street. Originally built in 1275, and rebuilt in 1378, and again, following a fire, in 1559. Burnt down in the Great Fire of 1666, and rebuilt yet again, by Wren, in 1671. Wren's building was destroyed in an explosion in 1714, and rebuilt, by Thomas Ripley, in 1715–27, and Ripley's building in turn burnt down in another fire. The present Custom House was built, by David Laing, in 1813–7, and rebuilt, following a partial collapse caused by the rotting of the beech-wood foundation piles, by Robert Smirke, in 1825. Perhaps surprisingly, given its previous history, it survived the Second World War comparatively unscathed. It is designed to be, and is, better viewed from the river than from the road.

Cutler Street. Takes its name from the Cutler's Company, who were left land here by one Agnes Carter in 1469.

Deptford (first recorded as *Depeford* in 1293). Takes its name from the Old English '*deop*', meaning deep, and '*ford*' (across the Ravenbourne or Deptford Creek). The church of St Nicholas was originally built at least as long ago as the twelfth century, and subsequently rebuilt in the fourteenth, and again in the late seventeenth, in 1697, only to be badly damaged by bombing during the Blitz of the Second World War. The fourteenth-century tower still stands.

Devereux Court. Named after Robert Devereux, Second Earl of Essex, who once lived here, in Essex House, the former site of his house being occupied from 1676 by the Grecian Coffee House, and from 1843 to the present day by the 'Devereux' public house. Devereux was a one-time favourite of Elizabeth I, but fell out of favour when he failed to carry out her order to him to suppress a rebellion in Ireland in 1599 – instead coming to terms with the rebel leader, Hugh O'Neill, Earl of Tyrone. To what end only he knew he later assembled a small army at Essex House and with it marched to the Tower to confront Her Majesty, and for his pains was executed for treason, in 1601. His co-conspirator Henry Wriothesley, Earl of Southampton – thought by some the mysterious H. W. to whom Shakespeare dedicated his sonnets – was spared. Some of the aforementioned events are fictionalised in Roland Emmerich's film *Anonymous*.

The 'Devil' Tavern, Fleet Street, also known as '*The Devil and St Dunstan*'. Built at least as long ago as 1608, and frequented by, among others, Shakespeare and Ben Jonson, and, a little later, Samuel Johnson, not to mention Goldsmith and Swift. Pulled down in 1787. A Corporation 'Blue Plaque' marks its former site.

Devonshire Row and *Square*. Named after the Cavendishes, the Earls and Dukes of Devonshire, who had a house here in the seventeenth century, on the site of 'Fisher's Folly', built by the goldsmith Jasper Fisher in the sixteenth. Thus also *Cavendish Court*.

Distaff Lane (first recorded in 1200 as *Distavelane*). Takes its name from 'distaff', meaning a cleft stick or staff used to spin yarn, in reference to such being made and sold here in Medieval times.

Dorset Buildings and *Rise*. Named after the Sackvilles, the Earls of Dorset, who after the Dissolution acquired property here before owned by the Bishops of Salisbury.

Dowgate Hill (first recorded in 1151 as *Duuegate*), also *Dowgate Ward*. Thought to take its name either from the ancient British – and modern Welsh – '*dwr*', meaning water, or from the Old English '*dufe*', meaning dove, or from one Duua, the owner of the water-gate that once stood here, where the Walbrook entered the Thames, or, according to Stow, from 'Downgate', in reference to 'the sudden … downgoing … from St John's Church upon Walbrook unto the river'.

Drapers' Gardens. Takes its name from the Drapers' Company, whose Hall is nearby.

Drury Lane (first recorded as *via de Aldwych*, and as *Drury Lane* in 1598). Takes its present name from the Drury family, who lived here in the sixteenth century.

Duke's Place. Named after the Duke of Norfolk, who after the Dissolution of the Monasteries acquired the land here that before belonged to the *Holy Trinity Priory, Aldgate*.

Dunster Court (indicated on seventeenth and eighteenth century maps as *St Dunstan's Court*). The site of the Worshipful Company of Clothmakers' Hall since 1528. Possibly takes its name from Dunster in Somerset, where there was a yarn market in Medieval times.

Dutch Church (Nederlandse Kerk), Austin Friars. Originally founded by the Friar Hermits of the Order of St Augustine of Hippo, or Augustinian or Austin Friars, under Humphrey de Bohun, Earl of Hereford and Essex, in 1253, rebuilt in 1354, dissolved under Henry VIII in 1538, and re-founded as a Dutch Protestant Church in 1550. Survived the Great Fire of 1666, but

damaged by another fire in 1863, and rebuilt in 1863–5, only to be destroyed by bombing on the night of 15/16 October 1940, and rebuilt again, by Arthur Bailey, in 1950–4. Photographs taken before and after the War clearly show the extent of the bomb damage sustained by the church.

Eagle Court. Takes its name from the Bailiff of Egle, a position within the Most Venerable Order of *St John*, whose Priory stood nearby.

East Harding Street. Named after one Agas or Agnes Hardinge, who bequeathed property hereabouts to the Worshipful Company of Goldsmiths in 1513. Thus also *West Harding Street.*

(Site of) *East India House*, Leadenhall Street. The head-quarters of the East India Company, originally built in 1648, on the former site of the residence of the one-time Lord Mayor, William Craven (*d.* 1618). Survived the Great Fire of 1666, together with its contents of spices and other immensely valuable merchandise, thanks to the action of an alderman, who handed out sums of money to anyone who helped hold back the encroaching blaze. Nonetheless, rebuilt in 1726, and again in 1799–1800. Sold after the Government took control of the Company's possessions in India in 1858, Britannia thus 'Receiving the Riches of the East', as depicted on an overmantel bas-relief in the Directors' Court Room; and demolished in 1861, when many of the furnishings were moved to the India Office. The site is now occupied by the Lloyd's of London Building.

East Smithfield (first recorded in 1140 as *Smethefeld*, and in 1229 as *Estsmethefeld*). Like *West Smithfield*, takes its name from the Old English '*smethe*', meaning smooth, in reference to a flat field. Also, as in the case of *West Smithfield*, fairs were held here. 'Museum of London Archaeology Service' monographs describe in detail the findings of archaeological excavations at the sites of *St Mary Graces* and the associated 'Black Death' burial ground, and the Royal Navy Victualling Yard (Grainger *et al.*, 2008; Grainger & Phillpotts, 2010; Grainger & Phillpotts, 2011).

Eastcheap (first recorded in around 1100 as Eastceape). Like *Cheapside*, takes its name from the Old English '*ceap*', meaning market, in reference to the market that was situated here.

Eleanor Crosses. Built by Edward I after the death of his queen, Eleanor of Castile, in 1290, to mark the locations where her body was rested overnight on its twelve-day journey from Nottinghamshire to London. The two in London, one on *Cheapside* and one on the *Strand* were demolished by, as Evelyn put

it 'furious and zealous' Parliamentarians during the Civil War (in 1643 and 1647, respectively). The one on the *Strand* was rebuilt outside Charing Cross Station in 1863.

Elsing Spital, London Wall. Founded in 1331 by William de Elsing as a small hospital for the blind, becoming a priory church in 1342, and the parish church of *St Alphage* after the Dissolution of the Monasteries in 1536. An 'English Heritage' monograph describes in detail the findings of archaeological excavations at the site (Milne & Cohen, 2002).

Ely Place. Named after the Bishops of Ely, whose London residence stood here from the late thirteenth century until the eighteenth, the property being handed over to Elizabeth I's favourite, Sir Christopher Hatton, after the Dissolution of the Monasteries in the sixteenth. Thus also *Ely Court*, and the 'Olde Mitre' Tavern therein, established in 1546, where Hatton danced with Elizabeth I around the cherry tree that can still be seen inside.

Essex Street. Built in around 1680 by Nicholas If-Jesus-Christ-Had-Not-Died-For-Thee-Thou-Hadst-Been-Damned Barbon (1640–98), the son of the fiercely puritanical Isaac Praise-God Barbon, or Barebone, and named after Robert Devereux, Second Earl of Essex, who once lived hereabouts. The water-gate and steps that led from the grounds of Devereux's house to the river was at the end of the street. Thus also *Little Essex Street*, where the 'Cheshire Cheese' Tavern occupies a site where one has stood since the sixteenth century.

Exeter Street. Named after Thomas Cecil, Earl of Exeter, the son of Elizabeth I's favourite William Cecil, Lord Burleigh, who lived in a house here in the late sixteenth and early seventeenth centuries. The house was originally built for Thomas Palmer in around 1547, and after his execution in 1553 was given to Burleigh by Elizabeth I. It survived the Great Fire of 1666, but was demolished in the 1670s.

Fair Street, Bermondsey. Takes its name from the *Horseleydown* Fair, held here in Medieval times.

Falcon Court. Takes its name from the sign of the Falcon over a private house or a business premises. The printer Wynkyn de Worde, an apprentice to William Caxton, worked here in the early sixteenth century.

Farringdon Ward (Within and Without). Named after either William de Farringdone, a Goldsmith, Alderman and, in 1282, Sheriff. Thus also *Farringdon Road* and *Street*, built after the Great Fire.

Faulkner's Alley. Thought to be named after a local property owner or builder.

Fen Court. Thought to take its name from the nearby 'fen' or marshy ground of the Langborne. Rather wonderfully, the surrounding ward was once known as 'Langbourn and Fennie About'.

Fenchurch Street (first recorded in 1283 as *Fancherchestrate*). Thought most likely to take its name from the church of *St Gabriel*, now no longer standing, and the 'fen' alluded to above near which it stood. Finds from the Roman *Basilica and Forum* came to light during excavations at No. 168 in 1995–2000. Thus also *Fenchurch Avenue*.

Fetter Lane (first recorded in 1292 as *Faytureslane*). Thought to take its name either from the Middle English '*faitour*' and later '*fewtar*' or '*fewter*', meaning impostor or cheat, or from the Old French '*faitor*', meaning lawyer, in reference to such once operating here, or, less likely, from '*feultre*', meaning felt, or '*fautre*', meaning spear-rest, in reference to such once being made here. The lane was known for its moneylenders, as alluded to by Ben Jonson in *Every Man out of his Humour*. Public executions were carried out at either end. Nathaniel Tomkins was executed at the Holborn end in 1643 for his role in the conspiracy to seize the City for Charles I during the Civil War. Photographs taken in the early twentieth century show that at this time a number of pre-Great Fire houses still stood on the street.

Finch Lane (first recorded in around 1235 as *Finkeslane*). Named after the Fink or Finke family, who lived here in the thirteenth century and built the church of *St Benet Fink* here or nearby.

Fish Street Hill (first recorded in around 1390 as *Fysshstrete*). Takes its name from the fish once sold here, conveniently close to the fish market at *Billingsgate*.

Fishmongers' Hall Street. Named after the Worshipful Company of Fishmongers' Hall built here in 1310.

Fleet Prison. Originally built in 1197, and rebuilt in the early fourteenth century, and again in the late, having been destroyed during the Peasants' Revolt of 1381. Burnt down in the Great Fire of 1666, and rebuilt again, only to be destroyed again during the anti-Catholic Gordon Riots of 1780, and rebuilt yet again. Finally decommissioned in 1842, and demolished in 1846.

Fleet Street (first recorded in 1188), also *Fleet Lane* (first recorded in 1544). Named after the River Fleet, which used to debouch into the Thames south of *Ludgate Circus*, but which has now been bridged and built over – and thus ultimately from the Old English '*fleot*', meaning, in this context, a tidal inlet navigable by boat (Brooke, 2010). The first printing press was set up in Fleet Street in 1500, by the wonderfully named Wynkyn de Worde, and a plaque on the wall of the Stationer's Hall commemorates the event. The 'Tipperary', formerly known as the 'Boar's Head', dates back to 1605, and substantial parts of it survived the Great Fire.

Fore Street (indicated on map of 1520 as *Forestreet*). Named in reference to its position in front of the old *City Wall*.

Foster Lane (indicated on map of 1520 as *Faster Lane*). Takes its name from a corruption of *St Vedast*, whose church still stands here.

Founders' Court. Takes its name from Founders' Hall, which stood here in the Middle Ages. Founders cast brass and bronze, and made brass and bronze objects such as candlesticks and weights.

Friar Street. Named after the Dominican, or Black, Friars.

Friary Court. Named after the Augustinian Friars of the Holy Cross.

Friday Street (first recorded in the twelfth century as *Fridaiestraite*). Thought to take its name either from one Frigedaeg or Friedai, or from the fish markets that used to be held here on Fridays, that is, on one the days on which certain religious observances forbade the eating of meat.

Frying Pan Alley. Thought to take its name from the sign, in the form of a frying pan, advertising the site of an ironmongers or braziers.

Furnival Street. Named after Sir Richard Furnival, whose town house, which in the late fourteenth century become Furnival's Inn, stood nearby.

Gardners Lane. Renamed in the nineteenth century from Dunghill Lane, 'a name for which no further explanation is necessary'.

Garlick Hill (first recorded in 1510 as *Garlyk hill*). Takes its name from the garlic that was once sold here.

Garlickhythe (first recorded in 1281 as *Garleckhithe*) takes its name from the 'hythe' where the garlic was delivered to the site by boat. The name lives on in that of the church of *St James Garlickhythe*.

Gate Street. Takes its name from the gates to *Lincoln's Inn Fields* that were put up here in the seventeenth century.

Giltspur Street (first recorded in the mid-sixteenth century as *Gyltesporestrete*). Takes its name from the gilt spurs either made and sold here or bought and worn by 'knights and others riding that way into Smithfield' to take part in the jousting tournaments held there between 1357 and 1467 (Stow). The site of a preserved section of Medieval *City Wall*. Also, incidentally, of one of London's last surviving watch-houses, built to prevent the practice of grave-robbing from the nearby churchyard (bodies being in great demand for medical research at the nearby *St Bartholomew's Hospital*). And the former site of the Giltspur Street Compter, built at the end of the eighteenth century and demolished in the mid-nineteenth, and marked by a Corporation 'Blue Plaque'.

Glasshouse Yard. Takes its name from the glass-makers who worked here in the seventeenth century. Glass-makers of Venetian extraction are recorded as working in the City as early as 1549.

Globe Theatre, Southwark. Built in 1599, and burnt down in a fire in 1613, after sparks from a theatrical cannon set some thatch alight during a performance of *Henry the Eighth*. Rebuilt in 1614. Fell into disuse sometime around 1642, when the performance of plays was banned by the Puritan Parliamentarians, and was pulled down in 1644. A plaque marks its site, on Park Street. A 'Museum of London Archaeology Service' monograph describes in detail the findings of recent archaeological excavations at the site in 1988–90 (Bowsher & Miller, 2009).

The new Globe Theatre was built by the late American film director and all-round good guy Sam Wanamaker, at a site on the river-front, only some 200 metres from the original one, in 1993. Here it is possible to experience performances as the common man would have in the early seventeenth century, standing in the open as a 'groundling'.

Godliman Street (first recorded in 1746 as *Godalming Street*, and indicated on map of 1520 as *Pawles Wharfes Hill*). Takes its present name from the 'godalmings' or 'godelmynnes', that is, shoes made from the soft skins of young animals, that were once sold here. Took one of its previous names, St Paul's Chain, from the barrier erected to prevent traffic crossing the churchyard during services.

Golden Lane (first recorded in 1274 as *Goldeslane*). Probably named after a family called Golde or Golding.

Goodman's Yard. Named after one Goodman, who once farmed land here owned by the nuns of the Order of St Clare, who had a convent in nearby *Minories*.

Gopher Lane (first recorded as *Gofairelane* in 1313). Thought to be named after the Gofaire family, who owned property hereabouts in the fourteenth century.

Goswell Road (first recorded in 1393 as *Goswellestrete*). Thought to take its name either from 'Godes-well', or from the Middle English '*Gosewell*', meaning a spring or stream frequented by geese, or from 'Goswelle', a garden owned by Robert de Ufford, Earl of Suffolk.

(Roman) Governor's Palace. Originally built during the Flavian period of the late first century, around 69–96, on the then-waterfront, and in use throughout the second and third, before being demolished in the late third or fourth, the remains only coming to light again during the nineteenth, and now forming part of a Scheduled Ancient Monument substantially under Cannon Street Station. A 'Museum of London Archaeology Service' monograph describes in detail the findings of recent archaeological excavations at the site of a substantial Roman town house immediately adjacent to the Governor's Palace, the site appropriately now known as 'Governor's House' (Brigham & Woodger, 2001; see also Marsden, 1975 and Stephenson, 1996). Incidentally, it is likely that the so-called '*London Stone*', first recorded at least as long ago as the twelfth century, is a relic of the Governor's Palace itself (see also *St Swithin London Stone*).

Gracechurch Street (first recorded in 1240 as *in vico de Graschirche*). Takes its name from a church that once stood here, either on a grassy site or with a grass roof, possibly Allhallows Gracechurch or *St Benet Gracechurch*. A pier base from the Roman *Basilica and Forum* can be seen in the basement of No. 90.

Gray's Inn see *Inns of Court*.

Gray's Inn Road (first recorded in 1234 as *Purtepolestrate*, and in 1419 as *Grayes Inne Lane*). Takes its present name from *Gray's Inn*.

Great Maze Pond, Southwark. Takes its name from the maze and pond in the grounds of the Abbot of Battle, set out here in the eleventh century.

Great St Helen's. Takes its name from the church of *St Helen.*

Great St Thomas Apostle. Takes its name from the church of *St Thomas the Apostle.*

Great Swan Alley (indicated on map of 1520 as *Swan Alley*). Takes its name from the 'Swan's Nest' Tavern that once stood here. An unsuccessful rebellion of 1661 began here, and its instigator, Thomas Venner, was hanged, drawn and quartered here.

Great Tower Street (first recorded as *la Tourstrate* in 1287). Takes its name from its proximity to the *Tower of London.*

Great Trinity Lane. Named after the church of *Holy Trinity the Less*, which once stood nearby.

Great Turnstile. Takes its name from the turnstile that was put here in Tudor times to prevent livestock from straying onto the thoroughfare.

Great Winchester Street. Named after Sir William Paulet, First Marquess of Winchester, who built a house here on the site of the former Augustinian Friary, after the Dissolution of the Monasteries in the reign of Henry VIII.

Gresham Street (first recorded in 1845, and indicated on map of 1520 as *Catte Street*, *Lad Lane* and *Yangellane*). Took its present name in the nineteenth century from the sixteenth-century figure Sir Thomas Gresham, a financier, who founded the *Royal Exchange*, and whose grasshopper insignia still adorns the building to this day; and also a philanthropist, who founded Gresham College in the year of his death, and who is buried in the church of *St Helen*. Took one of its previous names of *Cattestrete* in the fifteenth century from the then slang for prostitute.

Greyfriars Monastery. Originally founded in around 1225, and re-founded in 1552, after the Dissolution of the Monasteries, as the parish church of *Christ Church Newgate Street*, and the orphanage and school of *Christ's Hospital* (Kingsford, 1915). A 'Museum of London Archaeology Service' monograph describes in detail the findings of recent archaeological excavations at the site (Lyon, 2007). A Corporation 'Blue Plaque' on *Newgate Street* marks it.

Greyfriars Passage. Named after the Franciscans or Grey Friars who established themselves here in the thirteenth century.

Guildhall. Originally built at least as long ago as between 1260 and 1411, on the site of an even older building, where the Saxons held their Court of Husting. Burnt down in Great Fire of 1666, and rebuilt in the aftermath, only to be badly damaged by incendiary bombing on 29 December 1940, and rebuilt again after that (photographs of the building as it was before the War still survive). The lower levels of the walls and some of the horn windows still survive from the Medieval period, as do the crypts. The famous statues of the mythical giants Gog and Magog replace two sets of earlier ones, the first destroyed in the Great Fire, and the second in the Blitz. A 'Museum of London Archaeology Service' monograph describes in detail the findings of recent archaeological excavations at the site (Bowsher *et al.*, 2007). Another describes in detail the Roman *Amphitheatre* discovered during renovation work on the Medieval crypts in 1987 (Bateman *et al.*, 2008).

Guildhall Buildings and Yard. Named after the *Guildhall*.

Gun Street. Takes its name from the artillery yard that stood nearby in Tudor times, 'whereunto,' as Stow put it, ' … the gunners of the Tower do weekly repair'.

Gunpowder Alley and Square. Take their names from the gunpowder used to burn effigies of the Pope in nearby *Fleet Street* during the reign of Charles II.

Gutter Lane (first recorded in around 1185 as *Godrun lane*). Corrupted from the woman's name 'Godrun' or 'Guthrun'.

Hackney (first recorded as *Hakeneia* in 1198), also *Hackney Marsh* (first recorded as *Hakenemersshe* in 1397). Thought to take their names either from the Old English personal name 'Haakon' or 'Haca', or the word '*haca*', meaning hook-shaped, and '*eg*', meaning island, or area of high and dry ground surrounded by low marsh. Hackney fell under the Viking Danelaw in Saxon times, lying east of River Lea. The courtier Ralph Sadleir built a house here in 1535, which still stands, on what is now Homerton High Street. Now known as Sutton House, after Thomas Sutton, the founder of *Charterhouse* School, who was once thought to have lived here (but in fact did not), it is owned by the National Trust, and open to the public (Belcher *et al.*, 2004). Sadly, Brooke House, built here in the 1470s, and extended in 1578–83, had to be demolished in 1954–5 after sustaining bomb damage in 1940 and again in 1944 (a photograph of the bombed house taken in 1941 still survives).

Halfmoon Court. Takes its name from the 'Half Moon' Tavern that once stood here.

Hare Court. Named after Sir Nicholas Hare, one-time Master of the Rolls, who died here in 1557, and was buried in nearby *Temple Church*.

Harp Lane (indicated on map of 1520 as *Segeryneslane*). Thought to take its name from the sign of the harp that once hung above a 'messuage' here (that is to say, a substantial dwelling house with grounds and outbuildings), on the site of what is now the Worshipful Company of the Bakers of the City of London Hall. Alternatively rendered as 'Hart' Lane.

Hart Street (first recorded in 1348 as *Herthstrete*). Takes its name from the Old English '*herth*', meaning hearth, in reference to such being made and sold here in the fourteenth century.

Hatton Garden. Named after Christopher Hatton, a favourite of Elizabeth I, who lived here in the late sixteenth century. Home to a building purportedly 'erected as a church by Lord Hatton to serve the needs of the neighbourhood after St Andrew's Holborn had been destroyed in the Great Fire of 1666' (see also *St Andrew Holborn*).

Heneage Lane, just off Bevis Marks. Named after the courtier Sir Thomas Heneage, who acquired land here after the dissolution of the monastery of *Holy Trinity Priory, Aldgate*. The site of the Sephardic – or Spanish and Portuguese – Jewish synagogue, built between 1700 and 1701 by Joseph Avis, a Quaker, who refunded to the congregation the difference between the final cost of the construction and his original, higher, estimate, not wanting to profit from working on a House of God. At the time that the synagogue was built, Jews were still prohibited from building on a high street.

Henrietta Street. Built in 1631–4 and named after Charles I's queen, Henrietta.

Herbal Hill. Takes its name from the herbs once grown here, in gardens belonging to the Bishops of Ely.

High Holborn see *Holborn*.

High Timber Street (first recorded in 1272 as *road into la Tymberhythe*). Takes its name from the timber unloaded from the 'hithe' or dock immediately to the south in the thirteenth century. The wood was used by the Fishmongers' Company, who owned the dock, to make boxes for carrying fish.

Holborn (first recorded in 1086, in the Domesday book, as *Holeburne*). Takes its name from a tributary of the Fleet River, which in turn took its name from

the Old English '*hol*', meaning hole or hollow, and '*burna*' meaning, stream. Thus also *High Holborn*.

Holy Trinity Minories, formerly known as St Clare without Aldgate, Haydon Square. Founded after the Dissolution on the former site of the Convent of the Spanish Franciscan Nuns of the Order of St Clare, or 'Sorores Minores', or 'Minoresses'. Undamaged by the Great Fire of 1666. Nonetheless, rebuilt in 1706, having fallen into disrepair. The church closed down in 1899, when the parish was merged with that of *St Botolph Aldgate*. The remains were destroyed by bombing during the Blitz (a photograph taken in 1913 still survives). The site is now occupied by St Clare House.

Holy Trinity Priory, Aldgate. Originally founded by the secular priests known as the Canons of Augustine in around 1108, on the site of an even older, eleventh-century, parish church, added to in 1197–1221, and rebuilt in the years up to 1350, only to be dissolved in 1532. After the Dissolution, the site came to be owned initially, in 1532, by Sir Thomas Audley, subsequently, in 1544, by the Duke of Norfolk, and finally, in 1592, by the City. Fragments of the Medieval Priory survive in the basement of 76 *Leadenhall Street*. A 'Museum of London Archaeology Service' monograph describes in detail the findings of recent archaeological excavations at the site, which is bounded to the east by *Aldgate*, to the north by *Houndsditch* and *Duke's Place*, to the west by *Creechurch Lane*, and to the south by *Leadenhall Street* (Schofield & Lea, 2005). There is a commemorative Corporation 'Blue Plaque' in *Mitre Square*.

Holy Trinity the Less, Little Trinity Lane. Originally built in around 1258, rebuilt in 1606–7, burnt down in the Great Fire of 1666 and not rebuilt again afterwards, and the parish was merged with that of *St Michael Queenhithe*. Essentially nothing now remains of it other than a parish boundary marker in *Great Trinity Lane*.

Honey Lane (first recorded in around 1200 as *Hunilane*). Takes its name from the honey that was once sold here. The site is marked by a bee symbol in the archway opposite the church of *St Mary-le-Bow* in Cheapside.

Horseleydown (first recorded as *Horseidune* in around 1175, and *Horselydown* in around 1580). According to legend, takes its name from the place where King John's horse lay down with its rider still on its back. In fact, the original incarnation of the name dates back to the time before John was King, and simply meant an area of high and dry ground where horses were kept. Thus also *Horselydown Eyot*, a site of activity in Neolithic, Bronze Age and Iron Age times, and *Horselydown Lane*. Fragments of daub associated with

the Neolithic stone finds suggest settlement as well as tool-manufacturing activity.

Hosier Lane (first recorded in 1328 as *Hosiereslane*). Named after the hosiers or stocking-makers who worked here, from the fourteenth century. By the early eighteenth, the lane had become popular with revellers, especially at the annual Bartholomew Fair: 'all the houses ... being made publick for tippling and lewd ... people', as John Strype wrote in 1720, in his update of John Stow's *Survay*. The Haberdashers' Hall stands here today.

Houghton Street. Takes its name from the Holles family, the Barons Houghton.

Houndsditch (first recorded in 1275 as *Hondesdich*). Popularly thought to take its name from the dead dogs that were dumped over the *City Wall* here in Medieval times, along with other refuse. Long, though, thought that 'it is highly unlikely that Medieval Londoners preferred this one ditch over many when it came to matters of canine disposal', and more likely 'that hounds for hunting were kennelled here, conveniently located for the forests ... to the north and east'. Mills thought it possible that the area was frequented by feral dogs.

Hoxton (first recorded as *Hochestone* in the Domesday Book of 1086). Takes its name from the Old English personal name 'Hoc', and *'tun'*, meaning farmstead or estate.

Huggin Hill (first recorded in 1330 as *Hoggenelane*). Takes its name from the Middle English *'hoggene'*, meaning a place where hogs were kept (whence also *Huggin Court*). A Roman bath-house was discovered here in 1964. Parts of the walls can still be seen in nearby Cleary Gardens.

Idol Lane (indicated on map of 1520 as part of *St Dunstan's Lane*). Thought to take its name either from the idol or statue outside the nearby church of *St Dunstan-in-the-West*, or from the idol-makers who once worked here, or from the idlers who didn't.

Inner Temple Lane. Takes its name from *Inner Temple*. Thus also *Clement's Inn Passage* and *Clifford's Inn Passage*.

Inner Temple see *Inns of Court*.

Inns of Court. The four surviving Inns of Court, so named because they are where lawyers go to receive their training, are Gray's Inn, Lincoln's Inn, and

Inner and Middle Temple (a fifth, Serjeant's Inn, no longer survives, having been dissolved in 1877). Each includes, or included, a number of Inns of Chancery, which in the case of Gray's Inn are Barnard's Inn and Staple Inn; in the case of Lincoln's Inn, Furnival's Inn and Thavies Inn; in the case of Inner Temple, Clement's Inn, Clifford's Inn and Lyon's Inn; and in the case of Middle Temple, New Inn and Strand Inn. On the shield, Gray's Inn is symbolised by a winged dragon with a fearsome beak, gold on sable; Lincoln's Inn by what looks like a field of haystacks, gold on azure, inset with a lion rampant; Inner Temple by a winged horse, argent on azure; and Middle Temple by a Cross of St George emblazoned by what looks like a golden lamb with a halo around its head. There is an Inns of Court and City Yeomanry Museum.

Gray's Inn (first recorded in 1403 as *Grayesin*) takes its name from the de Grey family, who left land here to St Bartholomew's Priory, which after the Dissolution of the Monasteries became the site of the present Inn of Court. The Hall was built in 1560, and destroyed during the Blitz in May 1941, alongside the Library, built in 1555, and the Chapel, rebuilt in 1689. The Hall of Barnard's Inn, now the site of the relocated Gresham College, dates to the late fourteenth or early fifteenth century. The Hall of Staple Inn (first recorded in 1333 as *le Stapledhalle*, from the Middle English for pillared hall) was built in 1589, substantially destroyed by a flying bomb in August 1944, and rebuilt in 1955. The surviving half-timbered buildings on *High Holborn* were also built in 1589.

Lincoln's Inn (first recorded in 1399 as *Lincolnesynne*) takes its name either from Thomas de Lincoln, or from the Earl of Lincoln, who left land here to the Dominicans or Black Friars, which after the dissolution became the site of the present Inn of Court. The 'Old Hall' dates to 1489–92; the 'Old Buildings' to 1524–1613 (the Gatehouse to 1517–21); and the Chapel to 1619–23.

Temple takes its name from the Knights Templar of the Order of St John of Jerusalem, who established themselves here in the twelfth century, to be succeeded by the Knights Hospitaller in the fourteenth, the site becoming that of the present Inn of Court of the Inner and Middle Temple, and the residential development of the Outer Temple, after the dissolution in the sixteenth. Inner Temple Gatehouse, a fine timber-framed town house, the only surviving one in the City, also known as 'Prince Henry's Room', after Henry, the son of James I, is Jacobean and dates to 1610–11; Middle Temple Hall is Elizabethan, and dates to 1571. Photographs taken in 1903 and in around 1932 show Clifford's Inn, part of Inner Temple, before it was substantially demolished in 1935. Photographs taken after the Second World War show some of the bomb damage sustained by Lincoln's Inn and the Temple complex.

Ireland Yard. Named after the haberdasher William Ireland, who came into the possession of land and property here after the dissolution of the Black

Friars' monastery. William Shakespeare once lived here. According to the Deed of Conveyance in the City Archive, he paid £140 for his house.

Ironmonger Lane (first recorded as *Ysmongerelane* in around 1190). Takes its name from the Middle English '*ismongere*', meaning ironmonger, in reference to such having worked here from the end of the twelfth century. The Ironmongers' Company Hall stood here in the fifteenth. Thus also *Ironmonger Passage* and *Row*, and, from the company's coat-of-arms, *Helmet Row* and, bizarrely, *Lizard Street*.

Isle of Dogs see *Poplar*.

Islington (first recorded as *Gislandune* in around 1000, as *Isendone* in the Domesday Book of 1086, and as *Islyngton* in 1464). Takes its name from the Old English personal name 'Gisla' and '*dun*', or down, meaning an area of high and dry ground. Prior Bolton of *St Bartholomew the Great* built Canonbury House in Canonbury Square here in 1509, of which the tower still stands. The house was occupied at one time or another by Thomas Cromwell, the one-time Lord Mayor of London John Spencer, and Francis Bacon (not to mention, in the eighteenth century, Oliver Goldsmith). The church of St Mary also had its origins before the Great Fire of 1666.

Jamaica Road, Bermondsey. Named after the 'Jamaica' Tavern that once stood here, and which numbered Samuel Pepys as one if its habitués.

Jerusalem Passage. Thought to take its name either from the *Priory of St John of Jerusalem*, or from the tavern, in turn named after the priory, that stood nearby.

Jewry Street (first recorded in 1366 as *la Porejewerie*). Named after the impoverished Jewish community established here. Photographs taken in the early 1900s show that at that time several pre-Great Fire houses were still standing on the street.

Johnson's Court. Named not after Dr Samuel Johnson, who lived here while writing *Journey to the Western Islands of Scotland* in the eighteenth century, but after his namesake Thomas Johnson, 'Cittizen & Marchantaylor of London', who lived here in the sixteenth or seventeenth. Thomas is buried in the nearby church of *St Dunstan-in-the-West*.

King Edward Street (first recorded in 1228 as *Styngkynglane*). Takes its present name, given in 1843, from Edward VI, who founded Christ's Hospital for Orphans nearby in 1553. Previously known as Stinking Lane, in reference to the slaughterhouses that stood here until the end of the seventeenth century, or

Blowbladder Lane, from the butchers' nefarious practice of inflating bladders to make carcasses look bigger.

King John Court. Originally named not after King John but after the Benedictine Order of the Fraternity of St John the Baptist, established in Holywell Priory here up until the time of the Dissolution.

King Street, WC2. Named after King Charles I, who was on the throne when the street was first laid out, by Inigo Jones, in 1637. There used to be a statue of the king, by le Sueur, here, but it was taken down at the end of the Civil War.

King's Arms Yard. Takes its name from the 'King's Head' Tavern in nearby *Coleman Street*, which was burnt down in the Great Fire of 1666 and rebuilt as the 'King's Arms'.

Knightrider Street (first recorded in 1322 as *Knyghtridestrete*). 'So called, as is supposed, of knights well armed and mounted at the Tower Royal, riding from thence through that street west to *Creed Lane*, and so out at *Ludgate* towards *Smithfield* ... to tourney, joust or otherwise show activities before the king' (Stow). Nothing to do with talking cars or 'The Hoff'.

Lambeth (first recorded as *Lambehitha* in 1062). Takes its name from the Old English for a place where lambs or sheep were either landed from or else boarded onto boats. Lambeth Palace, the London residence of the Archbishop of Canterbury, was built here in the thirteenth century, the oldest surviving parts dating to the fifteenth. The church of St Mary was built in the fourteenth century, and substantially rebuilt in the eighteenth, the surviving tower dating to 1377.

Lambeth Hill (first recorded as *Lamberdeshul* in 1283). Literally means 'Lambert's Hill'. One Lambert the wood merchant is recorded as having lived here in around 1200.

Lamb's Conduit Street. Named after William Lamb or Lambe, who paid for a conduit to be built here in 1577 to provide a water supply to the local inhabitants from a nearby dam on the Fleet. The conduit had disappeared by the beginning of the nineteenth century.

Langbourn, also *Langbourn Ward* (first recorded in the twelfth century as *Langebord*). Takes its present name from the Langborne. Took its previous name either from the Old English '*lang*', meaning long, and '*bord*', meaning table, or from the Longobards or Lombards.

Laurence Pountney Lane (first recorded in 1248 as *St Laurence's Lane*, and in 1603 as *Poultney lane*). Named after the church of *St Laurence*, and the wealthy draper and benefactor Sir John de P(o)ult(e)ney or Pountney, four-times Lord Mayor of London in the 1330s, who lived nearby, died in 1349, possibly of the 'Black Death', and was buried in the old *St Paul's Cathedral*. Thus also *Laurence Pountney Hill*.

Lawrence Lane (first recorded in around 1200). Named after the church of *St Lawrence Jewry*.

Leadenhall Street (first recorded in 1605 as *Leaden Hall Street*). Takes its name from the lead-roofed manor house of the Neville family that stood here in the thirteenth and fourteenth centuries, before being acquired by Dick Whittington, on behalf of the City authorities, and converted into a market in the fifteenth, and destroyed in the Great Fire in the seventeenth. The present Leadenhall Market was built in the nineteenth century.

Leather Lane (first recorded in 1233 as *le Vrunelane*). Perhaps surprisingly, apparently takes its name from a corruption of the thirteenth-century Flemish '*le Vrunelane*', and ultimately from the Old English woman's name 'Leofrun'. Nothing to do with the manufacture or sale of leather.

Leicester Square. Named at the beginning of the eighteenth century after Robert Sidney, Second Earl of Leicester, who built a mansion here in 1631–5. Thus also *Leicester Place*.

Leman Street. Named after Sir John Leman, Lord Mayor in 1616, who owned land hereabouts.

Lime Street (first recorded in around 1180 as *Limstrate*). Takes its name from the lime that was manufactured and sold here in Medieval times. Thus also *Lime Street Passage* and *Lime Street Ward*.

Limeburner Lane, or *Seacoal Lane*. Named after the limeburners who worked here in the Middle Ages. Lime was burnt in kilns fuelled by sea-coal shipped in from Newcastle, and then powdered for use in mortar. The stench associated with the process was such that the works and workers had eventually to be moved to the river-front.

Limehouse (first recorded as *le Lymhostes* in 1367). Takes its name from the lime manufactories that one stood here.

Lincoln's Inn see *Inns of Court.*

Lincoln's Inn Fields (first recorded in 1598 as *Lincolnes Inne Feildes*, and indicated on map of 1520 as *Cup Field* and *Purse Field*). Named after *Lincoln's Inn*. The fields were laid out and a series of town houses built around them by the Neoclassical or Palladian architect Inigo Jones from 1618 onwards. No. 59/60, completed around 1638–40, survives to this day.

Little Britain (first recorded in 1329 as *Brettonestrete*). Named after one Robert le Bretoun. Thought to be named after the Dukes of Britany, who owned property here in the Medieval period. Became populated by publishers and booksellers in the seventeenth and eighteenth centuries. John Milton's *Paradise Lost* was first published here, in 1677.

Little Trinity Lane (indicated on map of 1520 as *Trinitie lane*). Takes its name from the church of *Holy Trinity the Less*, which once stood here.

Little Turnstile. Takes its name from the turnstile that was put here in Tudor times to prevent livestock from straying onto the thoroughfare.

Lollard Street, Lambeth. Takes its name from the 'Lollards', imprisoned in Lambeth Palace in the late fourteenth century. 'Lollards' were followers of the perceived heretic John Wycliffe, who translated the Bible into English for the first time.

Lombard Street (first recorded in 1285 as *Langburnestrate*, and in 1318 as *Lumbardstret*). Takes its present name, as do *Lombard Court* and *Lane*, from the Longobards or Lombards, from northern Italy, who took over banking and money-lending after the Jews who had formerly fulfilled those roles were expelled from the City following the 'Edict of Expulsion' issued by Edward I in 1290. Took its previous name from the Langborne.

London Bridge. Originally built by the Romans in timber around AD 50, and in stone and timber around 90, and rebuilt many, many times in the succeeding nearly two millennia, the present functional and understated structure having been built by Mott, Hay & Anderson in 1972, the immediately preceding one having been built by John Rennie in 1831, taken down in 1967 and rebuilt in Lake Havasu City in Arizona in 1968–71 (Jackson, 2002; Watson, 2004). A 'Museum of London Archaeology Service' monograph describes in detail the findings of archaeological excavations at the bridge-head site now occupied by 'Number One London Bridge' in *Southwark* (Watson *et al.*, 2001). According to the 'Olaf Sagas', the Norwegian King and later Saint Olaf or Olave

Haraldsson, an ally of the English King Ethelred II, 'the Unready', prevented a Danish attack on London in 1014 by pulling down the Saxon bridge with ropes tied to his long-boats (whence, 'London Bridge is broken down').

The famous Medieval bridge was built by Peter, chaplain of *St Mary Colechurch*, around 1176–1209, and stood until 1831. A fine scale-model of it as it would have looked in its fifteenth-century heyday is to be seen in the church of *St Magnus the Martyr* (note also that there are two further such models in the Museum of London Docklands). There were scores of buildings on it then, including a great many shops, and even a chapel dedicated to St Thomas Becket (it was on the pilgrimage route to Canterbury, where Archbishop Becket was the victim of the infamous 'Murder in the Cathedral' in 1170); and at the entrance, there were the heads of executed criminals, impaled on spikes. The Medieval bridge also had a total of nineteen arches or 'starlings', through which many of the more devil-may-care watermen would attempt to 'shoot', some unfortunately losing their lives in the process (it was said that 'London Bridge was made for wise men to go over, and fools to go under'). Only the northern end of the bridge was affected by the Great Fire of 1666, the southward progress of which across the river was halted at a gap in the buildings that formed a natural fire-break – ironically, the result of another fire in 1633.

London Stone, also known as *Lonestone*, Cannon Street. The so-called 'London Stone' now stands at 111 *Cannon Street*, although unfortunately in an easily overlooked position at street level, and behind a somewhat unprepossessing steel grille (Clark, 2010). From 1798 it had been incorporated into the south wall of the church of *St Swithin London Stone*, and was preserved when the church was demolished in 1957, according to a stipulation in the conditions for the redevelopment of the site. Previous to that it had stood in the middle of the street, as indicated on the map of 1520, and on the 'Agas' map of 1561–70, and was apparently used as a place from which to make important public announcements throughout the Middle Ages, being evidently richly endowed with symbolic significance. During the failed rebellion of 1450 that ended with the 'Harvest of the Heads' of the leaders, one of the same, Jack Cade, alias Mortimer, struck the stone with his sword, and declared himself to be 'Lord of this City', an act immortalised thus by Shakespeare in *Henry VI*, Part II, Act IV, Scene VI (London, Cannon Street): 'Now is Mortimer Lord of this City. And here, sitting upon London-stone, I charge and command that, of the city's cost, the pissing-conduit run nothing but claret wine this first year of our reign. And now, henceforward, it shall be treason for any that calls me other than Lord Mortimer.' Its recorded history extends as far back as the twelfth century, when the first Lord Mayor of London, from 1189 to 1213, was one Henry Fitz-Ailwyn or FitzAlwyn de Londonestone; and it is possible, although not proven, that before that, it formed part of the Roman *Governor's*

Palace that once stood nearby, and now forms part of a Scheduled Ancient Monument substantially under *Cannon Street* Station. Indeed, according to one of many romantic myths surrounding the stone, it was the very one from which King Arthur drew the Sword Excalibur, and possessed magic powers; and according to another, it was the one Brutus used to mark the city of Troia Nova, and 'So long as the Stone of Brutus is safe, so long will London flourish' (or, in Welsh '*Tra maen Prydain, Tra lled Llundain*'). As Hollis put it, 'We will never know [its true origin], and perhaps that is as it should be.'

London Wall (name first recorded in 1388 as *the highway near London Wall*). Named after the *City Wall* originally built by the Romans. The site of preserved sections of Medieval (fourteenth- and fifteenth-century) as well as Roman wall.

Long Acre (first recorded as *pasture called Longeacre* in 1547, and given over to development in 1612). Takes its name from its unusual length. Cromwell lived here from 1637–43.

Long Lane (first recorded in 1440). Also takes its name from its unusual length. A photograph taken in 1945 shows that at this time a number of seventeenth-century houses still stood on the street. No. 74 stands to this day.

Lothbury (first recorded in around 1190 as *Lodebure*). Thought to take its name either from one 'Hlotha', who once lived here, possibly as long ago as the seventh or eighth century, or from one 'Loteringus', who lived here in the eleventh century, or from the 'loathsome' noise and smell generated by the founderers, metal-workers and pewterers who worked here and nearby also in the Middle Ages, or from a '*lode*' or drain leading from here to the Walbrook. The Worshipful Company of Founderers was founded here, in Founderers' Court.

Lovat Lane (indicated on map of 1520 as *Love Lane* (Billingsgate)). Takes its present name from one of the Lords Lovat, either the one who owned the fisheries in Scotland from which salmon were exported to the nearby *Billingsgate* Fish Market at the time of the change of name in 1939, or the one executed at the *Tower of London* for his part in the failed Jacobite rebellion of 1745.

Love Lane (first recorded in 1336 as *Lovelane*). Takes its name from its popularity with lovers, or with prostitutes, in Medieval times.

Lower Marsh, Lambeth. Takes its name from the low-lying and marshy land here prior to reclamation.

Lower Thames Street (first recorded in around 1208 as *la rue de Thamise*, and indicated on map of 1520 as part of *Petywales*). Named after the City's river.

Ludgate Hill (first recorded in 1548). Thought to take its name either from the second-century gate to the City that once stood here, referred to in Old English as '*ludgeat*', meaning back- or postern-gate, or from the Ancient British or Celtic King Lud. The gate was damaged in the Great Fire of 1666, and demolished in 1760. The statues of King Lud and his sons Androgeus and Tenvantius, or Theomantius, and of Queen Elizabeth, which used to stand above it, still survive in the church of *St Dunstan-in-the-West* in *Fleet Street*.

Magpie Alley. Takes its name from the 'Magpie' Tavern that once stood nearby, on the site of the dissolved *Whitefriars' Monastery*.

Maiden Lane. First built up in around 1631, along the line of an ancient track-way, and thought to take its name either from a corruption of the word 'midden', meaning rubbish tip, or, according to Isaac D'Israeli, from a statue of the Virgin Mary that once stood here.

Mark Lane (first recorded in around 1200 as *Marthe lane*). Thought to take its name from a corruption of either the Old English '*mearth*', meaning marten, an animal much prized in Medieval times for its fur, or the Old French woman's name Marthe, or 'mart' or market.

Martin Lane (indicated on map of 1520 as *Saint Martins Orgar Lane*). Named after the church of *St Martin Orgar*. The 'Olde Wine Shades' dates back to 1663, and survived the Great Fire.

Masons' Avenue (indicated on map of 1520 as *Trystrams Alley*). Named after the masons who once worked here, and founded their the Masons' Hall here. James I used to visit a doctor here who was in the habit of prescribing his home-brewed beer to his patients. The doctor's name is commemorated in that of a local hostelry, the 'Old Dr Butler's Head', first founded in the early seventeenth century.

Merchant Taylors' Hall, Threadneedle Street. Originally built in around 1392. Damaged, but not destroyed, in the Great Fire of 1666, and rebuilt afterwards, only to be substantially destroyed by bombing during the Second World War, and rebuilt again after that. The late-fourteenth-century Hall and fifteenth-century Great Kitchen survive. In the Middle Ages, Merchant Taylors made

not only clothes but also protective quilted and padded waistcoats (the 'stab-proof vests' of the day), and linings for suits of armour. They were granted their Royal Charter by Edward III In 1326.

Middle Temple see *Inns of Court.*

Middlesex Street see *Petticoat Lane.*

Milk Street (first recorded in around 1140 as *Melecstrate*). Takes its name from the milk sold here in Medieval times. Sir, later Saint, Thomas More was born in a house here in 1478.

Millwall see *Poplar.*

Milton Street (first recorded in the early thirteenth century as *Grubbestrete*, and in 1830 as *Milton Street*). Takes its present name, as does *Milton Court*, from John Milton (1608–74), author of *Paradise Lost*, who once lived nearby, and took its previous name of Grub Street either from the Middle English '*grubbe*', meaning grub in the sense of an insect larva, or from a family called Grubbe. Grub Street was to become a by-word for literary and journalistic hackery.

Mincing Lane (first recorded in the twelfth century as *Mengenelane*). Takes its name from the Old English '*myncen*', meaning nun, probably in reference to the nuns of *St Helen*, who lived here in the twelfth century.

Minories (first recorded in 1624 as *Minorie Street*, and indicated on map of 1520 as *St Clare's Abbey*). Named after the Spanish Franciscan Nuns of the Order of St Clare, or 'Sorores Minores', or 'Minoresses', who founded a convent here in the late thirteenth century. After the dissolution, the site was used as a parish church (see *Holy Trinity Minories*).

Mint Street, Southwark. Takes its name from the mint that stood here during the reign of Henry VIII.

Mitre Court, off *Wood Street*. Takes its name from the 'Mitre' Tavern, frequented by Ben Jonson, and mentioned by him in his *Bartholomew Fair*, and also mentioned by Samuel Pepys in the entry in his diary for 18 September 1665. The tavern was burnt down in the Great Fire almost exactly a year later.

Mitre Street and Square. Take their names from another 'Mitre' Tavern, built on the site of the former *Holy Trinity Priory*, *Aldgate*, whose abbot wore a mitre

as a sign of his office. The site of a preserved Medieval (fourteenth- or fifteenth-century) arch, formerly part of the Priory. Also of one of Jack the Ripper's grisly murders, that of Catherine Eddowes on the night of 30 September 1888.

Monkwell Square. Named after the de Muchewell(a) or de Mukewell family, who lived here in the twelfth century.

Montague Close, Southwark. Named after Viscount Montague, who after the Dissolution of the Monasteries in the sixteenth century acquired land here that formerly had been owned by the Augustinian Priory since the twelfth.

Monument, Monument Street. Built in 1671–7 as a monument to the Great Fire of 1666, by Wren, whose original plan had been to crown the edifice with a symbolic and dramatic phoenix rising. The monument stands 202 feet high, the vertical distance from the base to the top being the same as the horizontal distance from the base to the seat of the fire in *Pudding Lane*. The ascent to the top is by means of a dizzying helical staircase with 311 steps. The view from the platform at the top, surrounded by sheer drops on all sides, is suitably rewarding and memorable – although as an acrophobic I found myself too terrified to take it in!

Moor Lane (first recorded in 1310 as *le Morstrate*). Takes its name from the moor or marsh immediately north of the *City Wall* in Medieval times.

Moorfields (first recorded in the mid-sixteenth century). Also takes its name from the moor north of the *City Wall*. An archaeological monograph describes in detail the findings of recent archaeological excavations at the junction Moorfields and *London Wall* (Butler, 2006). The area was evidently used for gatherings, both lawful and otherwise, in the summer months, and in the winter, when the Walbrook froze over, for skating, with makeshift skates made by tying animal bones to shoes. The modern (indoor) Broadgate Ice Arena is situated nearby, resounding to the echoes of the past.

Moorgate (first recorded in the mid-sixteenth century, and indicated on the map of 1520 as *Causeway*). Takes its name from the gate to the City that once stood here, leading out onto moor to the north. There was a postern gate here in Roman times. A gatehouse was added by Thomas Falconer, the Lord Mayor of London, in 1415. The gate survived the Great Fire of 1666, but was demolished in 1762.

Muscovy Court, Street. Take their names either from the Muscovy Company, which had its headquarters here in the sixteenth and seventeenth centuries, or from

the Russian ambassadors who had their living quarters here, also at that time. The 'Czar of Muscovy' Tavern is so named after Peter the Great (1672–1725).

Navy Office, Seething Lane. Built in 1656 on the site of the Crutched Friars monastery. Survived the Great Fire of 1666, only to be burnt down in another fire in 1673. Rebuilt in 1674–5, then demolished in 1788, when the office was moved to the rebuilt *Somerset House*. A Corporation 'Blue Plaque' in Seething Lane Garden marks its former site. Also in the garden is a bust of Samuel Pepys, who used to work in the office.

Newcastle Close. Named after Newcastle in the North East of England, from where so-called 'sea-coal' was shipped to here in Medieval times, either to be used locally or to be unloaded onto barges to be sent further up the Fleet, even as far as Ludgate. As long ago as the fourteenth century, local landlords Thomas and Alice Yonge complained to a lawyer about 'the stench of the smoke from seacoal' affecting the rents they could charge on premises in the street ('formerly ... 10 marks a year [and] now ... only 40 shillings'). They also complained about the wine and ale in their cellar becoming tainted, which seems an equally if not more legitimate concern. See also *Old Seacoal Lane*.

Newcastle Court. Took its former name of Royal Street from *le Reole* in the Gironde Department of Aquitaine in south-west France, from where wine was shipped to here, and from where also came many wine merchants who lived here or hereabouts, as long ago as the thirteenth century. Thus also the nearby church of *St Michael Paternoster Royal*, and *Tower Royal*.

Newgate Prison. Originally built in 1188, and rebuilt in 1236 and again, at the behest of Dick Whittington, in 1422, after having been destroyed during the Peasants' Revolt of 1381 (Halliday, 2006; Grovier, 2008). Burnt down in the Great Fire of 1666, and rebuilt in 1672, and again in 1770–1, and in 1782, having been destroyed again during the anti-Catholic Gordon Riots of 1780, and finally decommissioned in 1902, and demolished in 1904, whereupon the Central Criminal Court (the 'Old Bailey') was built in its place. Some of the cells are still visible in the basement of the 'Viaduct' Tavern. Newgate became a byword for everything bad about the prison system, from the conditions in which to the prisoners were kept to the treatment meted out to them, with Dick Whittington writing in 1419 'by reason of the foetid and corrupt atmosphere that is in the heinous gaol ... many persons are now dead who would be alive', and later Daniel Defoe, Giacomo Casanova and Henry Fielding respectively describing it as 'an emblem of hell', 'a hell such as Dante might the have conceived', and a 'prototype of hell'. Until 1783, prisoners condemned to death were dragged on a pallet all the way from Newgate, past baying crowds, to Tyburn to there meet

their Maker, stopping at various watering-holes along the way, to be allowed to drink themselves into a merciful early oblivion (see also *St Sepulchre Newgate Street*). From 1783 onwards, judicial executions were carried out at Newgate itself although still, at least until 1868, in public, and still attracting large crowds.

Newgate Street (first recorded in 1617, and indicated on map of 1520 as site of *The Shambles*). Takes its name from the gate to the City that once stood here, originally built by the Romans in the second century, and subsequently rebuilt by the Saxons, and referred to by them as 'Uuestgetum', meaning west gate or gates, and again by the Normans, and referred to by them as 'New gate'. The gate was damaged in the Great Fire of 1666, and demolished in 1767. The street was notorious as the site of *Newgate Prison*.

Newington, Southwark (first recorded as *Neuton* in around 1200, and *Neuwyngton* in 1325). Takes its name from the Old English '*niwe*', meaning new, and '*tun*', meaning farm-stead or estate. The church of St Mary had its origins before the Great Fire of 1666.

Newington Butts, Southwark (first recorded in 1558). Takes its name from the butts used for archery practice that stood here in Medieval times.

Newington Green, Islington (first recorded as *Newyngtongrene* in 1480). Takes its name from the green near (Stoke) Newington. Henry VIII hunted hereabouts. He also installed his mistresses in a house here.

Nicholas Lane (first recorded in 1244), also *Nicholas Passage*. Named after the church of *St Nicholas Acons*, which once stood here. The architect John Vanbrugh was born here in 1664.

Noble Street (first recorded in 1602 as *Noble streete*, and indicated on map of 1520 as part of Faster Lane). Named after the family of Thomas le Noble, who owned property here in the fourteenth century. Robert Tichborne, a signatory to Charles I's death warrant in 1649, and Lord Mayor of London in 1657, also lived here. The site of preserved sections of Roman wall, and of the footings of the Roman fort that once stood at Cripplegate.

Northumberland Alley. Named after the Earls of Northumberland, who had one of their town houses near here, in *Seething Lane*, in Medieval times. Thus also *Northumberland Avenue*, of 'Monopoly' fame.

Norton Folgate (first recorded in around 1110 as *Nortune*, and in 1433 as *Nortonfolyot*). Takes its name from the Old English 'north' and '*tun*', meaning

town, and from the Folyot or Foliot family, possibly either Gilbert, who was Bishop of London from 1163–87, or Richard, who was Canon of St Paul's in 1241. The Liberty of Norton Folgate was an enclave of land formerly owned by *St Paul's*.

Oat Lane. Takes its name from the oat market held here in Medieval times.

Old Bailey (first recorded in 1444 as *Old Baily*). Takes its name from the Middle English '*baille*', meaning the defensive enclosure formed by the *City Wall*. The building popularly known as the 'Old Bailey' is the Central Criminal Court, built in 1774 on the site of the former *Newgate Prison*.

Old Broad Street (first recorded in around 1212 as *Bradestrate*). Takes its name from its, for London, unusual breadth. Thus also *Broad Street Ward*.

Old Change Court. Takes its name from the Old or King's Exchange established here by Henry III. Old Change no longer exists, although photographs of it taken in the early 1900s do. New Change follows a closely similar route.

Old Fleet Lane (indicated on map of 1520 as *Fletelane*, and as joining on to *Old Baily*). Like *Fleet Street*, named after the River Fleet. The *Fleet Prison* lay immediately to the south.

Old Jewry (first recorded in 1328 as *le Oldeiuerie*). Named after the Jewish community established here in the twelfth century, and re-established here and elsewhere under the protection of William III in the seventeenth, following persecution and expulsion by Edward I in the thirteenth. A synagogue was built here in the seventeenth century.

Old Mitre Court, off *Fleet Street*. Takes its name from the 'Mitre' Tavern that stood here, on the site of the former Joe's Coffee House, at least as long ago as 1603. The 'Mitre' was much frequented by, among others, Johnson and Boswell, who enjoyed many a 'good supper' and much 'port wine' here, and later by Hogarth.

Old Seacoal Lane. Takes its name from the so-called sea-coal shipped here in Medieval times (see also *Newcastle Close*).

Outwich Street. Named after the de Ottewich or de Oteswyche family, which lived here or nearby from the thirteenth to fifteenth centuries. The family also gave its name to the church of *St Martin Outwich*.

Owen's Court. Named after Dame Alice Owen, née Wilkes, who established almshouses and schools for the poor of Islington in the early seventeenth century.

Oxford Court. Named after John de Vere, fifteenth Earl of Oxford (1482–1540), who bought a mansion here that he converted into Oxford Palace in the early sixteenth century, the palace later being disposed of by the seventeenth Earl in 1580.

Pancras Lane (indicated on map of 1520 as *St Pancresse Lane*). Named after the church of *St Pancras* that once stood here.

Panyer Alley (first recorded in 1442 as *ye Panyer Ale*). Takes its name from the 'Panyer' Tap or Tavern, which the records of the Worshipful Company of Brewers indicate stood in nearby *Paternoster Row* as long ago as 1430. A salvaged stone plaque of 1688 of a boy sitting on a pannier, or bread-basket, is set into the wall of a modern building here, and accompanied by the following rhyme: 'When Ye Have Sought The Citty Round, Yet Still This Is The Highest Ground.' While charming, this is not strictly accurate, as Cornhill is higher by about a foot.

Passing Alley. Thought to take its name either from the fact that it passes through buildings at either end, or, altogether more pleasingly, from a Bowdlerisation of 'Pissing Alley'. Today, 'the chief joy of Passing Alley is its ... exit' (Long).

Paternoster Row (first recorded in 1334 as *Paternosterowe*), also *Paternoster Square.* Takes their names either from the prayer books and other ecclesiastical supplies made and sold here, by so-called 'paternosterers', or from the prayers recited here on the processional route towards *St Paul's* (the Lord's Prayer in Latin begins with the words '*Pater noster*', meaning 'our Father'). A number of photographs of the street taken in the early 1900s still survive. They show a wealth of bookshops, all destroyed, along with an estimated six million books, during an incendiary air raid on the night of 29 December 1940.

Peter's Hill (indicated on map of 1520 as *Peter Lane*). Named after the church of *St Peter, Paul's Wharf*, which once stood here. The 'Cross Keys' Tavern stood here in Medieval times (the 'Cross Keys' symbolised St Peter).

Petticoat Lane (first recorded as *Peticote Lane* in 1602, and *Middlesex Street* in 1831). Takes its name from the ladies' petticoats sold here. The Sunday Market here is an East End institution.

Petty Wales (indicated on map of 1520 as *Petywales*). As recounted by Stow,

> towards the east end [of Thames Street] there have been of old time some large buildings of stone, the ruins whereof do yet remain, but the first builders and owners of them are worn out of memory, wherefore the common people affirm Julius Caesar to be the builder thereof ... Some are of another opinion, and that a more likely, that this great stone building was sometime the lodging appointed for the Princes of Wales, when they repaired to this city, and that therefore the street in that part is called Petty Wales.

Philpot Lane (first recorded in 1480). Named after Sir John Philpot, Grocer, Alderman of Langbourn Ward, Lord Mayor of London in 1378–9, and Member of Parliament for the City, who lived in a mansion here. Philpot died in 1384, and was buried in the choir of Grey Friars (*Christ Church Newgate Street*).

Pilgrim Street. Takes its name from the pilgrims who once processed past on their way from the landing stage on the Fleet River to *St Paul's*.

Playhouse Yard. Takes its name from the Blackfriars Playhouse that was built by Richard Burbage here, on the site of the dissolved Dominican or Black Friars' monastery, in the 1590s. The play-house was used by theatre companies, including Shakespeare's King's Players, in the winter, when the open-air *Globe* and *Rose Theatres* on the bank-side in *Southwark* were rendered unusable by bad weather. Shakespeare lived in nearby *Ireland Yard*.

Plough Place. Takes its name from an 'ordinary' eating house of the same name that stood here in the sixteenth century.

Plumtree Court. Thought to take its name from the plum trees once grown here, in orchards belonging to the Bishops of Ely.

Pope's Head Alley (indicated on map of 1520 as *Pope's Hede Entre*). Takes its name from the 'Pope's Head' Tavern that once stood here, at least as long ago as the early fifteenth century, on land then owned by Florentine merchants engaged in the Papal service. The name of the tavern changed from 'Pope's Head' to 'Bishop's Head' and back again during the religious turmoil of the late Medieval period. The building was burnt down during the Great Fire of 1666, and although then rebuilt, it no longer survives, having in 1769 been replaced by the New Lloyds Coffee House (in turn swallowed up by the Lloyds of London building).

Poplar (first recorded as *Popler* in 1327). Takes its name from the Old English *'popler'*, meaning poplar tree, in reference to such once having abounded in the marshy ground hereabouts. Fishing became an established way of life here and elsewhere on the Isle of Dogs at least as long ago as the fifteenth century (Hostettler, 2000). Fragments of a basket-work fish-trap carbon-dated to 1415–50 have recently been recovered from the foreshore at Millwall (Cohen & Stevens, 2011). The design appears similar to that of the complete late Medieval trap found in the moat in the *Tower of London* and now on display in the Medieval Gallery in the Museum of London.

Poppins Court (indicated on map of 1520 as *Popyngay Alley*). Takes its name from the 'Poppinjay', or parrot, on the crest of the Abbots of Cirencester, who had a town house nearby in the fourteenth century. Sadly, nothing to do with Mary Poppins, or Dick van Dyke's treasurable turn as a Cockney chimney-sweep in the Disney film of the book.

Portpool Lane. Takes its name from the ancient manor of Purtepole, that name in turn referring to a pond beside a gate.

Portsmouth Street. Named after the Earl of Portsmouth, who lived here, in a house designed by Inigo Jones, in the seventeenth century. The shop here purporting to be 'The Old Curiosity Shoppe' immortalised by Dickens in fact is not, although it does date to the sixteenth century. No. 2 dates to the seventeenth century, and has an interior by Inigo Jones.

Portsoken Street (first recorded in 1224 as *Portesokne*). Takes its name from the Middle English *'portsoken'*, meaning a district outwith the City over which jurisdiction was extended. Thus also *Portsoken Ward.*

Portugal Street. Takes its name from King Charles II's queen, Catherine of Braganza, who was from Portugal.

Post Office Court. Takes its name from the General Letter or Post Office that stood here from 1653 until 1666, when it was burnt down in the Great Fire.

Postern Gate, Tower Hill. Originally built in the thirteenth century, shortly after the moat around the Tower was dug in the 1270s. Partially collapsed in 1440 due to undermining of the foundations by water from the moat. Ultimately became derelict, and essentially disappeared in the eighteenth century, coming to light again during excavations in 1979. A 'Museum of London Archaeology Service' monograph describes in detail the findings of recent archaeological excavations at the site (Whipp, 2006).

Potters Fields, Southwark. Thought to take its name from the English Delft-ware pottery manufactured here from the mid-sixteenth century onwards.

Poultry (first recorded in 1301 as *Poletria*). Its not rocket science, it's where poultry was sold! 'Museum of London Archaeology Service' monographs describe in detail the findings of recent archaeological excavations at No. 1 (Burch *et al*., 2011; Hill & Rowsome, 2011; see also Rowsome, 2000, Thomas, 2002).

Prescott Street. Named after the Prescott family, related by marriage to the Lemans, who gave their name to *Leman Street*.

Priest's Court. Named after the resident priest of the church of *St Vedast-alias-Foster* on *Foster Lane*.

Priory of St John, Clerkenwell. The Priory of the Order of St John of Jerusalem, the home of the Knights Templar and later Hospitaller, was originally built in around 1145, destroyed during the Peasants' Revolt in 1381, rebuilt by Prior John Redington immediately afterwards and restored by Prior Thomas Docwra in 1504, and dissolved in 1540. The former priory church, in *St John's Square*, was substantially destroyed during an air raid on the night of 10 May 1941, and subsequently rebuilt. Photographs of it taken in the 1900s still survive. Remarkably, so does the original crypt of 1145. A separate gatehouse of 1504 also survives, on *St John's Lane*. The gatehouse re-entered the possession of the (by then) Order of the Hospital of St John of Jerusalem in 1873, and now houses the Order's museum. A 'Museum of London Archaeology Service' monograph describes in detail the findings from the priory precinct, bounded to the east by *St John Street*, to the south by *Cowcross Street*, to the west by *Turnmill Street*, and to the north by *Clerkenwell Green* (Sloane & Malcolm, 2004).

Pudding Lane (first recorded in 1360 as *Puddynglane*). Takes its name not from Spotted Dick and Custard, still less Eton Mess, as one might have fondly imagined, but rather from the 'puddings [meaning offal], with other filth of beasts ... voided down that way to ... [waiting 'dung barges' on] ... the Thames' in late Medieval times (Stow). The butchers of Eastcheap had their 'scalding house' for hogs here. Famously, it was also the site of the king's bakers, where the Great Fire started in 1666.

Puddle Dock (first recorded in 1598). Although the name is now commonly understood to refer to the puddles formed by horses after they were watered here, it may originally have referred to the dock itself, or to a one-time owner, one Puddle.

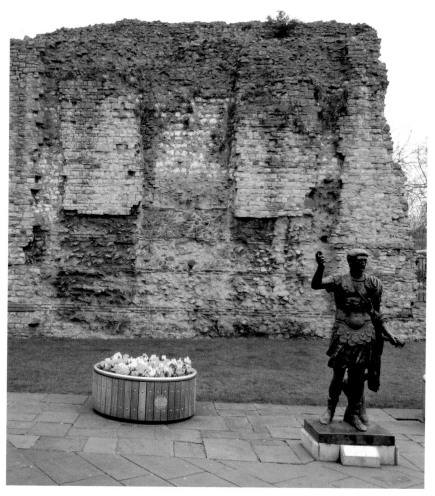

1. Roman and Medieval city wall, Tower Hill (early second century and later).

Above left: 2. Roman and Medieval city wall, from Salters' Hall, Barbican.

Above right: 3. Roman and Medieval bastion, from Museum of London.

Below: 4. Roman amphitheatre, Guildhall (amphitheatre built around 75).

Bottom left: 5. Temple of Mithras (early third century, *c.* 220–40).

Right: 6. London Stone, Cannon Street (possibly a relic of the Roman Governor's Palace, dating to 69–96).

Far right: 7. Saxon arch, All Hallows Barking (around 675).

Bottom right: 8. Tower of London (Norman, late eleventh century, and later).

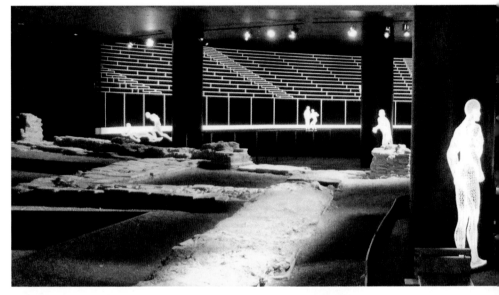

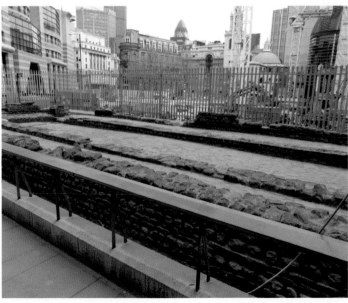

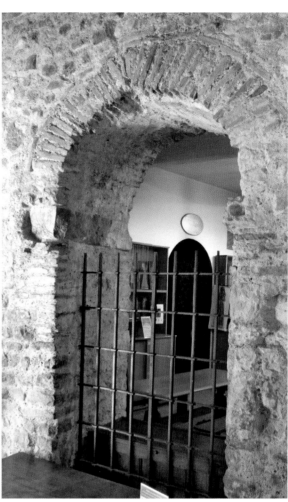

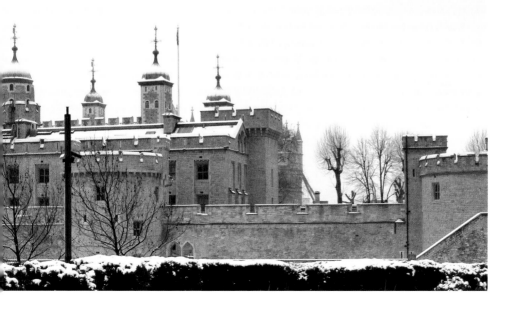

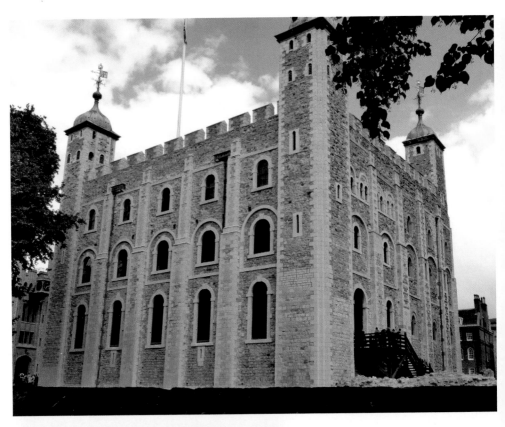

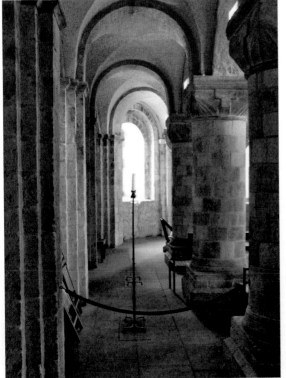

Above: 9. White Tower, Tower of London.

Left: 10. Norman colonnade, Tower of London.

 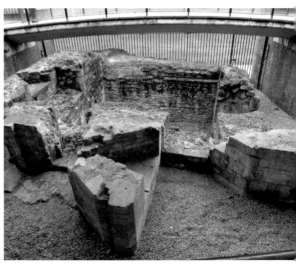

Above left: 11. Sixteenth-century graffito by a prisoner, Tower of London.

Above right: 12. Medieval Postern Gate, Tower Hill (late thirteenth century, around 1270).

Below: 13. Chapel of St Peter ad Vincula, Tower of London.

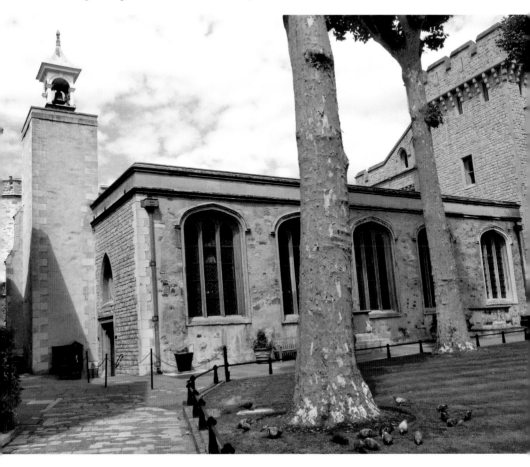

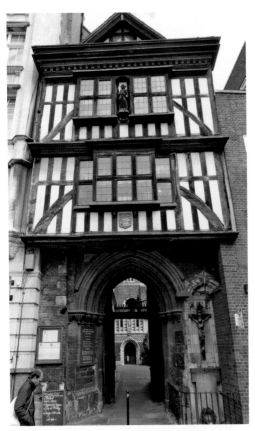

Left: 14. St Bartholomew the Great Gatehouse and entrance (church Norman, founded in 1123, gatehouse Tudor).

Below left: 15. Interior, with Bolton oriel window, St Bartholomew the Great.

Below right: 16. Rahere memorial, St Bartholomew the Great.

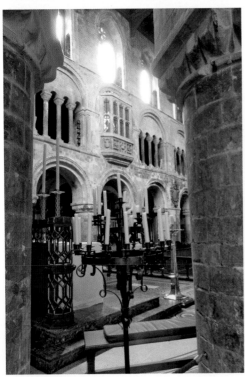

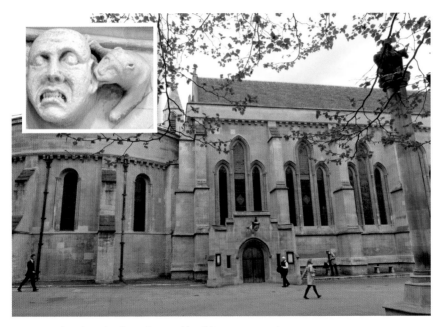

17. Temple Church (first phase of building 1160–85).

Inset: 18. Grotesque, Temple Church.

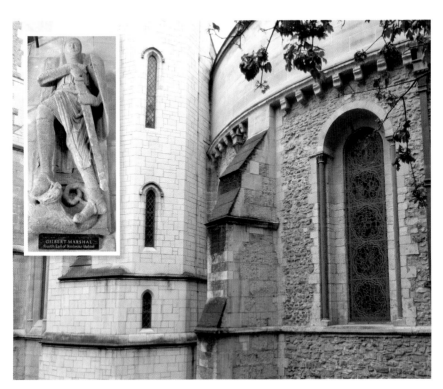

19. Contrasting architectural styles, Temple Church.

Inset: 20. Effigy of knight, Temple Church.

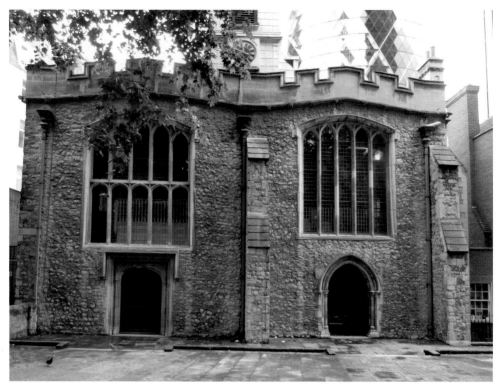

21. St Helen (early Gothic, originally completed around 1204).

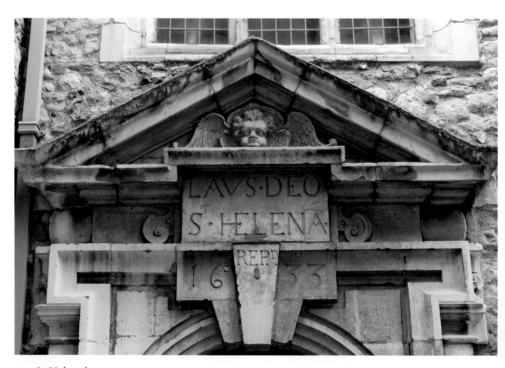

22. St Helen doorway.

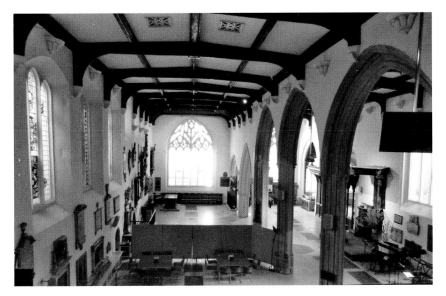

23. Interior, St Helen.

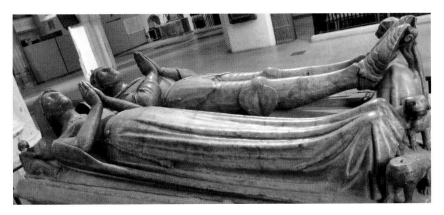

24. Crosby memorial, St Helen.

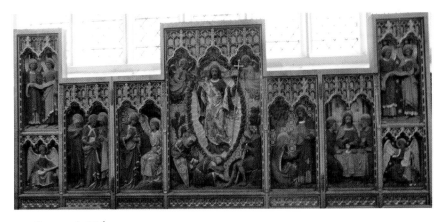

25. Screen, St Helen.

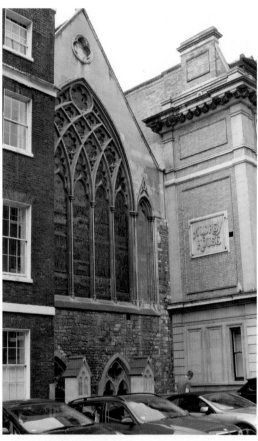

Above left: 26. St Etheldreda (Decorated Gothic, originally built in 1293).

Above right: 27. Interior, St Etheldreda.

Below left: 28. Stained-glass west window, St Etheldreda, depicting martyrdom of John Houghton and others at Tyburn Tree in 1535.

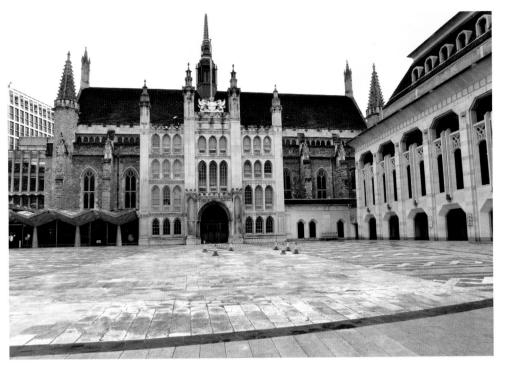

29. Guildhall, with outline of Roman amphitheatre (Guildhall originally built between 1260 and 1411).

Above left: 30. Interior, Guildhall.

Above right: 31. Entrance to crypt, Guildhall.

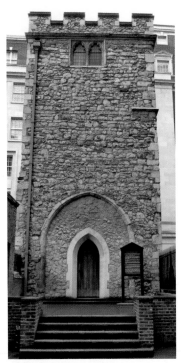

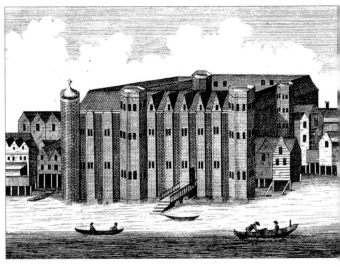

Left: 32. All Hallows Staining (essentially fifteenth-century Perpendicular Gothic).

Above: 33. Castle Baynard, *c.* 1428.

Below: 34. Interior, St Andrew Undershaft.

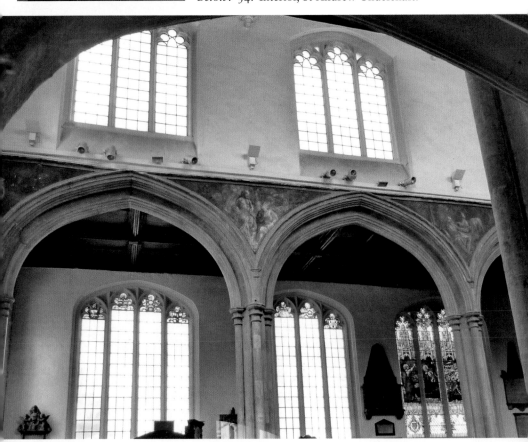

Above: 35. Stow memorial, St Andrew Undershaft.

Right: 36. St Andrew Undershaft with the Gherkin in the background.

Below: 37. St Andrew Undershaft doorway.

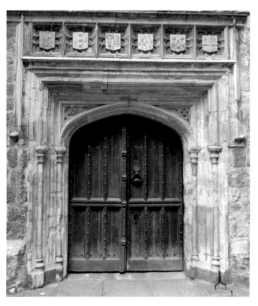

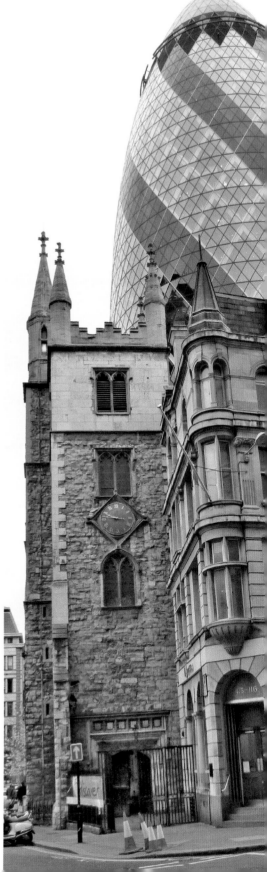

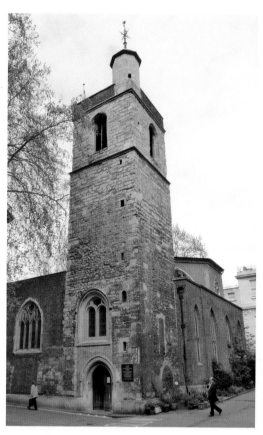

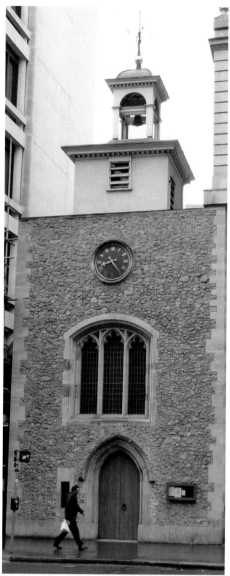

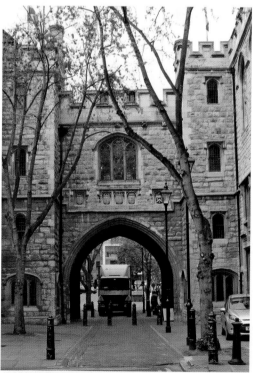

Above left: 38. St Bartholomew the Less.

Above right: 39. St Ethelburga.

Left: 40. St John Gatehouse.

Opposite top: 41. St Olave Hart Street.

Opposite bottom: 42. Interior, St Olave Hart Street.

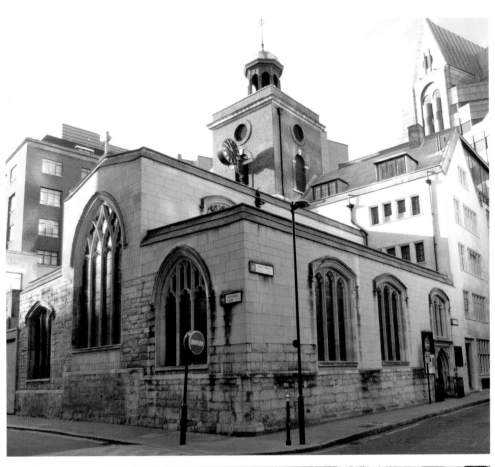

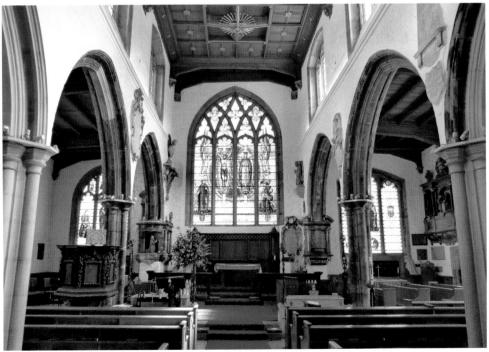

Above left: 43. Elizabeth Pepys memorial, St Olave Hart Street.

Above right: 44. Samuel Pepys memorial, St Olave Hart Street.

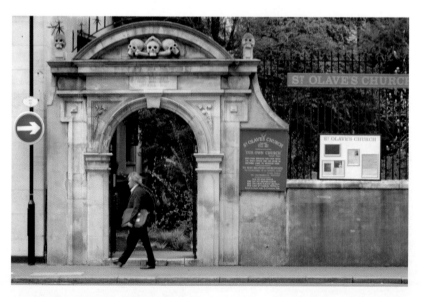

45. St Olave Hart Street churchyard.

Above: 46. South porch, St Sepulchre Newgate Street.

Right: 47. West tower, St Sepulchre Newgate Street.

Below: 48. Executioner's bell, St Sepulchre Newgate Street.

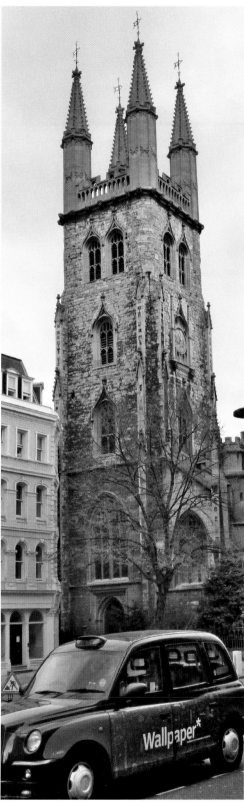

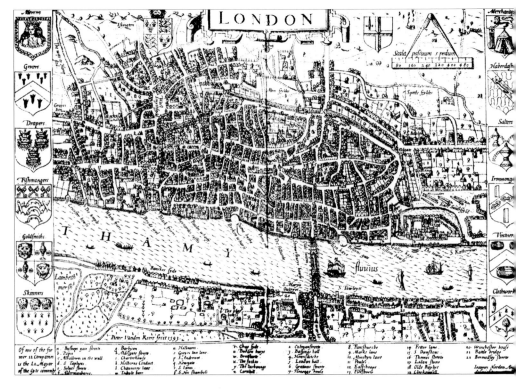

Above: 49. Norden map of 1593.

Below: 50. Watch House adjoining St Sepulchre Newgate Street (1791).

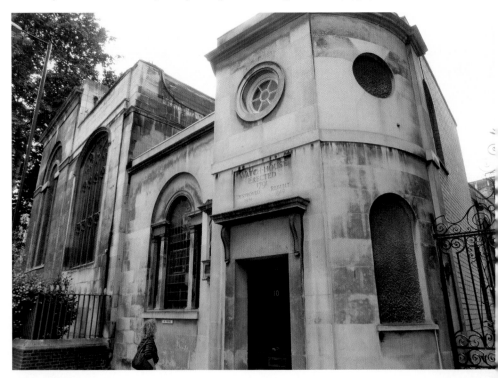

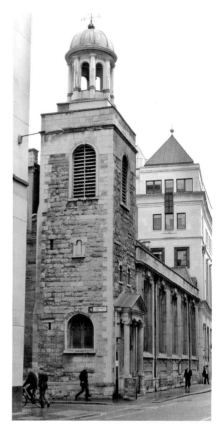

Right: 51. St Katharine Cree (essentially transitional to Neoclassical, 1628–31).

Below: 52. Interior, St Katharine Cree.

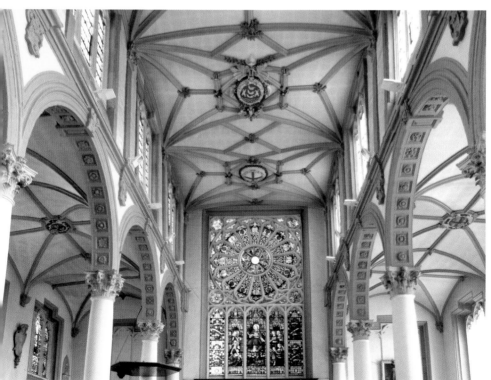

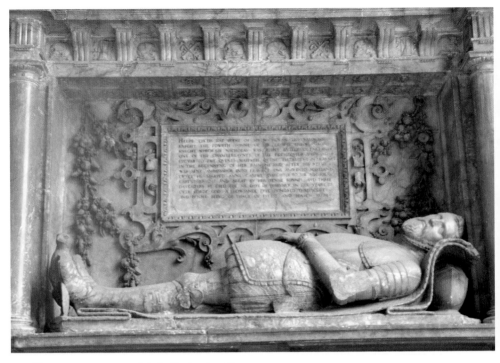

53. Throgmorton memorial, St Katharine Cree.

THIS GATE WAS BVILTE AT THE COST
AND CHARGES OF WILLIAM AVENON
CITEZEN AND GOVLDSMITH OF LOND
WHO DIED IN DECEMBER ANNO DNI 16

54. Avenon memorial, St Katharine Cree churchyard.

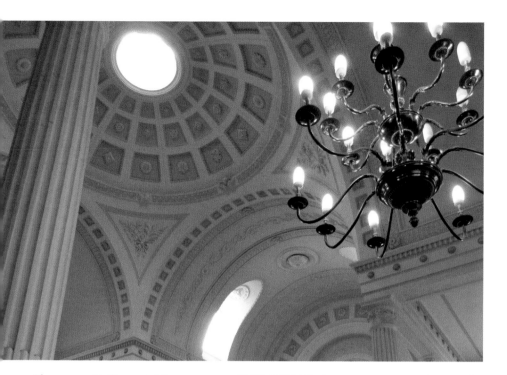

Above: 55. Ceiling,
St Mary at Hill
(rebuilt 1670–74,
incorporating
Byzantine quincunx
plan of Medieval
structure).

Right: 56.
Bankside
(Southwark) and
Old St Paul's from
Visscher's panorama
of 1616. Note the
Bear Garden and
Old Globe Theatre
in Bankside.

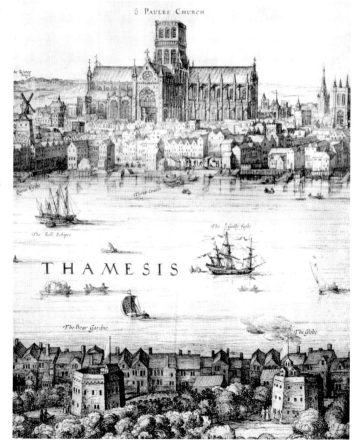

Above: 57. Fan-vaulted ceiling, St Mary Aldermary.

Left: 58. St Mary Aldermary (rebuilt 1679–82, incorporating Perpendicular Gothic elements of Medieval structure).

Below: 59. Barnard's Inn Hall (late fourteenth or early fifteenth century).

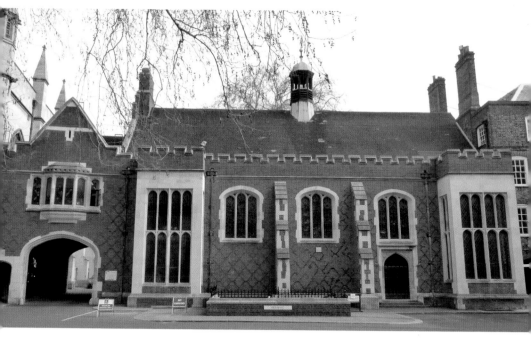

60. Lincoln's Inn Old Hall (1489–92).

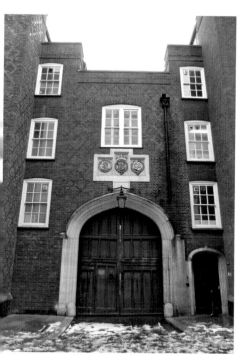

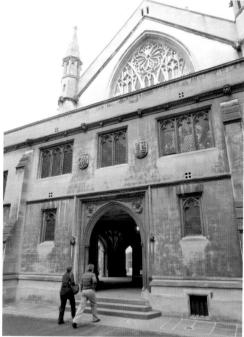

Above left: 61. Lincoln's Inn Gatehouse (1517–21).

Above right: 62. Lincoln's Inn Chapel (1613–22).

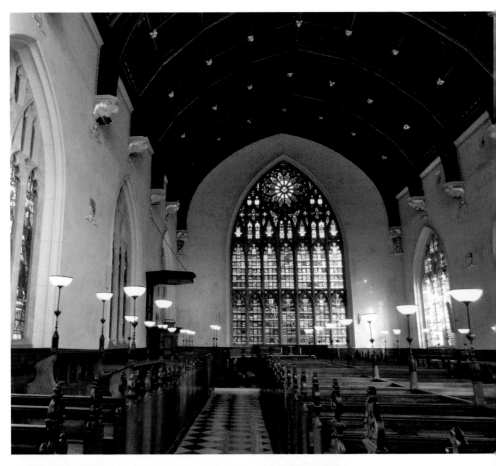

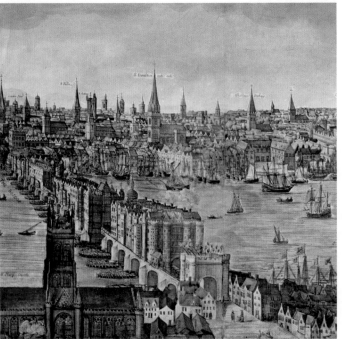

Above: 63.
Interior, Lincoln's
Inn Chapel.

Left: 64. St
Saviour, Southwark
(now Southwark
Cathedral) and
Old London Bridge
from Visscher's
panorama of 1616.
Note the severed
heads on spikes
at the end of the
bridge.

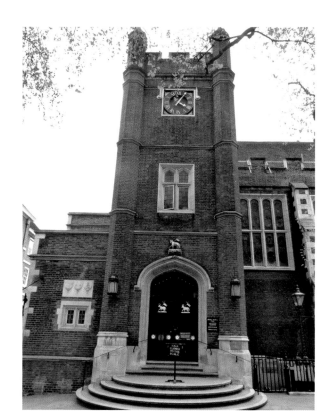

Right: 65. Middle Temple Hall,
entrance (Elizabethan, 1571).

Below: 66. Middle Temple Hall.

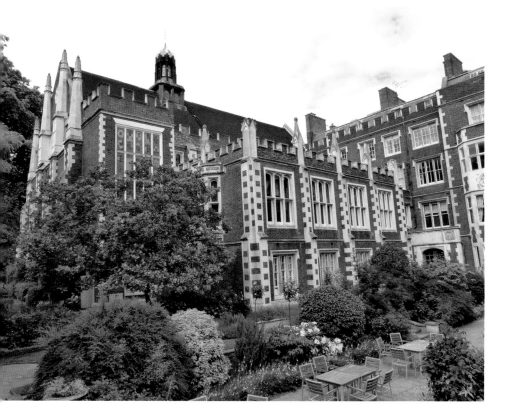

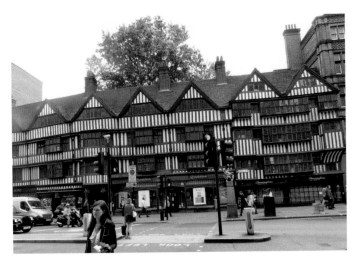

67. Staple
Inn Buildings
(Elizabethan, 1589).

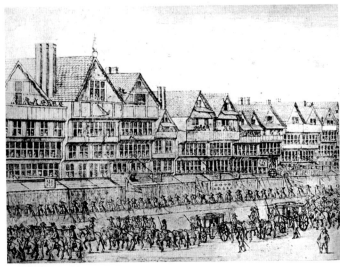

68. Cheapside in
1638.

69. Nos 59–60
Lincoln's Inn Fields
(Neoclassical,
1638–40).

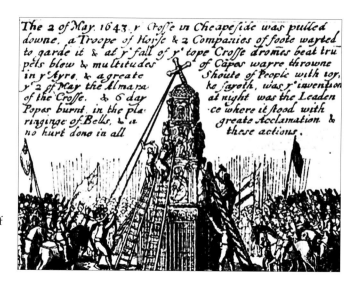

The 2 of May. 1643. y Croſſe in Cheapeſide was pulled downe. a Troope of Horſe & 2 Companies of foote warted to garde it & at y fall of y tope Croſſe dromes beat trū pets blew & multitudes of Capes warre throwne in y Ayre. & a greate Shoute of People with ioy. y 2 of May the Almara ke ſayeth, was y invention of the Croſſe. & 6 day at night was the Leaden Popes burnt. in the pla- ce where it ſtood with ringinge of Bells, & a greate Acclamation. & no hurt done in all theſe actions.

70. The destruction of the Eleanor Cross on Cheapside during the Civil War, 1643.

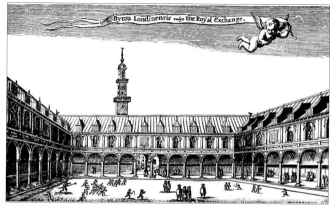

71. The Royal Exchange, from Hollar's drawing of 1644.

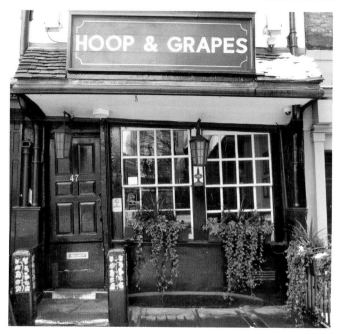

72. Hoop & Grapes, Aldgate High Street (part Medieval).

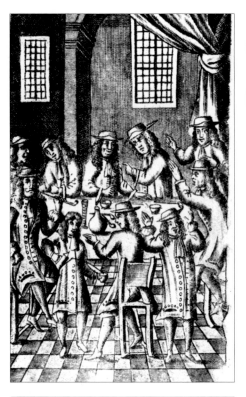

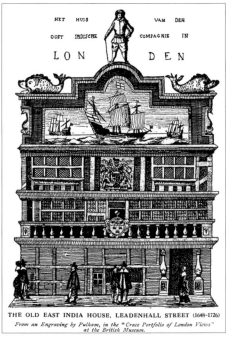

THE OLD EAST INDIA HOUSE, LEADENHALL STREET (1648-1726)
From an Engraving by Pulham, in the "Crace Portfolio of London Views" at the British Museum.

Top left: 73. Coffee house.

Top right: 74. East India House, Leadenhall Street, built in 1648.

Bottom left and right: 75 & 76. Bills of Mortality for the Plague year of 1665.

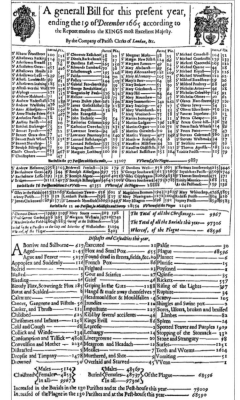

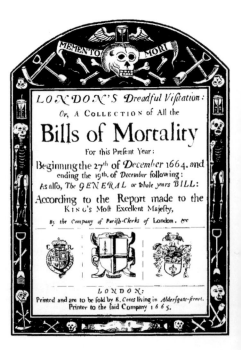

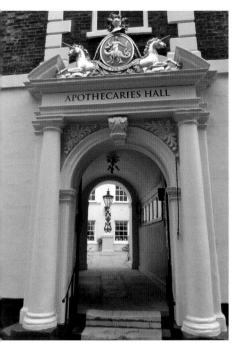

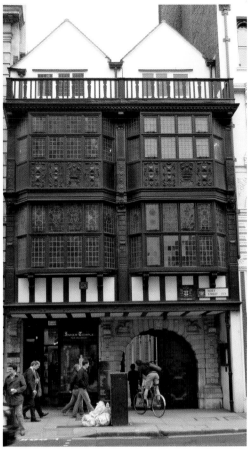

Top left: 77. Apothecaries' Hall (part dates to 1633).

Top right: 78. Inner Temple Gatehouse (Jacobean, 1610–11).

Bottom left: 79. No. 41 Cloth Fair (Elizabethan to Jacobean, 1597–1614).

Bottom right: 80. Merchant Taylors' Hall (part Medieval).

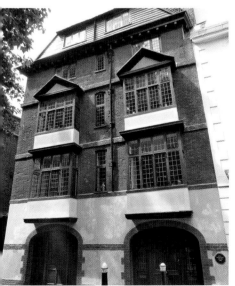

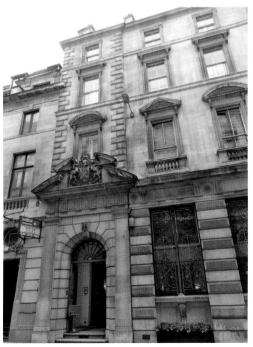

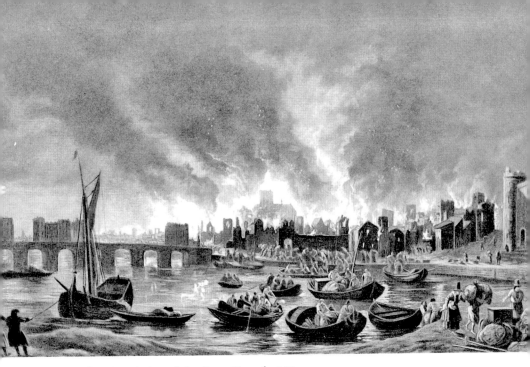

81. Verschuur's painting of the Great Fire of 1666.

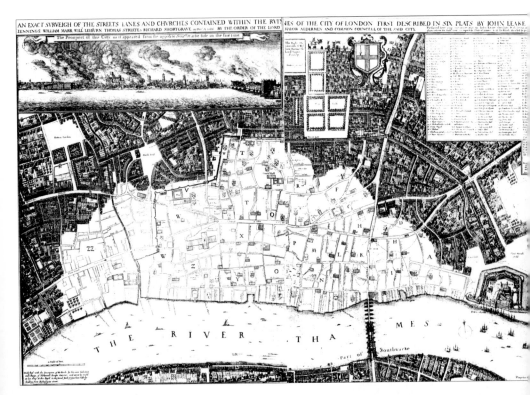

82. Map of London after the Great Fire.

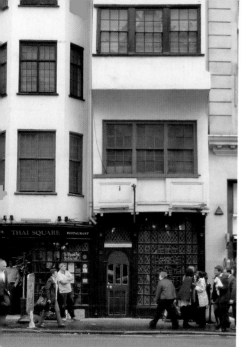

Above: 83. Wig and Pen, Strand (1625).

Right: 84. Tipperary, Fleet Street (1605).

Below: 85. The Olde Wine Shades, Martin Lane (1663).

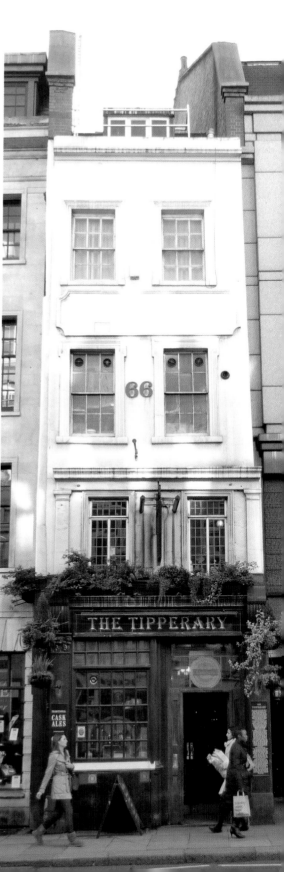

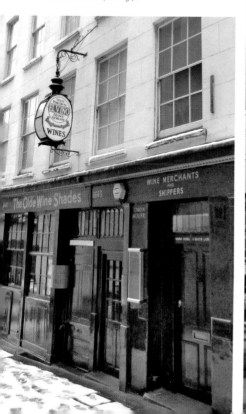

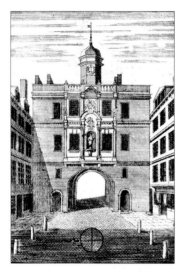
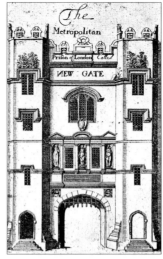
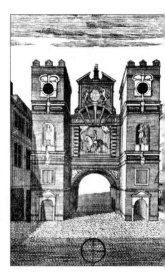

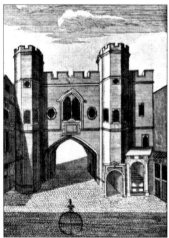
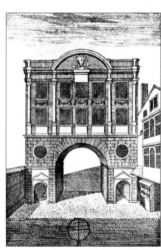

The old city gates.

Top, from left to right:
86. Ludgate; 87. Newgate;
88. Aldersgate.

Middle left: 89. Cripplegate.

Middle right: 90. Moorgate.

Bottom left: 91. Bishopsgate.

Bottom right: 92. Aldgate.

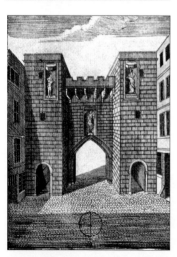
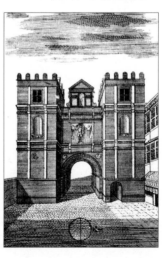

Pye Corner, at the junction of *Cock Lane* and *Giltspur Street*. Site of the famous statue of the 'Golden Boy', set into the wall of a building as a monument to the Great Fire. The statue was formerly part of the sign of the nearby 'Fortune of War' Tavern, a haunt of 'resurrectionists' or grave-robbers.

Queenhithe (first recorded in 898 as *Aetheredes hyd*, and in 1151 as *Quenhyth*), also *Queenhithe Ward*. Takes its present name from the Old English '*hyth*', meaning inlet or harbour or dock where goods could be unloaded from ships, and '*cwen*', meaning the Norman Queen Matilda (1100–35), the wife of Henry I, who, incidentally, paid for the first-ever public lavatory to be built here in the early twelfth century. Took its previous name from the Saxon King Ethelred I (866–71). The 'Alfred Plaque' marks the site.

Ratcliff, also known as *Ratcliffe* (first recorded as *la Rede clive* in 1294). Takes its name from the Old English '*read*', meaning red, and '*clif*', meaning cliff, in reference to the colour of the soil on the bank of the Thames here. The river-front became built up and industrialised as long ago as the fourteenth century, when ships were built or fitted out here. Martin Frobisher (1535–94) left from here in search of the Northwest Passage in 1576, the site being marked by a 'London County Council' plaque of 1922 in King Edward Memorial Park (beside the building housing one of the shafts servicing the Rotherhithe Tunnel). The area was connected to the City by the 'Ratcliffe Highway', much travelled by Pepys, and probably originally a Roman road. The highway was the scene of a series of shocking murders in 1811, and went on to acquire a reputation as 'the head-quarters of unbridled vice and drunken violence – of all that is dirty, disorderly, and debased' in Victorian times. Perhaps not surprisingly, it has since been renamed as, variously, St George's Street East, High Street (Shadwell), Cock Hill and Broad Street.

Red Lion Court. Takes its name from the 'Red Lion' Tavern that stood here from 1592 until it was burnt down in the Great Fire of 1666.

Rolls Buildings. Takes its name from the Rolls of Chancery stored here in the thirteenth century, or the Rolls Chapel on Chancery Lane, established by the Keeper of the Rolls. Thus also *Rolls Passage*.

Roman bath-house, Strand Lane. Surviving parts of a Roman (or Roman-style) bath-house can be seen on Strand Lane, in the basement of a building owned by the National Trust, either close up, if the building is open, or through a rather grubby outside window if it is closed.

Rood Lane (first recorded in 1557, and indicated on map of 1520 as *St Margaret Patyns Lane*). Thought to take its name from the large 'rood' or cross that stood in the churchyard of *St Margaret Pattens*. As recounted by Stow, 'in the year 1538, about the 23 of May, in the morning, the said rood was found to have been in the night preceding, by people unknown, broken all to pieces, together with the tabernacle wherein it had been placed'.

Ropemaker Street. Takes its name from the craft of rope-making once practised here.

Rose Alley, Southwark. Takes its name from the *Rose Theatre* that once stood here.

Rose and Crown Court. Presumably takes its name from a 'Rose and Crown' Tavern that once stood here. Thirteenth-century glass shards, one bearing the inscription 'ENIMA', have been excavated here by archaeologists.

Rose Theatre, Southwark. Built to a fourteen-sided design in 1587, rebuilt to a less regular design in 1592, and demolished in 1606 (Gurr, 2009). A 'Museum of London Archaeology Service' monograph describes in detail the findings of recent archaeological excavations at the site in 1988–90 (Bowsher & Miller, 2009). The site is currently conserved in the basement of Rose Court in Park Street, and marked by a Corporation Blue Plaque on the outside of the building.

Rotherhithe (first recorded as *Rederheia* in around 1105, and as *Rotherhith alias Redderiffe* in 1621). Takes its name from the Old English *'redhra'*, meaning mariner, and *'hyth'*, meaning haven. Rotherhithe appears to have been a small settlement surrounding the church of St Mary in the Medieval period, when Edward III had a retreat on the river here, built in 1349, and then to have undergone a major phase of development in the seventeenth century, when a timber wall and number of yards were built along the river-front. The *Mayflower* set sail from here in 1620 for Plymouth and eventually the Americas. A 'Museum of London Archaeology Service' monograph describes in detail the findings of recent archaeological excavations at Medieval sites in Rotherhithe (Blatherwick & Bluer, 2009). Another 'MoLAS' publication investigates the later, maritime history of the area, based on the findings of excavations at Pacific Wharf, 165 Rotherhithe Street (Heard & Goodburn, 2003).

Royal Exchange, Threadneedle Street and Cornhill. Originally founded, on a site provided by the City of London Corporation and the Worshipful Company of Mercers, by Sir Thomas Gresham in 1565, and officially opened

by Queen Elizabeth I in 1571. Burnt down in the Great Fire of 1666. As one eye-witness, one Thomas Vincent, vividly wrote,

> The Royal Exchange itself, the glory of the merchants, is now invaded with much violence. And when once the fire was entered, how quickly did it run round the galleries, filling them with flames; then descendeth the stairs, compasseth the walks, giving forth flaming volleys, and filleth the courts with sheets of fire. By and by, down fall all the kings upon their faces, and the greatest part of the stone building after them, with such a noise as was dreadful and astonishing.

Rebuilt in 1669. The new building in turn burnt down in 1838, and was rebuilt in 1844. It remained a centre of commerce until 1939, but is currently a shopping centre. The grasshopper insignia is that of Gresham, and is also to be seen on the former Gresham's Bank building on nearby *Lombard Street*.

Royal Wardrobe. Built as an office for managing royal assets and provisions, and a storehouse for clothes worn on ceremonial occasions and suchlike in the reign of Edward III in the late fourteenth century, and burnt down in the Great Fire of 1666. A Corporation 'Blue Plaque' marks its former site. Samuel Pepys's cousin, the Earl of Sandwich, held the position of the Master of the Wardrobe in the seventeenth century.

Saffron Hill (first recorded in 1602), also *Saffron Street*. Take their names from the saffron once grown hereabouts, in gardens belonging to the Bishops of Ely. The saffron came from Saffron Walden in Essex, which was within the Bishops' diocese. It was highly prized in the Middle Ages as a dye and also as a food colouring and flavouring (actually probably more to disguise the taste of rotten meat).

St Alban Wood Street. Originally built in the eleventh century, on the site of an eighth-century chapel believed to have been attached to the palace of the Mercian King Offa, and rebuilt by Inigo Jones in the 1630s. Badly damaged in the Great Fire of 1666, and rebuilt by Wren in 1682–8, using some of the surviving structure, and altered and Victorianised by Gilbert Scott in 1858, only to be severely damaged by incendiary bombing on 29 December 1940, and substantially demolished in 1955 (a photograph of the bombed church taken in 1941 still survives). Only the Perpendicular Gothic tower remains today. Alban was the first English martyr, done to death in 304.

St Alphage, London Wall (indicated on 'Agas' map of 1561–70 as St Tapius or Thaphins). Originally part of the priory church of *Elsing Spital*, becoming

the parish church of St Alphage after the Dissolution in the sixteenth century. Undamaged in the Great Fire of 1666, although substantially rebuilt by William Hillyer in 1777, and further restored by Henry Ling in the early twentieth century. Fell into disrepair, and indeed was partially demolished, following the merger of the parish with that of *St Mary Aldermanbury* in 1924, and was substantially destroyed by bombing during the Blitz, only a partial shell surviving (together with a photograph of the church taken in around 1907). Alphage or Alphege, Archbishop of Canterbury, was martyred in 1012, beaten to death by the Danes with the bones of oxen. There is another church dedicated to him in Greenwich.

St Andrew-by-the-Wardrobe, also known as *St Andrew Castle Baynard*, Queen Victoria Street. Originally built in around 1170. Burnt down in the Great Fire of 1666, then rebuilt by Wren between 1685 and 1695, only to be gutted by incendiary bombing on 29 December 1940, and rebuilt again by Marshall Sisson in 1961. The pulpit and font were salvaged from *St Matthew, Friday Street*. Andrew was crucified on a diagonal cross.

St Andrew Holborn, Holborn Circus. Originally built in timber in around 951, and rebuilt in stone in the fifteenth century. According to most sources, undamaged in the Great Fire of 1666. Note, though, that there is a building on *Hatton Garden* that was, according to a plaque affixed to the outside, erected as a church by Lord Hatton 'to serve the needs of the neighbourhood after St Andrew's Holborn had been destroyed in the Great Fire of 1666'. In any case, rebuilt by Wren and Hawksmoor between 1684 and 1687, and further restored by S. S. Teulon in 1868–72, only to be gutted by bombing on the night of 16/17 April 1941, and rebuilt again by Lord Mottistone of Seeley & Paget, in 1960–1 (photographs taken before and after the war clearly show the extent of the bomb damage sustained by the church). The stone arches leading to the altar in the chapel are original, fifteenth-century. Thomas Coram, the founder of the Foundlings' Hospital in Coram's Fields, is buried in the church. The Renatus Harris organ presented by Handel to the same Foundlings' Hospital can now be seen in the church, which, incidentally, was also the site of the site of the first public performance of the composer's *Messiah*, with its famous 'Hallejuah Chorus'. There are some interesting Russian icons on either side of the altar.

St Andrew Hubbard, Eastcheap. Originally built at least as long ago as 1454, to which year the churchwardens' accounts date, and possibly to around 1202, the church was burnt down in the Great Fire of 1666 and never rebuilt, and the parish was merged with that of *St Mary-at-Hill*. Essentially nothing now remains of it above ground, other than parish boundary markers in *Philpot*

Lane and Talbot Court. Excavations in 1836 revealed that it was founded on a former Roman site.

St Andrew Undershaft, Leadenhall Street and St Mary Axe. Originally built in the twelfth century, and rebuilt in the fourteenth century, and again, in the Perpendicular Gothic style, in around 1520–32. Undamaged both in the Great Fire of 1666 and in the Blitz of 1940–1, although the seventeenth-century stained-glass windows were destroyed by an Irish Republican Army bomb in 1992. A sword-rest salvaged from *All Hallows Staining* can be seen in the church. The artist Hans Holbein was a parishioner here. Among the many memorials inside is one to John Stow (*d.* 1605), the author of *A Survay of London* (the famous last words of which were 'And so I end, wanting time to travel further in this work'). Stow appears with a quill-pen in his hand. The pen is ceremoniously replaced each year.

St Andrew's Hill. Named after the church of *St Andrew-by-the-Wardrobe*.

St Ann Blackfriars, Ireland Yard and Church Entry. Originally built around 1540, and rebuilt around 1550 and again in 1597, the church was burnt down in the Great Fire of 1666 and not rebuilt again afterwards, and the parish was merged with that of *St Andrew-by-the-Wardrobe*. Two portions of the former churchyard, which remained open for burials until 1849, survive. One is in *Church Entry*, and the other, containing part of the wall of the former *Blackfriars Monastery*, in *Ireland Yard*.

St Anne and St Agnes, also known as *St Anne in the Willows*, Gresham Street. Originally built around 1150, and rebuilt around 1548. Badly damaged in the Great Fire of 1666, and rebuilt by Wren and Hooke, using some of the surviving structure, in 1677–87, only to be badly damaged again by incendiary bombing on 29 December 1940, and rebuilt again, by Braddock and Martin Smith, in 1963–8. Many of the interior fittings were salvaged from *St Mildred Bread Street*, and the pulpit from *St Augustine Watling Street*. The church itself was saved 'partly by the intrepidity of its vergeress, who kept it open after the war even when the City Surveyor had served a Dangerous Structure Notice'.

St Antholin Watling Street, also known as *St Antholin Budge Row*. Originally built in the early twelfth century. Burnt down in the Great Fire of 1666, and rebuilt by Wren in 1678–88, only to be demolished during the construction of Queen Victoria Street in 1874, when the parish was merged with *St Mary Aldermary*. Essentially nothing now remains of the church at its former site. A stone tablet that once marked its former site was salvaged when the site was developed to make way for Bucklerbsury House, and still survives in *St*

Mary Aldermary. The salvaged reredos survives in the church of St Anthony in Nunhead.

St Anthony's Hospital, Threadneedle Street. Originally founded in 1242, on the site of a former synagogue, as the Hospital of St Antoine de Viennois, a hospital specifically for the treatment of sufferers of 'St Anthony's Fire', or ergotism, a disease caused by eating cereals contaminated by an alkaloid-secreting fungus. Later expanded so as to incorporate, in 1429, a hospice; in 1440, a school, where Thomas More (1478–1535) studied; and, in 1550, a chapel, where Protestant Huguenots, fleeing religious persecution in Catholic France, worshipped. All burnt down in the Great Fire of 1666.

St Audouen or Ewen, Newgate Street. Lost in the sixteenth century, when the parish was merged with *Christ Church Newgate Street*.

St Augustine Papey, also known as *St Augustine on the Wall*, Camomile Street. Lost in the fifteenth or sixteenth century.

St Augustine Watling Street, also known as *St Augustine-by-St Paul's* or *St Augustine Old Change*, St Paul's Churchyard and New Change. Originally built in the twelfth century. Burnt down in the Great Fire of 1666, and rebuilt by Wren in 1680–95, and further altered in the late nineteenth century, only to be damaged by bombing on 29 December 1940, and then, as the Rector, Henry Ross, wrote, 'bombed … and utterly demolished on Saturday night and Sunday Jan. 11–12 [1941] by the Nazi enemy', and bombed again, in a 'Ghastly raid' on the night of 10 May 1941, which left the 'Vestry gone; tower gone [and] everything burnt out', after which the parish was eventually merged with *St Mary-le-Bow*. A photograph of the bombed church taken in 1941 still survives. Only the restored tower survives at the site, as part of the Cathedral Choir School of St Paul's. The salvaged pulpit survives in the church of *St Anne and St Agnes*, and the somewhat charred Service Register in the *Guildhall* Library. Augustine was sent to England as a missionary in 597, and converted the then king, Ethelbert, to Christianity.

St Bartholomew-by-the-Exchange, Bartholomew Lane. Originally built in the early thirteenth century. Badly damaged in the Great Fire of 1666, and rebuilt by Wren in 1675–83, only to be demolished, to allow for the widening of *Threadneedle Street* and the rebuilding of the *Royal Exchange*, in 1840. A Corporation 'Blue Plaque' marks its former site. The salvaged organ-case of 1731 survives, in *St Vedast-alias-Foster*. The salvaged pulpit also survives, in the church of St Bartholomew in Craven Hill in Tottenham (having been housed in St Bartholomew Moor Lane until that church was demolished to

make way for the extension to the Metropolitan Line in 1902). Bartholomew was martyred by being flayed alive.

St Bartholomew-the-Great, West Smithfield. The priory church of the Augustinian Priory of St Bartholomew was founded by Rahere, a courtier of Henry I, in 1123, and much added to and modified in the thirteenth, fourteenth and fifteenth centuries, before being dissolved by Henry VIII in around 1539, when the nave was destroyed, thereafter becoming a parish church, to which a red-brick tower was added in 1622–8. Undamaged in the Great Fire of 1666, although nonetheless requiring to be restored by Aston Webb in 1886–98, and also undamaged by bombing in the Blitz of 1940–1, such that, uniquely, much of the Medieval fabric of the church still survives, and its interior in particular is correspondingly darkly atmospheric and evocative. The stone-built choir is original, twelfth-century; the west door also, thirteenth-century, although incorporated into a later, Tudor, gatehouse; the vaulted aisles, fourteenth-century; the rare, octagonal font and memorial to Rahere, fifteenth-century; and the oriel window, inscribed with Prior Bolton's rebus of a crossbow-*bolt* and a barrel or *tun*, early sixteenth-century. The dedication of the church – and of the nearby hospital – to St Bartholomew was on account of Rahere's recovery from malaria following a vision he had of the Saint.

St Bartholomew-the-Less, West Smithfield. The former chapel attached to *St Bartholomew's Hospital* was founded in 1184, and added to in the fifteenth century, before being dissolved by Henry VIII in around 1539, thereafter becoming a parish church. Undamaged in the Great Fire of 1666, although nonetheless requiring to be substantially rebuilt by George Dance the Younger in 1789–93, and again by Thomas Hardwick between 1823 and 1825, and restored by his grandson Philip Hardwick in 1862–3, only to be badly damaged by bombing during the Second World War, and having to be rebuilt yet again, by Lord Mottistone, in 1950–1. The oldest surviving parts of the church are the tower, immediately inside the gates of the hospital, and the vestry, which both date back to the fifteenth century. Inigo Jones was baptised here in 1573.

St Bartholomew's Hospital ('St Bart's'), West Smithfield. Originally founded as a hospital within the former Augustinian Priory of St Bartholomew in 1123, re-founded after the Dissolution in 1546, and rebuilt in 1702–69. The Hospital is home to a small but fascinating museum, and to a panelled staircase sumptuously painted by Hogarth.

St Benet Fink, Threadneedle Street. Originally built in around 1216, burnt down in the Great Fire of 1666, and rebuilt by Wren in 1670–5, only to be demolished to make way for the rebuilding of the *Royal Exchange*, in

1841, when the parish was merged with *St Peter-le-Poer*. A Corporation 'Blue Plaque' marks its former site. The salvaged organ of 1731 survives, in *St Vedast-alias-Foster*. Some salvaged communion plate also survives, in the church of St Benet Fink in Tottenham. Salvaged paintings of Moses and Aaron, which were formerly part of the altar-piece, ended up in Emmanuel School in Wandsworth.

St Benet Gracechurch, Gracechurch Street. Burnt down in the Great Fire of 1666, and rebuilt by Wren in 1681–7, only to be demolished to allow for road-widening, in 1867–8, when the parish was merged with *All Hallows*. A Corporation 'Blue Plaque' marks its former site. The salvaged seventeenth-century pulpit survives in *St Olave Hart Street*.

St Benet Paul's Wharf, also known as *St Benet Thames* or *St Benet Welsh Church*, Queen Victoria Street. Originally built in the early twelfth century. Burnt down in the Great Fire of 1666, and rebuilt by Hooke, under Wren, in 1678–84, and still standing in something close to its rebuilt state, with many interior fittings attributed to Grinling Gibbons, who had a workshop here. Mercifully spared from demolition in 1879, when an Act of Parliament made it the Metropolitan Welsh Church of the City and Diocese of London. Inigo Jones was buried in the chancel of the pre-Great Fire church.

St Benet Sherehog, Sise Lane. Originally built in the late eleventh to early twelfth century, and rebuilt in the fourteenth, at which latter time it came to be commonly known as either St Osyth, Sythe or Sithe, or St Benet and St Sithe. The church was burnt down in the Great Fire of 1666, after which it was not rebuilt, and its parish was merged with that of *St Stephen Walbrook* (although its burial ground remained open until 1853). A Corporation 'Blue Plaque' marks its former site. A 'Museum of London Archaeology Service' monograph describes in detail the findings of recent archaeological excavations at the site (Miles *et al.*, 2008). Benedict or Benet of Nursia was a fifth-century religious reformer and the founder of western Christian monasticism. The suffix 'sherehog' could either come from a founder or benefactor, one Alfwinus Scerehog having been cited in this context; or from 'shere hog', meaning a ram castrated after its first shearing (the church being in the centre of the old wool district). Osyth was beheaded by marauding Danes, and according to legend resurrected herself head in hand, much to the consternation of those about her.

St Benet's Place. Named after *St Benet Gracechurch*.

St Botolph Aldersgate. Originally probably built during the reign of the last Saxon King, Edward III, 'the Confessor', in 1042–66. Undamaged in the Great

Fire of 1666, protected from it by the *City Wall*, but essentially completely rebuilt by Nathaniel Wright in 1788–91, and further modified by J. W. Griffith in the early nineteenth century. The interior contains a memorial to one Anne Packington, dated 1563. Botolph was an abbot in the seventh century. All of the past and present churches dedicated to him around the City are associated with one or other of its gates.

St Botolph Aldgate. Originally probably built in the Saxon period, and rebuilt in the sixteenth century. Undamaged in the Great Fire of 1666, but essentially completely rebuilt by George Dance the Elder in 1741–4, and further modified by J. F. Bentley in 1888–95, and Rodney Tatchell in 1965–6. The interior contains memorials to Thomas Lord Darcy and Sir Nicholas Carew, two Catholics executed by Henry VIII, dating to 1560–70, and to one Robert Dow, dated 1563.

St Botolph Billingsgate, Lower Thames Street. Originally built at least as long ago as 1592, to which year the vestry minutes date, and possibly to around 1181. The church was burnt down in the Great Fire of 1666 and never rebuilt, and the parish was merged with that of *St George Botolph Lane*. Essentially only the former 'upper burying ground' survives above ground level, between Nos 31 and 35 Monument Street. However, excavations in Billingsgate Lorry Park in 1982 brought to light some other remains.

St Botolph Bishopsgate. Originally probably built in the Saxon period, and rebuilt in the sixteenth century. Undamaged in the Great Fire of 1666, but essentially completely rebuilt by George Dance the Elder, Giles Dance, Thomas Dunn and John Townshend, under James Gould, in 1725–8, restored by Cachemaille-Day after the Second World War, and further restored following damage by an IRA bomb blast in 1993. The interior contains a memorial to Sir Paul Pindar, dated 1650.

St Bride, off Fleet Street. Originally built in the sixth century (Bride, or Bridget, was born in Ireland in 453, and went on to become Abbess of Kildare), on a former Roman site, and extended in the ninth, twelfth, thirteenth, fourteenth, and fifteenth. Burnt down in the Great Fire of 1666, and rebuilt by Wren in 1670–75, only to be gutted by incendiary bombing on 29 December 1940, and rebuilt again by Godfrey Allen, in 1955–7 (a photograph taken after the War shows the extent of the damage sustained by the church). The Saxon and Medieval crypts survive, and are home to a fascinating exhibition of the church's long and rich history, and its extraordinary eight incarnations. The church is perhaps best known for its steeple of gracefully diminishing octagons, once memorably described by the

poet W. E. Henley as 'a madrigal in stone', and said to have influenced the design of the modern wedding cake. It also has many important literary and artistic associations, unsurprisingly in view of its proximity to *Fleet Street* and its printing presses, set up by Caxton's apprentice Wynkyn de Worde in around 1500. Pepys, who wrote about it in his diary, was christened here; Dryden, Milton, 'The Compleat Angler' Izaak Walton and Elias Ashmole were one-time parishioners, as were, a little later, Johnson, Boswell, Goldsmith, Pope, Joshua Reynolds and William Hogarth; Lovelace and the 'father of the English novel' Samuel Richardson are buried here, alongside Wynkyn de Worde, who died in 1535.

St Bride's Avenue, Passage, Street. Named after the church of *St Bride*.

St Christopher-le-Stocks, Threadneedle Street. Originally built around 1225, and added to in the sixteenth and early seventeenth centuries. Badly damaged in the Great Fire of 1666, and rebuilt by Wren, using surviving material, in 1669–71, and by Dickinson, in 1711–4, only to be demolished to allow for improvements to the security of the Bank of England after the Gordon Riots, in 1781, when the parish was merged with *St Margaret Lothbury*. Only parish boundary markers survive at its former site. Some salvaged interior fittings survive in *St Margaret Lothbury*, including the bronze head by Hubert le Sueur (who also made the equestrian statue of Charles I at Charing Cross), and the paintings of Moses and Aaron. The salvaged reredos survives in *St Vedast-alias-Foster*, the pulpit in St Nicholas in Canewdon in Essex. A thirteenth-century gravestone, discovered during the rebuilding of the Bank in 1934, can be seen in the Victoria and Albert Museum. Christopher is the patron saint of travellers.

St Clare Street. Takes its name from the Spanish Nuns of the Order of St Clare, who founded a Convent in *Minories* in 1293. Thus also *St Clare Place*.

St Clement Danes, Strand. Originally built in stone at the turn of the eleventh and twelfth centuries, on the site of an even older wooden structure, and rebuilt by Wren in 1677–86, despite having survived the Great Fire of 1666 undamaged, only to be damaged during the Blitz of the Second World War, restored by Anthony Lloyd in 1955–8, and reconsecrated in 1958. Parish boundary markers feature an anchor, Clement having been martyred by being tied to an anchor and thrown overboard from a boat to drown.

St Clement Eastcheap, also known as *St Clement Candlewick Street*, Clement's Lane, off King William Street. Originally built at least as long ago as 1106. Burnt down in the Great Fire of 1666, and rebuilt by Wren in 1683–7. Later

altered by William Butterfield in 1872, and by Ninian Comper in 1932–4. This is probably the St Clements of nursery rhyme fame.

St Clement's Court. Named after the church of *St Clement Eastcheap.*

St Clement's Lane. Named after the church of *St Clement Danes.*

St Dionis Backchurch, corner of Fenchurch Street and Lime Street. Originally built at the turn of the eleventh and twelfth centuries, on the south-eastern corner of the Roman *Basilica and Forum*, using robbed Roman building materials, and added to in the sixteenth and early seventeenth. Burnt down in the Great Fire of 1666, and rebuilt by Wren, in 1670–86, only to be demolished in 1878, when the parish was merged with *All Hallows Lombard Street.* A Corporation 'Blue Plaque' marks its former site. The salvaged communion table, font and pulpit also survive, in the church of St Dionis in Parsons Green. A 'squirt', or fire extinguisher, from the vestry can be seen in the Museum of London. Dionis, or more properly Denys, is the patron saint of France, who was beheaded after attempting to convert Paris to Christianity in the third century. The church on, or rather just off, *Fenchurch Street* dedicated to him became commonly designated 'backchurch'; that dedicated to *St Gabriel*, 'forechurch'.

St Dunstan-in-the-East, also known as *St Dunstan-towards-the-Tower-in-the-East*, St Dunstan's Hill, off Lower Thames Street. Originally built at least as long ago as the twelfth century, high-quality carved stonework of this age and possibly from this site having recently been discovered in nearby *Harp Lane*. Partly burnt down in the Great Fire of 1666, and rebuilt by Wren, in the Gothic style, in 1695–1701, and by David Laing, in the Georgian Perpendicular style, in 1817–21, only to be gutted by bombing in the Blitz of 1940–1. The tower, with its spire supported by almost miraculous flying buttresses, by Wren, still survives. Washington Irving's words could have been written for it: 'Stone seems, by the cunning labour of the chisel, to have been robbed of its weight, suspended as if by magic'. The surrounding ruins were made into a peaceful and beautiful city garden in 1967. Dunstan was Archbishop of Canterbury in the tenth century.

St Dunstan-in-the-West, also known as *St Dunstan-over-against-the-New Temple*, Fleet Street. Originally built at least as long ago as 1170, and possibly even earlier, sometime between the death of Archbishop Dunstan in 988 and the consecration of Archbishop Lanfranc in 1070. Undamaged in the Great Fire of 1666, thanks to the action of forty scholars from Westminster School, under their Dean. Nonetheless, demolished in 1828, then rebuilt by John Shaw Senior and, after his death, his son John Shaw Junior, in 1830–

3, damaged by a bomb in 1944, and rebuilt again in 1950, with financial support from the newspaper magnate Viscount Camrose. The entrance to the vestry incorporates a statue of Elizabeth I dating to 1586, that used to stand on Ludgate until its demolition in 1760. Inside the porch are statues of King Lud and his sons Androgeus and Tenvantius, or Theomantius, that also used to stand on Ludgate, and probably also date to around 1586. The clock, and the wooden aedicule above it containing the figures of two giants, possibly Gog and Magog, used to stand on the gate, too, at least according to most sources, although they are not obvious on any images of it that I have seen, and they date to 1667 or 1671 (again, sources differ). The giants, clad only in loincloths, ring the bells with their clubs each quarter-hour – they are at once a bit 'butch' and the campest of campanologists! The distinctively octagonal interior of the church, impressionistically dappled with colour from the stained glass windows, contains a number of sixteenth- and seventeenth-century memorials. It is presently home to not only an Anglican congregation but also a Romanian Orthodox one, and the altar screen is from a monastery in Bucharest.

St Dunstan's Court. Named after the church of *St Dunstan-in-the-West.*

St Dunstan's Lane (first recorded in 1329). Named after the church of *St Dunstan-in-the-East.* Thus also *St Dunstan's Alley* and *St Dunstan's Hill.*

St Edmund the King, also known as *St Edmund the King and Martyr*, Lombard Street. Originally built at least as long ago as 1157, possibly on the site of an even older Norman or Saxon church destroyed by a fire in 1135 (King Edmund of East Anglia was murdered by the Danes in 870 for refusing to renounce his Christian faith, the Abbey of Bury St Edmund's being built at his burial site). Burnt down in the Great Fire of 1666, and rebuilt by Wren and Hooke between 1670–9 and 1706–7, and restored by William Butterworth in 1864, only to be damaged by bombing during the Second World War, and rebuilt again by Rodney Tatchell in 1955–7. This was one of the few City churches to have been damaged by bombing during the First as well as the Second World War, suffering a direct hit on 7 July 1917. Fragments of the bomb from that former time are preserved in a display commissioned to mark the public launch of the church as The London Centre for Spirituality on 21 September 2003.

St Ethelburga, also known as *St Ethelburga the Virgin*, Bishopsgate. Originally built in around 1250, possibly on the site of an even older, Saxon, church, and extended in 1390, and again in the fifteenth and sixteenth centuries. Undamaged in the Great Fire of 1666, although nonetheless restored in 1861–

2, and again, by Ninian Comper, in 1912, only to be severely damaged by an IRA bomb on 24 April 1993, and substantially rebuilt by Purcell Miller Tritton, and reopened as a Centre for Peace and Reconciliation, focussing on the role of faith in conflict resolution, in 2002. The west front was rebuilt using stone from the Medieval church, the doorway along the lines of the fourteenth-century one, and the three-light window along the lines of the Early Gothic fifteenth-century one. 'The Tent' and 'Peace Garden' at the back were built at the same time, to encourage inter-faith dialogue. Ethelburga was the sister of the seventh-century Saxon Bishop Erkenwald (see *Bishopsgate*).

St Etheldreda, Ely Place. Originally built as the private chapel of the Bishops of Ely in around 1293, pressed into service as an Anglican church after the Reformation, and 'restored to the old faith' in 1874. Undamaged in the Great Fire of 1666, although somewhat modified subsequently. The interior contains a number of memorials to Catholic martyrs, including John Houghton, Prior of *Charterhouse*, who was hanged at Tyburn in 1535 for challenging King Henry VIII's supremacy over the Church. The exterior is a rare, restrained and fine surviving example of the Decorated Gothic style of ecclesiastical architecture. The church is easily overlooked on account of its tucked-away location (and small size). Etheldreda was the Abbess of Ely in the seventh century.

St Faith under St Paul's. Rebuilt in the western end of the crypt of *St Paul's* in 1255–6, when the cathedral was extended, the church was burnt down in the Great Fire of 1666 and not rebuilt again afterwards, and the parish was merged with that of *St Augustine Watling Street*. Essentially only a parish boundary marker survives, on the wall of the Choir School in New Change (although a pump 'erected by St Faith's Parish 1819' also still stands, in *St Paul's Alley*). Faith was martyred in France in the third century.

St Gabriel Fenchurch, Fenchurch Street. Originally built around 1315, the church was burnt down in the Great Fire of 1666 and never rebuilt, and the parish was merged with that of *St Margaret Pattens*. A Corporation 'Blue Plaque' marks its former site.

St George Botolph Lane. Originally built around 1180. Burnt down in the Great Fire of 1666, and rebuilt by Wren in 1671–6, using material from the old *St Paul's*, only to be allowed to fall into disrepair, and eventually to be declared an unsafe structure, and demolished, in 1904, when the parish was merged with *St Mary-at-Hill*. Essentially nothing now remains of the church at its former site, other than the name, which lives on in that of *St George's Lane*, and parish boundary markers in *Botolph Alley* and on *Pudding Lane*. Two seventeenth-century chairs salvaged from the church survive, in *St Margaret*

Pattens. George is the patron saint of England. Surprisingly, this was the only church in the City of London ever dedicated to him.

St George the Martyr, Borough High Street, Southwark. Originally built around 1122, shortly after the Battle of Acre, when the myth of St George became adopted by English crusaders, and rebuilt in the fourteenth century, and again, by John Price, in 1734–6, in the Classical style. The surviving part of the wall of the second, nineteenth-century Marshalsea prison, where Dickens's father was incarcerated for debt, forms the northern boundary of the churchyard.

St George's Lane. Named after the church of *St George Botolph Lane*.

St Giles Circus. Takes its name from the church of *St Giles in the Fields*. Thus also *St Giles High Street*.

St Giles Cripplegate, Fore Street. Originally built in around 1100, possibly on the site of an even older, Saxon, church, and rebuilt in 1390, and again in 1545. Undamaged by the Great Fire of 1666, although nonetheless requiring to be restored in 1682–4, when the top stage of the tower was added, only to be severely damaged by bombing on 24/25 August and 29 December 1940, and substantially rebuilt by Godfrey Allen in 1960. The walls are in part original, fourteenth-century. The church was the site of Oliver Cromwell's wedding, and of John Milton's burial. There is also a memorial here to the sixteenth-century explorer Martin Frobisher. Giles is the patron saint of cripples, indigents and social outcasts.

St Giles in the Fields, St Giles High Street. First recorded as *Hospitali Sancti Egidii extra Londinium*, or the 'hospital of St Giles outside London', a leper colony, in around 1101. The present church was built by Henry Flitcroft in 1734.

St Gregory by St Paul's. Originally built in around 1010, rebuilt after the Fire of 1087, and further restored in 1631–2 and, by Inigo Jones, in 1641. The church was burnt down in the Great Fire of 1666 and not rebuilt again afterwards, and the parish was merged with that of *St Mary Magdalen Old Fish Street*. Essentially nothing now remains of it at its former site (although there are church records in the *Guildhall* Library). The site is now occupied by the statue of Queen Anne in front of *St Paul's*.

St Helen, Great St Helens, off Bishopsgate. The original parish church dates back to the eleventh century, possibly around 1010. The later Benedictine nunnery, built immediately alongside and giving rise to an unusual double

nave, dates to around 1204, and the still later embellishments to the fifteenth, sixteenth and seventeenth centuries. Undamaged by the Great Fire of 1666, although nonetheless requiring to be restored in 1893, only to be damaged by IRA bombs in 1992 and 1993, and restored again by Quinlan Terry in 1993–5. The church is dubbed 'The Westminster Abbey of the City' because of the beauty of its interior. The two chancels date to the early fourteenth century (west) and early fifteenth (east); the arcade separating the two naves to the late fifteenth. The pulpit dates to 1633, the poor-box on a wooden figure of a beggar also to the early seventeenth century. The alabaster effigies of Sir John de Oteswich and his wife, salvaged from the church of *St Martin Outwich*, date to the fourteenth century, and numerous other monuments to the fifteenth to seventeenth, including that of Sir John Crosby (*d.* 1476), Sir Thomas Gresham (*d.* 1579), and Martin Bond (*d.* 1643), in his Civil War uniform. The exterior is substantially surviving thirteenth- to sixteenth-century. The right doorway, to the former parish church, is fourteenth-century; the left one, to the former nunnery, sixteenth-century. Helen was the mother of the first Christian Roman Emperor, Constantine.

St Helen's Place. Named after the church of *St Helen*.

St James Duke's Place. Originally built in 1622, on land that before the Dissolution used to belong to *Holy Trinity Priory*. Undamaged in the Great Fire of 1666, but fell into disrepair and had to be rebuilt in 1727, only to be demolished in 1874, when the parish was merged with *St Katharine Cree*. Essentially nothing now remains of the church at its former site, other than the name, which lives on in that of *St James's Passage*, and some parish boundary markers in *Creechurch Lane* and in *St Katharine Cree* churchyard in *Mitre Street*. Some memorial plaques salvaged from the church survive in *St Katharine Cree*.

St James Garlickhythe, Garlick Hill, off Upper Thames Street. Originally built in around 1170, and rebuilt in the fourteenth century. Burnt down in the Great Fire of 1666, and rebuilt by Wren between 1676–82 and 1714–17, only to be damaged by bombing in the First World War, and narrowly escaping total destruction in the Second, when a 500-lb bomb landed in the south-east corner but failed to explode, after which it was rebuilt again by D. Lockhart-Smith and Alexander Gale in 1954–63. It was also damaged by and repaired after a freak accident involving a falling crane in 1991. The church registers date back to 1535, and are the oldest in England. The recurring stylised scallop motif, for example on the clock above the doorway, dated 1682, and on the parish boundary markers, is an allusion to the sea-shells carried by pilgrims to Compostella in Spain, where St James's bones were miraculously

discovered some 800 years after his death (the church being the customary point of departure for pilgrims leaving from London). Some of the interior fittings were salvaged from *St Michael Queenhithe*, including the fine carved pulpit (with wig-peg), the choir stalls, and a wrought-iron sword-rest. The church is popularly known as 'Wren's lantern' on account of the illumination from the clerestory windows, which are characteristically barren of stained glass.

St James's Passage. Named after the church of *St James Dukes Place.*

St John the Baptist, also known as *St John the Baptist upon Walbrook*, Cloak Lane. Originally built around 1150, rebuilt in 1412, and repaired in 1621 and again in 1649–50. The church was burnt down in the Great Fire of 1666 and not rebuilt again afterwards, and the parish was merged with that of *St Antholin Budge Row*. A tiny portion of the churchyard survives, in *Cloak Lane*, together with a commemorative plaque put up in 1671. Some parish boundary markers also survive.

St John Friday Street, also known as *St John the Evangelist Friday Street*. Originally built in the mid-thirteenth century, and repaired in 1626. The church was burnt down in the Great Fire of 1666 and not rebuilt afterwards, and the parish was merged with that of *All Hallows Bread Street*. A Corporation 'Blue Plaque' marks its former site. A 'Museum of London Archaeology Service' archaeology study describes in detail the findings from archaeological excavations of the early Medieval (late eleventh- to fourteenth-century) church, which evidently up until the middle of the fourteenth century was known as St Werburga, Werburge or Wereburga, after an eighth-century Mercian princess and Abbess of Ely (Elsden, 2002).

St John Street (indicated on map of 1520 as *Seynt Johns Strete*). Named after the Order of the Hospital of St John of Jerusalem, who founded their London base here in 1145. Thus also *St John's Lane and Square.*

St John Zachary, Gresham Street. Originally built in around 1120, and enlarged in the early seventeenth, the church was burnt down in the Great Fire of 1666 and never rebuilt, and its parish was merged with that of *St Anne and St Agnes*. The former churchyard survives, as a city garden provided by the Goldsmiths' Company, and a Corporation 'Blue Plaque' marks the former site of the church.

St Katharine Cree, Leadenhall Street. Originally built in the grounds of *Holy Trinity Priory* in around 1280, and rebuilt in 1500–4, and again in 1628–31.

Undamaged by the Great Fire of 1666, although later requiring restoration by R. P. Notley in 1878–9, and again, after being damaged by bombing in the Blitz of the Second World War, by Marshall Sisson in 1956–62. The tower dates to around 1500 (although the cupola is eighteenth-century), and the gateway to the churchyard, on *Mitre Street*, by William Avenon, to 1631. The interior contains some Late Gothic elements, such as the east window, in the form of an elaborately stylised Katharine Wheel, and the intricately ribbed ceiling; and some Neoclassical ones, such as the Corinthian columns in the nave. It also contains monuments to Sir Nicholas Throckmorton, Throkmorton or Throgmorton (*d.* 1570) and Bartholomew Ellnor (*d.* 1636), and a marble font of around 1631; and some memorial plaques and a reredos salvaged from *St James Duke's Place*. The church is the home of the 'Lion Sermons', given on 16 October of every year in remembrance of the former Lord Mayor Sir John Gayer being spared by a lion in Syria in 1643. It also has strong connections from that same Civil War period with the Royalist cause. It was consecrated by Archbishop Laud, who went on to be executed in 1645 for his close association with Charles I, his persecution of Puritans, and his High Church views. It even contains a wooden statue of the former king in the nave.

St Katharine's Way (indicated on map of 1520 as *St Catheryn's Laen*). Takes its name from the Hospital of St Katharine, originally founded in 1148.

St Katherine Coleman, off Fenchurch Street. Originally built around 1346, restored in 1489, and extended in 1624. Undamaged in the Great Fire of 1666, but rebuilt by James Horne in 1739–40, in the 'Vernacular Palladian' style, only to be demolished in 1925, when the parish was merged with *St Olave Hart Street*. Part of the former churchyard survives, and a Corporation 'Blue Plaque' marks the former site of the church.

St Katherine's Row. Named after the church of *St Katherine Coleman*.

St Laurence Pountney, Laurence Pountney Lane. Originally built around 1275, the church was burnt down in the Great Fire of 1666 and never rebuilt, and the parish was merged with that of *St Mary Abchurch*. The church ground and churchyard survive, and a Corporation 'Blue Plaque' marks the former site of the church.

St Lawrence Jewry, Gresham Street. Originally built in the twelfth century. Burnt down in the Great Fire of 1666, and rebuilt by Wren in 1670–87, only to be gutted by incendiary bombing on 29 December 1940, and rebuilt again by Cecil Brown in 1954–7 (photographs taken before and after the war clearly show the extent of the bomb damage sustained by the church). A 'Museum

of London Archaeology Service' monograph deals with the finds from the church (Bowsher *et al.*, 2007). The font of 1620 was salvaged from *Holy Trinity Minories*. The weathervane in the shape of a grid-iron honours the story that Saint Lawrence was put to death in 258 by being roasted alive on one such. The so-called 'Spital Sermons', originally given in the priory church of *St Mary Spital*, are currently given in St Lawrence Jewry, on or around the second Wednesday after Easter, and are attended by the Lord Mayor, the Courts of Common Council and of Aldermen, and other civic dignitaries.

St Leonard Eastcheap. Originally built around 1214, partially rebuilt in 1584, and completely rebuilt after the Fire of 1618, the church was then burnt down in the Great Fire of 1666 and not rebuilt again afterwards, and the parish was merged with that of *St Benet Gracechurch*. A Corporation 'Blue Plaque' marks its former site.

St Leonard Foster Lane. Originally built around 1278, and enlarged in the sixteenth century (following the demolition of the nearby Collegiate Church of St Martin in 1548), the church burnt down in the Great Fire of 1666 and was never rebuilt, and the parish was merged with that of *Christ Church Newgate Street*. A Corporation 'Blue Plaque' marks its former site. A St Leonard's communion cup of 1616 is now in *St Sepulchre* on Holborn Viaduct.

St Magnus the Martyr, Lower Thames Street. Originally built around 1067. Burnt down in the Great Fire of 1666, and rebuilt by Wren in 1671–87, although much modified, possibly by Dance The Elder, in 1762–8, and subsequently sympathetically restored by Martin Travers in 1924–5. Miles Coverdale, who was church rector here in the sixteenth century, and who, with William Tyndale, published the first English Bible, is buried here.

St Margaret Fish Street Hill, also known as *St Margaret New Fish Street Hill*. Originally built in the twelfth century, the church burnt down in the Great Fire of 1666 and was never rebuilt, and the parish was merged with that of *St Magnus the Martyr*. A Corporation 'Blue Plaque' marks its former site, which is where the *Monument* (to the Great Fire) now stands (the church was the closest to the seat of the fire in *Pudding Lane*). There is also a parish boundary marker on the tower of *St Magnus the Martyr*.

St Margaret Lothbury. Originally built at least as long ago as 1181, and rebuilt in the fifteenth century. Burnt down in the Great Fire of 1666, and rebuilt again by Wren in 1683–92 and by Hooke in 1698–1700. The Wren-period chancel screen, tester and candelabra were salvaged from *All Hallows the Great*, the bronze head by Hubert le Sueur, and the paintings of Moses

and Aaron, dating to around 1700, from *St Christopher-le-Stocks*, and the font, from the workshop of Grinling Gibbons, and the reredos from *St Olave Jewry*. Margaret was martyred in the fourth century. Legend has it that she was then swallowed by a dragon, and regurgitated because she was wearing a cross. She is often depicted with a dragon.

St Margaret Moses, Friday Street. Originally built in the twelfth century, the church burnt down in the Great Fire of 1666 and was never rebuilt, and the parish was merged with that of *St Mildred Bread Street*. Essentially nothing now remains of the church on its former site. A silver dish given to the church in 1631 is now in the Museum of London.

St Margaret Pattens, Eastcheap. Originally built in the twelfth century, and rebuilt in 1538. Burnt down in the Great Fire of 1666, and rebuilt again by Wren in 1684–7, and further modified by the Victorians in 1880, only to be damaged by bombing in the Blitz of the Second World War, and having to be rebuilt yet again in the 1950s. The very fine tondo in the interior is attributed to the fifteenth-century Italian sculptor Della Robbia. Two seventeenth-century chairs were salvaged from *St George Botolph Lane*.

St Martin in the Fields, Trafalgar Square. Originally built at least as long ago as the twelfth century, and rebuilt in the sixteenth, around 1544. Also recorded as *St Martin by les Mewes*, meaning the mews where the royal falcons were housed, in the fifteenth. The present structure, by James Gibb, dates to 1721–6. Charles II's mistress Nell Gwyn or Gwynn or Gwynne (1650–87) was buried here. Martin was a soldier who converted to Christianity in the fourth century. He is known for sharing his cloak with a beggar, an act commemorated on the lamp-posts around the church.

St Martin Ludgate, Ludgate Hill. Originally built at least as long ago as 1138 (Geoffrey of Monmouth claimed that it was founded in the seventh century, and St Martin died in the fourth), and rebuilt in 1437. Burnt down in the Great Fire of 1666, and rebuilt by Wren and Hooke in 1677–86, and restored in 1894, only to be damaged by bombing in 1942, and restored again in the post-war period, and yet again in 1990. The west wall is part of the Medieval *City Wall*. Some of the interior fittings were salvaged from *St Mary Magdalen Old Fish Street*, including a plaque of 1586, and a sword-rest. William Penn Senior, the father of William Penn Junior, who founded Pennsylvania, was married in St Martin in 1643.

St Martin Orgar, Martin Lane. Originally built in the twelfth century, and added to in the fifteenth, the church was badly damaged in the Great Fire of 1666, and never rebuilt, and the parish was merged with that of *St Clement*

Eastcheap. Even in its damaged state, the church continued to be used, by French Protestant Huguenots, until it became unsafe and had to be pulled down in the 1820s. A Corporation 'Blue Plaque' marks its former site. The nearby red-brick tower was built in 1851–2.

St Martin Outwich, Threadneedle Street and Bishopsgate. Originally built around 1400. Undamaged in the Great Fire of 1666, but severely damaged in a fire of 1765, and rebuilt by Samuel P. Cockerell in 1796–8, only to be demolished in 1874 when the parish was merged with *St Helen*. A Corporation 'Blue Plaque' marks its former site. Salvaged alabaster effigies of the church founder Sir John de Otewsich and his wife also survive, in *St Helen*.

St Martin Pomary, Ironmonger Lane. Rebuilt in 1627, the church was burnt down in the Great Fire of 1666, and not rebuilt again afterwards, and the parish was merged with that of *St Olave Jewry*. Only the former graveyard survives, in the open space in front of *St Olave*, together with some parish boundary markers.

St Martin Vintry, College Hill/Upper Thames Street. Rebuilt by the executors of the wealthy wine-merchant Sir Matthew de Columbars in 1299, and added to in the fifteenth century, the church was burnt down in the Great Fire of 1666 and not rebuilt again afterwards, and the parish was merged with that of *St Michael Paternoster Royal*. The site of the former churchyard is now occupied by Whittington Garden.

St Martin's Lane. Takes its name from the church of *St Martin in the Fields*.

St Martin's-le-Grand (first recorded in 1265, and indicated on map of 1520 as *St Martin le Grand*). Named after the Benedictine monastery dedicated to St Martin founded here, as long ago as the eleventh century, by the brothers Ingelric and Girard, and dissolved and demolished in the sixteenth, the crypt coming to light again during redevelopment in the nineteenth.

St Mary Abchurch, Abchurch Lane, off King William Street. Originally built in the twelfth century, and added to in the fourteenth. Burnt down in the Great Fire of 1666, and rebuilt by Wren in 1681–7, only to be badly damaged by bombing in 1940, and rebuilt again by Godfrey Allen, W. Hoyle and E. W. Tristram in 1945–57. The interior is a surprise and a delight, described by Betjeman as 'both uplifting and intimate', with 'three levels of attraction: ground and eye level ... ; wall level ... ; and roof level'. The reredos by Grinling Gibbons, dating from 1686, was blown into 2,000 pieces during the Blitz, and took five years to meticulously reassemble, in 1948–53.

St Mary Aldermanbury, also known as *St Mary the Virgin, Aldermanbury*. Originally built around 1181, and added to in 1438. Burnt down in the Great Fire of 1666, and rebuilt by Wren in 1671–5, and further modified in the late eighteenth and early nineteenth centuries, only to be substantially destroyed by incendiary bombing on 29 December 1940, after which the parish was eventually merged with *St Vedast-alias-Foster*. A photograph of the bombed church taken in 1941 still survives. Only the foundations remain at the site today, together with a city garden created in 1966. Much of the building material salvaged from the church survives, in the remarkable reconstruction, true to Wren's design, in Fulton, Missouri!

St Mary Aldermary, Queen Victoria Street. Originally built at least as long ago as 1080, and rebuilt in 1510–28, and again in the early seventeenth century. Substantially burnt down in the Great Fire in 1666, and rebuilt yet again by Wren between 1679–82 and 1701, in the Perpendicular Gothic style, although significantly modified in 1876–7. Wren was evidently able to incorporate some parts of the Medieval church that had survived the Great Fire into his rebuild, notably parts of the tower. Some of the interior fittings were salvaged from *St Antholin*. The fan-vaulted ceiling is very fine.

(Church of) *St Mary-at-Hill*, Lovat Lane, between Eastcheap and Lower Thames Street. Originally built in around 1177, and partly rebuilt in 1487–1504. Substantially burnt down in the Great Fire of 1666, and rebuilt by Wren in 1670–4, although much modified subsequently, in 1780, in the early nineteenth century, in the late 1960s, and again, following another fire, in 1988. Wren was evidently able to incorporate some parts of the Medieval church that had survived the Great Fire into his rebuild, most obviously the north wall. It has even been suggested that his overall plan for the church, which is essentially in the form of a Byzantine 'quincunx', may have been based on that of the Medieval one.

St Mary-at-Hill (first recorded in 1275, and indicated on map of 1520 as *Saint Mary Hill Lane*). Takes its name from the church of *St Mary-at-Hill*, the suffix alluding to the moderately steep climb up from the nearby river-front.

(Church of) *St Mary Axe*. Built around 1197, and demolished in the sixteenth century, when the former parish was amalgamated with that of *St Andrew Undershaft*. St Mary's formerly housed one of the three axes said to have been used by Attila the Hun to behead St Ursula and her 11,000 hand-maidens.

St Mary Axe (first recorded in 1275, and indicated on map of 1520 as *S. Marie Streete*). Named after the church of *St Mary Axe*.

St Mary Bothaw, also known as *St Mary Botolph*, Cannon Street. Originally built in the twelfth century, the church was burnt down in the Great Fire of 1666 and never rebuilt, and the parish was merged with that of *St Swithin London Stone*. Only parish boundary markers survive at its former site (although there are also extensive records dating back to 1536 in the *Guildhall Library*).

St Mary Colechurch, on *Poultry*. Originally built in the twelfth century, the church was burnt down in the Great Fire of 1666 and never rebuilt, and the parish was merged with that of *St Mildred*, *Poultry*. A Corporation 'Blue Plaque' marks its former site.

St Mary Coneyhope, off *Poultry*. Probably originally built in the 1150s or 1160s, possibly by one Wlwardus de Cuninghop, and in use by the Fraternity of Corpus Christi by the fourteenth century. Shown as a small chapel at the junction of Conyhope Lane and *le Pultrye* on the map of 1520, but not shown on the Hogenberg Map of 1553–9, the Braun & Hogenberg Map of 1572, or the 'Agas' Map of 1561–70. Apparently, after the Dissolution of the Monasteries, it was sold off to a haberdasher for use as a warehouse!

St Mary Graces, East Smithfield. A Cistercian Abbey founded in 1349, dissolved in 1539, and demolished in 1598 by Arthur Darcie, who 'in place thereof … built a storehouse for victuals; and convenient ovens for baking of biscuites to serve Her Majesty's ships' (Stow). 'Museum of London Archaeology Service' monographs describe in detail the findings of archaeological excavations at the site, and the associated 'Black Death' burial ground of the Holy Trinity Chapel (Grainger *et al.*, 2008; Grainger & Phillpotts, 2011).

St Mary-le-Bow, also known as *Bow Church*, Cheapside. Originally built in around 1077–87 by the Norman King William I's Archbishop of Canterbury, one Lanfranc (possibly on the site of an even older, Saxon, church); and rebuilt following damage by a tornado (!) in 1091, following a fire in 1196, and following a partial collapse in 1271 (Byrne & Bush, 2007). Burnt down in the Great Fire of 1666, and rebuilt again by Wren in 1670–83, only to be gutted by bombing on 10 May 1941, and rebuilt yet again by Lawrence King in 1956–64 (photographs taken before and after the War clearly show the extent of the bomb damage sustained by the church). The famous bells, used to sound the nine o'clock 'curfew' in the Medieval era, were destroyed during the bombing (only those born within earshot of the bells can truly call themselves 'Cockneys'). The eleventh-century crypt survives. The wonderful 9-foot-long copper weathervane made by Robert Bird in 1679 in the form of a flying dragon is worthy of note. The iron balcony facing

Cheapside is said to echo the former grand-stand built nearby by Edward III, as a vantage point from which to view jousts taking place on the tilt-yard in Crown Fields.

St Mary-le-Strand, Strand. Built by James Gibbs in 1714–17, on the site of the Church of the Nativity of Our Lady and the Innocents, in turn built in 1147, and demolished in 1549 to make way for *Somerset House*.

St Mary Mounthaw, Fish Street Hill/Upper Thames Street. Originally built around 1275, the church was burnt down in the Great Fire of 1666, and never rebuilt, and the parish was merged with that of *St Mary Somerset*. Nothing remains of the church today, the last vestige, the churchyard, having been lost during the construction of Queen Victoria Street.

St Mary Overie see *Southwark Cathedral.*

St Mary Somerset, Upper Thames Street. Originally built in around 1150–70. Burnt down in the Great Fire of 1666, and rebuilt by Wren in 1685–95, only to be substantially demolished in 1869 or 1871 (sources differ), when the parish was merged with *St Nicholas Cole Abbey*. The south-west tower survives, thanks to the intervention of the Gothic Revival architect Ewan Christian, as does a 'brave little garden on the N. side where the traffic thunders into the tunnel under *Peter's Hill*' (Bradley & Pevsner). The salvaged altar, font, pulpit and bell also survive, in the church of St Mary Britannia Street in *Hoxton*.

St Mary Spital, also known as the *New Hospital of St Mary-without-Bishopsgate*, Spital Square. Founded in 1197 on the site of a former Roman cemetery, dissolved in 1538, and demolished around 1700. A 'Museum of London Archaeology Service' monograph describes in detail the findings of archaeological excavations at the site, uncovered in 1999 (Thomas *et al.*, 1997). The excavated crypt-cum-charnel house is on view beneath a reinforced glass pavement in the Bishop's Square office complex (the bodies formerly laid to rest here having been relocated). The so-called 'Spital Sermons', originally given in St Mary Spital, are currently given in *St Lawrence Jewry*.

St Mary Staining, Oat Lane. Originally built around 1189, the church was burnt down in the Great Fire of 1666, and never rebuilt, and the parish was merged with that of *St Michael Wood Street*. The former churchyard survives.

St Mary Woolchurch Haw, also known as *St Mary-at-Stocks*, Mansion House Square. Originally built in the eleventh century, and rebuilt in 1442, the church was burnt down in the Great Fire of 1666, and not rebuilt again afterwards,

and the parish was merged with that of *St Mary Woolnoth*. A Corporation 'Blue Plaque' marks its former site.

St Mary Woolnoth, corner of Lombard Street and King William Street. Originally built at least as long ago as 1191, and rebuilt in 1438. Burnt down in the Great Fire of 1666, rebuilt by Sir Robert Vyner in 1670–5, in the Modern Gothic style, and rebuilt again by Wren's brilliant pupil and later successor Nicholas Hawksmoor in 1716–27, in the Later (English) Baroque style (and restored by William Butterfield in 1875–6, and again in the 1990s). If Wren's style was about gracefulness and lightness, Hawksmoor's was about geometry and solidity, although in such perfect balance as to be equally aesthetically pleasing, and arguably even more expressive (as Bradley & Pevsner put it, 'the effect is of powerful forces firmly held in check').

Hawksmoor's other London churches are the equally impressive, yet individually distinct, Christ Church Spitalfields, St Alphege Greenwich, St Anne Limehouse, St George Bloomsbury and St George-in-the-East. He was also responsible for the west towers of *Westminster Abbey*, and partly responsible for St Luke Old Street, with its striking, obelisk-like spire, and for St John Horsleydown, just off *Tooley Street*. The last-named was substantially destroyed during, or demolished after, the Blitz of the Second World War, and the surviving parts were subsequently incorporated into the London City Mission. A photograph of the bombed church taken in 1940 still survives. It shows a spire in the form of a fluted Ionic column similar to that of St Luke Old Street, topped by a weathervane supposed to be shaped like a comet, but in actuality more like a louse.

St Mary Magdalen Milk Street. Originally built in 1162, the church was burnt down in the Great Fire of 1666, and never rebuilt, and the parish was merged with that of *St Lawrence Jewry*. Only parish boundary markers survive at its former site (actually, on *Cheapside*).

St Mary Magdalen Old Fish Street, Knightrider Street. Originally built around 1181. Burnt down in the Great Fire of 1666, and rebuilt by Wren in 1683–7, only to be substantially destroyed by another fire in 1886, and subsequently demolished in 1893, when the parish was merged with *St Martin Ludgate*. Essentially nothing now remains of the church at its former site. Some salvaged interior fittings survive in *St Martin Ludgate*, including a plaque of 1586 honouring a benefactor, believed to be Thomas Beri or Berrie. The salvaged font survives in *All Hallows-on-the-Wall*.

St Matthew Friday Street. Originally built around 1261, the church was burnt down in the Great Fire of 1666, and rebuilt by Wren in 1682–5, only to be

demolished in 1886, when the parish was merged with *St Vedast-alias-Foster*. Only some parish boundary markers survive at its former site. Some salvaged interior fittings also survive, in *St Andrew-by-the-Wardrobe* and *St Vedast-alias-Foster*. Sir Hugh Myddelton (1555–1631), one of the architects of the 'New River', was buried in St Matthew's, where he had served as a warden. Concerted attempts to locate his coffin and monument following the church's demolition were ultimately unsuccessful.

St Michael Bassishaw, Basinghall Street. Originally built around 1141, and rebuilt in the fifteenth century. Burnt down in the Great Fire of 1666, and rebuilt by Wren in 1676–9, only to be fall into disrepair, and to be declared an unsafe structure in 1892, and demolished in 1900 when the parish was merged with *St Lawrence Jewry*. A Corporation 'Blue Plaque' marks its former site of the church. The weathervane salvaged from the church still survives, atop *St Andrew-by-the-Wardrobe*. An early nineteenth-century painting of the church by William Pearson also survives, in the *Guildhall* Art Gallery. A 'Museum of London Archaeology Service' monograph deals with the finds from the church (Bowsher *et al.*, 2007).

St Michael Cornhill. Originally built in the Saxon period, on the site of the Roman *Basilica and Forum*. Burnt down in the Great Fire of 1666, and rebuilt by Wren's office in 1669–72, in the Classical style, although much modified subsequently, especially by Hawksmoor in 1715–24, when the tower was rebuilt, in the Gothic style, and by Sir George Gilbert Scott in 1857–60, when further additions were made, in the Victorian Gothic style (and also following damage by an IRA bomb in 1993). The interior contains a memorial to John Vernon (*d.* 1615), remade after the Great Fire, and one to Sir William Cowper (*d.* 1664). The octagonal font dates to 1672, and the Renatus Harris organ to 1684.

St Michael Crooked Lane, off King Wiliam Street. Originally built around 1270, and much added to in the fourteenth century. Burnt down in the Great Fire of 1666, and rebuilt by Wren, or Hooke, in 1684–98, only to be demolished in 1831 to allow for widening of the approach to the rebuilt *London Bridge*, when the parish was merged with *St Magnus the Martyr*. Essentially nothing now remains of the church on its former site, although there is a parish boundary marker on the tower of *St Magnus the Martyr*. The so-called 'Falstaff' Cup of 1590 was salvaged from St Michael's, and still survives, in the Treasury of *St Paul's*. According to legend, this is the cup on which, in the 'Boar's Head' Tavern (where St Michael's held its vestry meetings), Sir John Falstaff swore to wed Mistress Quickly. A fine painting of St Michael's in 1830/1, by George Scharf, also survives, a reproduction of which was used by both Huelin and Jeffery on the covers of their books. Another, by Canaletto, hangs in the *Guildhall* Art Gallery.

St Michael-le-Querne, also known as *St Michael at Corn*, Cheapside/ Paternoster Row. Originally built around 1181, the church was burnt down in the Great Fire of 1666 and never rebuilt, and the parish was merged with that of *St Vedast-alias-Foster*. Essentially only a parish boundary marker survives, on the wall of the Choir School in New Change.

St Michael Paternoster Royal, College Hill/Upper Thames Street. Originally built around 1100, and rebuilt by four-times Lord Mayor of London Dick Whittington, whose house was next-door, in 1409. Burnt down in the Great Fire of 1666, rebuilt by Wren in 1685–94, and modified in 1713–7, when the steeple was added, and again in the nineteenth century, only to be damaged by bombing in 1944, and rebuilt again, by Elidir Davies, in 1966–8. Many of the interior fittings were salvaged from *All Hallows the Great*, including the statues of Moses and Aaron flanking the reredos, the carved figure of Charity on the lectern, and the brass chandelier. The stained-glass window in the south-west of the nave depicts Dick Whittington and his cat, and the streets of London paved with gold.

St Michael Queenhithe, Upper Thames Street. Originally built in the twelfth century. Burnt down in the Great Fire of 1666, and rebuilt by Wren in 1676– 86, only to be demolished in 1876, when the parish was merged with *St James Garlickhythe*. Essentially nothing now remains of the church on its former site, although there is a parish boundary marker in *Little Trinity Lane*. The choir stalls and pulpit salvaged from the church still survive, in *St James*, and the weathervane in the shape of a ship, on top of *St Nicholas Cole Abbey*. The font also survives, in the church of St Michael in Camden Town.

St Michael Wood Street. Originally built around 1170. Burnt down in the Great Fire of 1666, and rebuilt by Wren in 1670–5, and further modified, unsympathetically, in 1887–8, only to be demolished in 1897, when the parish was merged with *St Alban Wood Street*. Essentially nothing now remains of the church on its former site, although salvaged paintings of Moses and Aaron survive in *St Anne and St Agnes*.

St Michael's Alley. Named after the church of *St Michael Cornhill*.

St Mildred Bread Street. Originally built around 1252. Badly damaged in the Great Fire of 1666, and rebuilt, using some of the surviving structure, by Wren in 1681–7, only to be substantially destroyed during an air raid, and subsequently demolished, in 1941 (a photograph of the bombed church taken in 1942 still survives). Percy Bysshe Shelley and Mary Wollstonecraft were married in the church in 1816. Only a parish boundary marker survives at its

former site (actually, on *Cannon Street*). Many of the interior fittings salvaged from the church still survive, in *St Anne and St Agnes*.

St Mildred Poultry. Originally built at least as long ago as the twelfth century, around 1175, and possibly even of Saxon origin, bearing in mind that Mildred or Mildthryth, the daughter of one saint, the sister of two, and one herself, was born in Mercia, in 694. Burnt down in the Great Fire of 1666, and rebuilt by Wren in 1671-4, only to be demolished in 1872, when the parish was merged with *St Olave Jewry*. The weathervane in the shape of a ship salvaged from St Mildred still survives, on top of *St Olave Jewry*. Some salvaged furniture also survives, in the church of St Paul in *Goswell Road*. A Corporation 'Blue Plaque' marks the former site of St Mildred.

St Mildred's Court. Takes its present name from the church of *St Mildred Poultry*. Took its former name of Scalding Alley or Wike from the poulterers' scalding houses that once stood here in Medieval times (scalding softened the skins of chickens and made it easier to pluck them, apparently).

St Nicholas Acon, Nicholas Lane. Originally built at least as long ago as 1084, and possibly even in the Saxon rather than the Norman period, the church was burnt down in the Great Fire of 1666, and never rebuilt, and the parish was merged with that of *St Edmund the King*. A Corporation 'Blue Plaque' marks the former site of its parsonage. 'St NA' is also inscribed on a fire plug at the foot of a building opposite *Nicholas Passage*. The suffix 'Acon' is thought to be in honour of Haakon, a Danish benefactor.

St Nicholas Cole Abbey, also known as *Cole Abbey Presbyterian Church* or *St Nicholas West Fishmarket*, Queen Victoria Street. Originally built in around 1130. Burnt down in the Great Fire of 1666, and rebuilt by Wren in 1671-81, and modified in 1873, and again in 1928-31, only to be gutted by bombing in 1941, and rebuilt again, by Arthur Bailey, in 1961-2. The leaded hexagonal spire inset with porthole-like windows is a most distinctive feature of the City skyline, especially when seen from the South Bank. The topping weathervane in the shape of a ship was salvaged from *St Michael Queenhithe*. Nicholas lived in Asia Minor in the fourth century. He is known for his kindness to an impoverished nobleman and his daughters, and is the patron saint of children.

St Nicholas Olave, Bread Street Hill/Upper Thames Street. Originally built around 1188, the church was burnt down in the Great Fire of 1666, and never rebuilt, and the parish was merged with that of *St Nicholas Cole Abbey*. Nothing remains of it today.

St Nicholas Shambles, Newgate Street. Originally built around 1196, and demolished in 1547, when the parish was merged with *Christ Church Newgate Street*. Some 200 eleventh- to twelfth-century skeletons were excavated at the site in the 1970s.

St Olave Hart Street, corner of Hart Street and Seething Lane. Originally built in wood in the eleventh century, and rebuilt in stone in the late twelfth to early thirteenth, and again in the mid-fifteenth, around 1450, and extended in the sixteenth to seventeenth. Undamaged in the Great Fire of 1666, thanks to the action of William Penn Senior and Samuel Pepys, who demolished some surrounding buildings to create a fire-break, but gutted by bombing on the night of 10 May 1941, and rebuilt again by E. B. Glanfield in 1951–4. The thirteenth-century crypt, some thirteenth- and fifteenth- century walls, the fifteenth-century tower, the gateway, dating to 1658, and the vestry, dating to 1662, survive, as do a number of sixteenth- and seventeenth-century memorials, including ones to not only Samuel Pepys but also his long-suffering wife Elizabeth (whose expression suggests she is 'admonishing her wayward husband'). The gateway is to the churchyard especially memorable for its adornment of skulls and cross-bones, from a design by Hendrik de Keyser. Some of the interior fittings were salvaged from *All Hallows Staining*, *St Benet Gracechurch* and *St Katharine Coleman*.

St Olave Jewry, Ironmonger Lane, between Gresham Street and Cheapside. Originally built sometime in the eleventh century (that is, either in Saxon or in Norman times), and added to in the fourteenth and fifteenth. Burnt down in the Great Fire of 1666, and rebuilt by Wren in 1670–9, only to be substantially demolished in 1888 or 1892 (sources differ), when the parish was merged with *St Margaret Lothbury*. The tower still stands, although modified from its original form in 1892 and again in 1986–7, and now serving as an office. The topping weathervane in the shape of a ship was salvaged from *St Mildred Poultry*. The former churchyard is now a garden.

St Olave Silver Street, London Wall. Originally built around 1181, the church was burnt down in the Great Fire of 1666 and never rebuilt, and the parish was merged with that of *St Alban Wood Street*. Parish records show that in 1665–6 the corpses of 119 people hanged at Tyburn were handed over to the nearby Barber-Surgeons Hall for the purposes of dissection. The former churchyard survives, as a city garden.

St Olave Southwark. Originally built in the eleventh century, after the martyrdom of Olave in 1030, and mentioned in the Domesday Book of 1086, entering the possession of the Priors of Lewes between 1090 and 1121.

Damaged by a flood in 1327, and rebuilt following a partial collapse in 1740, only to be damaged again, by a fire, in 1843, and demolished in 1926. A photograph of the church taken in around 1910 still survives. A 'Museum of London Archaeology Service' monograph describes in detail the findings of archaeological excavations at the site (Knight, 2002). The site is now occupied by St Olaf House.

St Olave's Court. Takes its name from the church of *St Olave Hart Street.*

St Pancras Soper Lane, Pancras Lane. Originally built around 1257, the church was burnt down in the Great Fire of 1666 and never rebuilt, and the parish was merged with that of *St Mary-le-Bow.* A Corporation 'Blue Plaque' marks its former site. Pancras was martyred in the fourth century.

St Paul's Alley. Named after *St Paul's.* Widened so as to be almost as wide as it is long following legislation passed in 1667 that required alleyways and passages to be at least nine feet wide 'for the common benefit of accommodation'. Now gated off at either end. The site of a pump donated by the parishioners of *St Faith's.*

St Paul's Cathedral. There have been five cathedrals on the site of the present St Paul's (Saunders, 2001; Keene *et al.*, 2004; Tudor-Craig, 2004; Schofield, 2011b). The first was built in 604, shortly after the first Christian mission under St Augustine landed in Kent, by the King of Kent, Ethelburg, for the Bishop of London, Mellitus, and destroyed by fire in 675. The second, the Church of Paulesbyri, was built in 675–85 by the Bishop, Erkenwald, and destroyed by the Vikings in 962. The third was built in 962, and destroyed by fire in 1087.

The fourth, Old St Paul's, was built in the Norman, or Romanesque, to Early Gothic styles in the years after 1087 by the Bishop Maurice and his successors; rebuilt and extended in the Gothic style in 1221–40, and in the 'New Work' of 1269–1314; renovated in the Neoclassical style by Inigo Jones in 1633–41, and again by Wren, after the Civil War, during which it had been occupied by Parliamentary troops and horses, in 1660; and burnt down in the Great Fire of 1666. There is a model of Old St Paul's in the Museum of London. It was clearly an impressive building, measuring some 600 feet in length, and rising to a height of between 460 and 520 feet (estimates vary), inclusive of the spire, which was substantially destroyed by a lightning strike in 1561, and subsequently demolished. As John Denham wrote in 1624,

That sacred pile, so vast, so high
That whether 'tis a part of earth or sky

Uncertain seems, and may be thought a proud
Aspiring mountain or descending cloud

The fifth, present cathedral was built by Wren in 1675–1711, after its immediate predecessor was burnt down in the Great Fire of 1666. It famously survived the bombing of the Blitz of the Second World War essentially intact: some would say due to divine intervention; others, due to the heroism of the St Paul's Watch, who extinguished around thirty fires caused by incendiary bombs on the night of Sunday 29 December 1940, alone. There are a great many important memorials in the interior of the cathedral. The one in the south quire aisle to the metaphysical poet John Donne (1572–1631) survived the Great Fire of 1666. If you look carefully, you can still see scorch-marks around its base!

(Old) St Paul's Chapter House. Originally built to an octagonal plan in 1332, in the Perpendicular Gothic style, and burnt down in the Great Fire of 1666, with only the foundations surviving, in the churchyard on the south side of the cathedral. The new Chapter House, in *Paternoster Square*, on the north side, was built by Wren in 1672.

St Paul's Cross. Built in the grounds of *St Paul's Cathedral*, on the site where the Saxons had held their *'folkmoot'*, in around 1241, damaged in 1382, possibly by the earthquake of that year, repaired in 1387, and rebuilt as a sort of open-air pulpit by Bishop Kempe in 1448. In 1549, at the height of the Reformation, a rabble-rousing Protestant preacher incited the congregation to sack the Cathedral, seen as a symbol of the Catholic Church, which they did with great zeal, rampaging through the interior, destroying the high altar and wall-hangings, and desecrating the tombs. In 1643, during the Civil War, the cross itself was demolished by order of Parliament. The one that stands on the site today was built in 1910.

St Peter Cornhill, also known as *St Peter-upon-Cornhill*. Originally built at least as long ago as the late eleventh century, and possibly in Saxon or even, according to tradition, Roman times, and extended in the fifteenth, and restored in 1630. Burnt down in the Great Fire of 1666, and rebuilt by Wren, probably assisted by Hooke, in 1667–87, and restored in the nineteenth century. Peter was martyred in the first century by being crucified upside-down. The church's weathervane bears his symbol of crossed keys (of the kingdom of heaven).

St Peter-le-Poer, Old Broad Street. Originally built around 1181, and much added to in 1629–31. Undamaged in the Great Fire of 1666 (although ash from the fire settled on an open prayer book in the church, and obscured the text), but fell into disrepair and had to be rebuilt by Jesse Gibson in 1788–90,

only to be demolished in 1908, when the parish was merged with *St Michael Cornhill*. Nothing now remains of the church at its former site, although the salvaged pulpit and font still survive, in St Peter-le-Poer in Friern Barnet.

St Peter Paul's Wharf, also known as *St Peter-the-Little*, Peter's Hill. Originally built around 1170, the church was burnt down in the Great Fire of 1666 and never rebuilt, and the parish was merged with that of *St Benet Paul's Wharf*. Essentially nothing now remains of the church at its former site, other than the name, which lives on in that of *Peter's Hill*. However, some headstones were saved and transferred to St Ann's when the churchyard was built over in 1962.

St Peter Westcheap, also known as *St Peter Cheap*, Wood Street, off Cheapside. Originally built around 1196, and rebuilt in 1503, the church was burnt down in the Great Fire of 1666, and not rebuilt again afterwards, and the parish was merged with that of *St Matthew Friday Street*. The former churchyard survives, as a city garden. Some parish boundary markers also survive.

St Peter's Alley. Named after the church of *St Peter upon Cornhill*.

St Saviour see *Southwark Cathedral*.

St Sepulchre, also known as *Church of the Holy Sepulchre* or *St Sepulchre-without-Newgate*, Giltspur Street/Holborn Viaduct. Originally built around 1137, and rebuilt by Sir John Popham, the Treasurer to Henry VI, in the fifteenth century. Damaged in the Great Fire of 1666, and rebuilt, using the surviving structure and materials, in 1667–71 (although much modified subsequently, particularly in the Victorian period). The west tower and south porch still survive from the fifteenth century (although modified). On the stroke of midnight on the day of the execution of a prisoner from nearby *Newgate Prison*, the church sexton would ring his handbell and recite lines urging the condemned man to repent his sins, ending with the words 'And when St Sepulchre's bell in the morning tolls, The Lord above have mercy on your soul'. The same handbell is on exhibit in the church.

St Stephen Coleman Street. Originally built around 1214. Burnt down in the Great Fire of 1666, and rebuilt by Wren in 1674–81, only to be destroyed by incendiary bombing on 29 December 1940 (photographs of the church as it was before the war still survive). A salvaged carved panel depicting the Last Judgement, clearly seen in one of the photographs above the entrance gate, also survives, in the Museum of London. Nothing of the church remains at its original site, other than some parish boundary markers bearing the insignia of the encircled cockerel (see *Coleman Street*). A Corporation 'Blue Plaque'

marks the site. Apparently Anthony Munday, who continued John Stow's *Survay*, was buried in the church in 1633, alongside members of the Coleman family who gave it its name.

St Stephen Walbrook. Originally built on the west side of the street in around 1090, possibly on the site of an even older, Saxon, church (and in turn on a Roman site), and rebuilt on the east side of the street in 1428. Burnt down in the Great Fire of 1666, rebuilt by Wren between 1672–80 and 1713–7, and respectfully modified in the eighteenth and nineteenth centuries, only to be damaged during the Second World War, restored by Gilbert Meadon and Godfrey Allen in 1948–52, and modified again subsequently. The interior, approached up a flight of steps, is domed and filled with light, very much 'in the spirit of St Paul's', and very beautiful (although, according to one critic, 'worthy not of Purcell, who never forgot his heart, but of J. S. Bach, who sometimes mislaid his'). Vanbrugh is buried here, although he has no monument. Nathaniel Hodges, a doctor who dedicated himself to the treatment of those afflicted by the 'Great Plague' of 1665, is commemorated by a plaque. Stephen was the first Christian martyr, stoned to death in the first century.

St Stephen's Row. Named after the church of *St Stephen Walbrook*.

St Swithin London Stone, Cannon Street. Originally built in the Medieval period, at least as long ago as the fifteenth century. Burnt down in the Great Fire of 1666, and rebuilt by Wren in 1677–86, using materials from *St Mary Bothaw*, only to be severely damaged by bombing in 1941, and subsequently demolished in 1957. John Dryden was married to Lady Elizabeth Howard in the church in 1663. Essentially only the so-called '*London Stone*' that was built into the south wall of the church in 1798 still survives at the site, as stipulated in the conditions for its redevelopment. There are parish boundary markers on Cannon Street and in Oxford Court (and another just off Walbrook). St Swithin's Church Garden also survives, between *Salters Hall Court* and *Oxford Court* (and near where Henry Fitz-Ailwyn or FitzAlywn de Londonestone, the first Lord Mayor of London in 1189–1213, once lived). The pulpit of 1682 salvaged from the church is now in *All Hallows Barking*. Swithin was Bishop of Winchester in the ninth century.

St Swithin's Lane (first recorded in 1270 as *vicus Sancti Swithuni*, and indicated on map of 1520 as *St Swithens Lane*). Named after the church of *St Swithin London Stone*.

St Thomas of Acre (shown as 'Hospital of St Thomas of Acre' on map of 1520). Originally built at least as long ago as the late fourteenth century, when

it was much frequented by Lombards. The site was taken over by the Mercers' Company, who built their hall there, in the early sixteenth century. The Mercers' Company Hall was destroyed in the Great Fire of 1666, and rebuilt in 1672–82, only to be destroyed again by bombing in the Blitz of 1941, and rebuilt again in 1954–8. By a quirk of fate, the post-Great Fire façade still survives, having been taken down and taken to Swanage and incorporated into the Town Hall building there, in 1879.

St Thomas the Apostle, Great St Thomas Apostle/Queen Street. Originally built around 1170, the church was burnt down in the Great Fire of 1666, and not rebuilt afterwards, and the parish was merged with that of *St Mary Aldermary*. A Corporation 'Blue Plaque' marks its former site.

St Thomas the Apostle, St Thomas Street, Southwark. Originally built in 1136, and rebuilt by Wren's master mason, Cartwright, in 1702. The church served as the Chapel of *St Thomas's Hospital* (see below) from 1215, and housed the hospital's operating theatre from 1822. It closed down in 1862, when the parish merged with St Saviour, which became *Southwark Cathedral* and the collegiate Church of St Saviour and St Mary Overie in 1905. The former church building then saw service as the Chapter House to *Southwark Cathedral*, and as an office owned by the Chapter Group. It now houses the Old Operating Theatre Museum. A 'Museum of London Archaeology Service' monograph describes in detail the findings of archaeological excavations at the site (Knight, 2002).

St Thomas's Hospital, Southwark. Originally built by Augustinian monks in 1215, and rebuilt in 1702. Later relocated to Lambeth, when most of the buildings were demolished to make way for London Bridge Station. The former chapel and parish church building still survives (see above).

St Vedast alias Foster, Foster Lane, between Cheapside and Gresham Street. Originally built around 1170. Burnt down in the Great Fire of 1666, rebuilt by the parish and by the Rebuilding Commissioners in 1669–72, and again by Wren in 1695–1701, and modified in 1709–12, when the spire was added, only to be gutted by incendiary bombing on 29 December 1940, and restored by Stephen Dykes-Bower in 1953–63. The pulpit was salvaged from *All Hallows Bread Street*, the seventeenth-century organ-case from *St Bartholomew-by-the-Exchange*, the eighteenth-century reredos from *St Christopher-le-Stocks*, and, among other items, the seventeenth-century communion table from *St Matthew Friday Street*. Vedast was Bishop of Arras in France in the sixth century.

Salisbury Court. 'So called for that it belonged to the Bishops of Salisbury, and was their inn, or London house, at such time as they were summoned to come to the parliament, or ... for other business' (Stow). Samuel Pepys was born here in 1633. Thus also *Salisbury Square*.

Salters Hall Court. Named after the Worshipful Company of Salters, who set up their Hall here in 1641.

Saracen's Head Yard. Named after the 'Saracen's Head' Tavern. See also *Aldgate*.

Savage Gardens. Named after Thomas, Viscount Savage of Melford Hall, who lived here in the seventeenth century. His widow Elizabeth's fortunes fell after she backed the Royalists in the Civil War.

Savoy Palace. Built by the Count of Savoie or Savoy, the uncle of Henry III, in 1324, and later given to Edward I's younger brother, Edmund, Earl of Lancaster, and passed down from him to Henry, Duke of Lancaster, who accommodated King John of France there after the latter's defeat at the Battle of Poitiers in 1356, and from him to John of Gaunt. Burnt down during the Peasants' Revolt of 1381. Later buildings on the site saw service as, among other things, a hostel and chapel for the poor in the sixteenth century, and a hospital where some of the wounded from the Civil War were treated in the seventeenth, before being substantially demolished in the early nineteenth. The site is now occupied by the Savoy Hotel and Theatre. Parts of the Savoy Chapel survive.

Seething Lane (first recorded in 1257 as *Shyvethenestrat*). Takes its name from a corruption of the Old English '*sifethen*', meaning sifting, in reference to the threshing of the corn and the winnowing of the wheat from the chaff that likely took place here, near the old Corn Market, in Medieval times. In the late fourteenth century, one Robert Knollys, a soldier who lived here, was made to pay a token fine to the City, in the form of annual floral tribute, for undertaking some building work without having previously sought what at the time passed for planning permission. Quaintly, the practice continues, albeit in modified form, to this day, with the Master of the Company of Watermen and Lightermen of the River Thames, accompanied by a guard of honour formed by the Doggett Badge winners, picking a single red rose from Seething Lane Garden and presenting it to the Lord Mayor at the Mansion House, every 24 June (on the occasion of the Feast of St John the Baptist). Seething Lane Garden is also the site of the former *Crutched Friars* monastery and *Navy Office* (and of a bust of Samuel Pepys, who used to work in the office).

Sermon Lane (indicated on map of 1520 as *Sermoners Lane*). Thought to take its name either from one Adam le Sarmoner, who owned land here in the thirteenth century, or from the open-air sermons preached here, when it was on an established processional path, or from the 'sheremoniers' who worked here. Sheremoniers were responsible for shearing the silver plates used for making coins.

Shafts Court. Takes its name from the shaft of the May Pole erected here during May Day celebrations in the fifteenth and early sixteenth centuries. The celebrations were discontinued after the riots of the so-called 'Evil May Day' of 1517. Thus also *Undershaft*.

Shadwell (first recorded as *Schadewelle* in 1222). Takes its name from the Old English '*sceald*', meaning shallow, and '*wella*', meaning spring. The river-front became built up and industrialised in the seventeenth century. A survey of 1650 revealed four docks and thirty-two wharves along a 400-yard section, and also, tellingly, that 53 per cent of the working population were mariners, 10 per cent ship-builders, and 7 per cent lightermen (there were also carpenters, smiths, rope-makers and other ancillary tradesmen, tanners and, of course, brewers). The church of St Paul Shadwell was originally built in 1656, and rebuilt in 1669 and again in 1820.

Sherborne Lane (first recorded in 1273 as *Shitteborwelane*). Takes its name from a Bowdlerisation of Shitteborwelane or Shitebourne or Shiteburn Lane. In Middle English, '*shite-burgh*', and in Old English, '*scite-burh*', in the sense of shit-house, was a jocular name for a privy.

Ship Tavern Passage. Thought to take its name from the 'Ship' Tavern that stood here from 1447. A plaque at the far end of the passage marks the former site of the church of *St Dionis Backchurch*.

Shoe Lane (first recorded in 1279 as *Sholane*). Thought to take its name either from the Old English '*scohland*', meaning, literally, shoe land, 'land given to a monastic community to provide it with shoes', or from Showell, a site that used to attract pilgrimages on holy days, or simply from a field at the end of the lane shaped like a shoe.

Shoreditch (first recorded as *Soredich* in 1148). Thought to take its name either from the Old English '*scora*', meaning shore, and '*dic*', meaning ditch, possibly in reference to a ditch leading into or off the Walbrook, or from the ancient British '*skor*', meaning fort or rampart, in reference to former fortifications around *Bishopsgate*. Alternatively, from one Jane Shore, kept as a mistress

by Edward IV, then imprisoned in the *Tower of London* by Richard III after Edward's death, made to walk barefoot through the streets as a penance for her 'harlotry' by the Bishop of London, imprisoned again in *Ludgate*, and finally dying, at least according to popular perception, on the streets of Shoreditch. The Priory of St John the Baptist at Haliwell or Holy Well, also known as Holywell Priory, was founded as an Augustinian convent here in around 1158, and dissolved in 1539, when 'The Theatre' was built in its former grounds. A 'Museum of London Archaeology Service' monograph describes in detail the findings of recent archaeological excavations at the site (Bull *et al.*, 2011). The church of St Leonard also had its origins in the twelfth century.

Sion College. Originally built on *London Wall* in 1624. Rebuilt at its present site on the Victoria Embankment in 1886.

Sise Lane. Takes its name from a corruption of the name of the church of St Osyth, Sythe or Sithe, also known as *St Benet Sherehog.*

Skinners Lane (indicated on map of 1520 as *Kyrounlane*). Takes its name from the skinners who once worked in the area. Skinners' Hall is situated on nearby *Dowgate Hill.*

Smithfield see *West Smithfield.*

Snow Hill (first recorded in the thirteenth century as *Snore Hylle*). Most likely takes its name, as also does *Snow Court*, from the Old English '*snor*', meaning a road curving or winding up a steep incline. In the eighteenth century, gangs of youths such as the infamous 'Mohocks' used to roll old ladies down the hill in barrels!

Somerset House, Strand. The original Somerset House was built for the Lord Protector Somerset in 1547–50, and after his execution came to be owned by the then-future queen, Elizabeth I, in 1553, then by Anne of Denmark, in 1603, and then by then-future king, Charles I, in 1619 (Thurley, 2009). It survived the Civil War, and the Great Fire of 1666, but was substantially demolished to make way for the present building in 1775. Only the 'Dead House' survives.

Southwark (first recorded as *Sudwerca* in the Domesday Book of 1086). Takes its name from the Old English '*suth*', meaning south, and '*weorc*', meaning defensive work or fort, in reference to the Roman defences south of the river. Also referred to historically as *Suthriganaweorc*, meaning the defensive work or fort of the men of Surrey. The area was unaffected by the Great Fire of

London in 1666, the southward progress of which across the river was halted at a gap in the buildings on *London Bridge* that formed a natural fire-break. However, it suffered its own Great Fire in 1676.

Southwark Cathedral. Originally founded as a nunnery in 606, becoming the priory church of St Mary Overie in 1106, the parish church of St Saviour following the Dissolution in 1540, and Southwark Cathedral and the collegiate Church of St Saviour and St Mary Overie in 1905. Being over the 'rie' or river, the church was undamaged in the Great Fire of 1666, and also survived the bombing of the Second World War. Some elements of the present structure are survivors from the twelfth-century building, although most are from the thirteenth or early fifteenth rebuilds following fires in 1212 and 1390. The interior contains many memorials, including a wooden effigy of a knight buried in around 1275, and the tomb of Lancelot Andrewes (1555–1626), who was responsible for the translation of the Authorised or King James Version of the Bible. One of the legends surrounding Mary Overie is worth recounting. According to which, her father John Over was a ferryman, and a very mean man. Indeed, such was his miserliness that one day, in order to avoid having to fork out for provisions, he faked his own death, assuming that his servants would fast for a day to show their respects. Unfortunately for him, his plan backfired when, instead of fasting, his servants feasted. Enraged by this, he leapt out of his supposed deathbed to confront them, in so doing so alarming them that they beat him to death with a broken oar, thinking his body possessed by the Devil. Mary was so distressed by this bizarre and tragic turn of events that she decided to dedicate the rest of her life to the service of God, and used her inheritance money to found the priory church, eventually being made a saint for her chastity. In St Mary Overie dock, incidentally, is a fine full-size replica of the '*Golden Hinde*', the galleon in which Sir Francis Drake first circumnavigated the globe in 1577–80.

Spital Yard. Takes its name from *St Mary Spital.*

Spitalfields (first recorded in 1561 as *Spyttlefeildes*). Takes its name from the Old English '*spitel*', meaning hospital, and '*feld*', in reference to land owned by *St Mary Spital*, founded here in 1197 (Bennett, 2009). Spitalfields became famous for its fruit and vegetable market in the late seventeenth century. It also became an important refuge for French Protestant Huguenots, and especially for Huguenot silk-weavers, fleeing religious persecution following the repeal of the 'Edict of Nantes' in Catholic France in 1685.

Staining Lane (first recorded in 1181 as *Staninge lane*). Thought to take its name from the Old English '*lane*', prefixed by '*Staeningas*', meaning people

from Staines, rather than from the painters and strainers who lived and worked hereabouts, as Stow had it. Site of the church of *St Mary Staining*.

Staple Inn (Gray's Inn) see *Inns of Court*.

Staple Inn Buildings. Named after *Staple Inn*.

Star Alley. Thought to take its name from a 'Star' Tavern that once stood here. Site of the church of *All Hallows Staining*.

Stationers' Hall Court. Takes its name from the Worshipful Company of Stationers' Hall that has stood here in various guises since 1606, on the former site of a great house belonging to John, Duke of Britaine, and later to Lord Abergavenny. The original hall was destroyed in the Great Fire.

Steelyard, Upper Thames Street. Takes its name from a corruption of the German '*stahl-hof*', meaning steel-yard, or '*stapel-hof*', meaning stock-yard. Originally built in around 1157, as essentially the London headquarters of the Hanseatic League. The former privileges extended to the League were revoked by Edward VI in 1551, and the merchants who stayed on after that date were expelled in 1598, whereupon the site came to be used as a storehouse. Burnt down in the Great Fire of 1666. The site is marked by a plaque put up on Cannon Street Bridge by the British-German Association.

Stepney (first recorded as *Stybbanhythe* in around 1000). Takes its name either from the Old English personal name 'Stybba', or the word '*stybba*', meaning a wooden pile, and '*hyth*', meaning landing place. Became built up around the old church of St Dunstan in the seventeenth century.

Stew Lane (first recorded in the late sixteenth century). Named after the 'stew or hot-house [brothel] there kept' (Stow).

Stocks Market. Established for the sale of dried or 'stock' fish, and other goods, in 1272, the year the Stock-Fishmongers received their Royal Charter, and done away with in 1737, to make way for the Mansion House, the official residence of the Lord Mayor of London. A Corporation 'Blue Plaque' on the front of the Mansion House marks the former site.

Stone House Court. Thought to take its name from a stone house built here by the Augustinian Friars in the thirteenth century.

Strand (first recorded in 1185 as *Stronde*). Takes its name from the Old English '*strand*', meaning strand-line or shoreline, in reference to the former location on the bank of the Thames. The 'Wig and Pen' dates back to 1625, and survived the Great Fire. Thus also *Strand Lane*.

Stratford (first recorded in 1067 as *Straetforda*). Takes its name from the Old English for a ford on a Roman road.

Suffolk Lane (indicated on map of 1520 as *Suffolke Lane*). Named after the Dukes of Suffolk, who grew rich in the wool trade in the Middle Ages, and once lived here, in the splendid 'Manor of Roses', whose gardens stretched all the way down to the river. The property was later given over to the Merchant Taylors' Company, for use as a school.

Sugar Bakers' Court. Takes its name from the Sugar Bakers who once worked here. Survived the Great Fire.

Surrey Street. Named after the Howard family, Earls of Arundel and Surrey.

Swan Lane. Takes its present name from the 'Olde Swan' Tavern that stood here in late Medieval times. Previously named *Ebbegate* or *Ebgate Lane*, in reference to the water-gate that stood here in early Medieval times. An excavation here in 1981 yielded many exciting finds, including three fifteenth-century armorial mounts from a knight's sword belt, and the remains of a twelfth-century dyehouse complex.

Temple see *Inns of Court*.

Temple Bar. Originally built at least as long ago as 1293 as an outer gateway to the City, at the point at which the *Strand* meets *Fleet Street*, some distance west of the inner gateway on *Ludgate Hill*, and rebuilt in 1351. Undamaged in the Great Fire of 1666, although, at the behest of Charles II, rebuilt again by Wren in 1669–72, only to be taken down, numbered stone by numbered stone, in 1878, and rebuilt yet again, originally in Theobalds Park in Hertfordshire in 1887, and subsequently in its present position in Paternoster Square in 2001. Temple Bar is the only surviving gateway to the City, all the others – *Aldersgate, Aldgate, Bishopsgate, Cripplegate, Ludgate, Moorgate and Newgate* – having been demolished by the end of the eighteenth century.

Temple Church. Originally built in around 1160–85 and 1220–40. Undamaged in the Great Fire of 1666, although still restored several times subsequently, only to be badly damaged by bombing in 1941, and restored by

Carden & Godfrey in 1947–57. The round tower is modelled on the Church of the Holy Sepulchre in Jerusalem. The corresponding circular nave in the interior is original, twelfth-century, and 'transitional' in terms of architectural style between Norman, or Romanesque, and Early Gothic. The chancel is thirteenth-century, and decidedly Gothic. The famous Purbeck Marble effigies of Knights Templar and of a bishop are also thirteenth-century. The alabaster altar-tomb to Edmund Plowden, the Treasurer of Middle Temple, dates to 1584; the monument to Richard Martin, the Recorder of London, to 1615.

(*Roman*) *Temple of Mithras*, Queen Victoria Street. Originally built in the early third century, around 220–40, and abandoned in the fourth, when Christianity came to replace paganism throughout the Roman Empire, only coming to light again during rebuilding after the Second World War, when it was moved to its (at the time of writing) present location. Mithras, sometimes referred to as the 'pagan Christ', was originally a Persian god, from the Zoroastrian pantheon, an assistant of the powers of good in their struggle against those of evil, who served to slay a bull created by evil, from the blood of which all life was believed to have sprung. He eventually came to be identified with the Unconquered Sun, or *Sol Invictus*, and to epitomise purity, honesty, and courage. Mithraism, the practice and mystery cult of Mithras worship, as by then distinct from Zoroastrianism, came to Rome in around the first century BCE, and spread throughout much of the Roman Empire by the first century AD, becoming most widespread in the third. It was practised in specially dedicated temples or 'Mithraea' (sing., 'Mithraeum'), many of which were underground (because Mithras slew the bull underground, in a cave). The temple in London is (at the time of writing) in the process of being moved back closer to its original location on the Walbrook, some 100 yards away from its present one, and 30 feet lower. A marble head of Mithras recovered from it can be seen in the Museum of London.

Threadneedle Street (first recorded in 1598 as *Three needle Street*, and in 1616 as *Thred-needle-street*). Thought to take its present name from the arms of either the Needlemakers or the Merchant Taylors, whose Halls were here in Medieval times. The Merchant Taylors' Hall still is, at No. 30.

Throgmorton Street (first recorded in 1598, and indicated on the map of 1520 as part of *Lothebury*). Named after Sir Nicholas Throckmorton, Throkmorton or Throgmorton, the ambassador to France (and Scotland!), chief butler of England (!), and one of the chamberlains of the exchequer during the reign of Elizabeth I. Throgmorton is buried the nearby church of *St Katharine Cree*.

Tokenhouse Yard. Takes its name from the house here where farthing tokens were minted in the seventeenth and eighteenth centuries. A farthing was one

quarter of an old penny, one fourty-eighth of a shilling, or one nine-hundred-and-sixtieth of a pound.

Took's Court. Named after Thomas Tooke, who owned the land on which the court was built in around 1650. Nos 14–15 date back to the late seventeenth century.

Tooley Street, Bermondsey (first recorded as *St Olaves Street* in 1598, *St Tooley's Street* in 1606, and *Towles Street* in 1608). Takes its name from a corruption of *St Olaves Street*. See also *St Olave Southwark*.

Tower Hill (first recorded in 1343 as *Tourhulle*). Takes its name from its proximity to the *Tower of London*. The site of public executions, especially of those imprisoned in the nearby Tower accused of treason, in the Middle Ages, and indeed up until the eighteenth century. Thus also *Tower Ward*.

Tower of London, also known as *Her Majesty's Royal Palace and Fortress*. Originally built on the site of the old Roman fort of Arx Palatina, by William I, 'the Conqueror', in the late eleventh century, and added to by a succession of later kings and queens, many of whom used it as a royal residence, through to the seventeenth (Rowse, 1972; Parnell, 1998; Impey & Parnell, 2000; Impey, 2008; Jones, 2011). The Chapel of St Peter ad Vincula within is arguably of even older, Saxon origin. A 'Historical Royal Palaces' monograph describes the findings in the Tower of London moat (Keevill, 2004). The Tower features in the earliest known painting of London, by an unknown artist, dating to the reign of Henry VII, in 1485–1509, and commissioned to illustrate a book of poems written by Charles, Duc d'Orleans, who was imprisoned there after his capture at the Battle of Agincourt in 1415, where a superior French force, including cavalry, was routed by Henry V and his fearsome Welsh bowmen. Hundreds were imprisoned here over the centuries; and scores tortured and executed, in a variety of horrible ways – one wonders how much better a world it would have been if all the imaginative effort expended in devising means of inflicting suffering had instead been channelled elsewhere.

Tower Royal, Cannon Street. Ultimately takes its name from *le Reole* in the Gironde Department of Aquitaine in south-west France, from where wine was shipped to Royal Street (now *Newcastle Close*), and from where also came many wine merchants who lived there or thereabouts, including here, as long ago as the thirteenth century. The tower was burnt down in the Great Fire of 1666.

Trig Lane (formerly known as *Fish* and then *Sunlight Wharf*). Thought to be named after the Trigge family, who lived and worked here, as fishmongers, in the fourteenth and fifteenth centuries. A pair of bone-riveted spectacles, believed to

have been manufactured in around 1440 by an expatriate spectacle-maker from the Low Countries, was recovered in an archaeological excavation here in 1974.

Trinity Place, Square. Take their names from Trinity House, the organisation responsible for the maintenance of the nation's lighthouses, which has its headquarters here, alongside the former Port of London Authority building. Trinity House was established in 1514, when Henry VIII granted a charter to the Guild of the Holy Trinity, which looked after the welfare of mariners. Its headquarters was originally in *Deptford*, and subsequently in *Ratcliff* and *Stepney*, before being moved to Water Lane, off *Eastcheap*, in 1660, where it was burnt down in the Great Fire of 1666, rebuilt, and burnt down again in 1715. It was rebuilt again at its present site in 1795, seriously damaged by bombing in 1940, and restored in 1953.

Tudor Street. Named after the Royal House of Tudor.

Turnagain Lane (first recorded in 1293 as *Wendageyneslane*, and in 1415 as *Turneageyne lane*). Takes its name from its being a cul-de-sac, 'from whence men must turn again the same way they came' (Stow). Nothing to do with the tale of Dick Whittington, as one might have thought.

Turnmill Street (first recorded in 1374 as *Trilmullestrete*). Takes its name from a mill called 'Trillemille' that stood here in the Medieval period. 'Trillemille' took its name in turn from the Middle English '*trille*', meaning turn.

Undershaft. Takes its name from its position under the shaft of the May Pole erected here during May Day celebrations in the fifteenth and early sixteenth centuries. The celebrations were discontinued after the riots of the so-called 'Evil May Day' of 1517. Thus also *Shafts Court*.

Upper Ground, Southwark. Takes its name from the high ground beside the low.

Upper Marsh, Lambeth. Takes its name from the low-lying and marshy land here prior to reclamation.

Upper Thames Street (first recorded in around 1208 as *la rue de Thamise*, and indicated on map of 1520 as *Thames Street, Billingsgate Strete, Stokfisshmongerowe, Roperestrete*, and *The Vyntre*). Named after the City's river.

Vauxhall (first recorded as *Faukeshale* in 1279). Takes its name from a corruption of the Old French personal name 'Falkes', and the Middle English

'*hall*', meaning manor house, in reference to that given to Falkes de Breaute by King John in 1233.

Vine Hill. Takes its name from the vines once grown here, in gardens belonging to the Bishops of Ely.

Vine Street. Takes its present name, given in 1746, from the vines once grown here. Previously part of *Houndsditch*, which was leased out for various uses in the sixteenth century.

Vintners Place (indicated on map of 1520 as *Anker Lane*). Named after the Worshipful Company of Vintners, whose Hall was here in Medieval times, and is still. The company enjoyed a monopoly on trade with Gascony in wine, cloth and herrings from as long ago as 1364, although since then it has 'ditched the fish'. The Place leads to the riverside, where wines were unloaded at a wharf called *Vintry* (first recorded as *Vinetria* in 1274). Thus also *Vintry Ward*.

Walbrook (first recorded in 1274 as *Walbrokstrate*), also *Walbrook Ward*. Named after the Walbrook, which rose in the area around *Moorfields* to the north of the *City Wall*, flowed south through the City, and debouched into the Thames at *Dowgate*. The Walbrook takes its name in turn from the Old English '*wala*', meaning of the Welsh, or Ancient British, and '*broc*', meaning brook. Like the Fleet, the Walbrook is now covered over.

Wapping (first recorded in around 1220). Takes its name from either the Old English personal 'Waeppa' or the word '*wapol*', meaning marsh or pool, together with the word '*ingas*', meaning place. Thus also *Wapping Stairs* and *Wall*. The famous 'Prospect of Whitby', on *Wapping Wall* was originally built in 1520, at around the same time as the marsh was drained, and is still standing. It was formerly known as 'The Devil's Tavern'. Pirates were hanged at nearby 'Execution Dock'.

Wardrobe Court, Place. Take their names from the *Royal Wardrobe*.

Warwick Lane (first recorded in the mid-thirteenth century as *Eldedeneslane*, in 1475 as *Werwyk Lane*, and in 1515 as *Eldens lane alias Warwik lane*, and indicated on map of 1520 as *Warwyke Lane*). Like *Warwick Square*, named after the Earls of Warwick, who owned a tenement here in the fourteenth century and a town house called Warwick Inn in the fifteenth. The Earls are also commemorated by a relief of 1668 on Nos 6–9 *Newgate Street*.

Watergate. Takes its name from the water gate to the *Bridewell Palace* that once stood here. Now an 'unlovely, shapeless cul-de-sac'.

Watling Street (first recorded in around 1213 as *Aphelingestrate*). Takes its name from a corruption of the Old English '*aetheling*', meaning noble or prince. No. 34 is the site of a fourteenth-century undercroft.

Wentworth Street. Named after Thomas Wentworth, the Lord Chamberlain during the reign of Edward VI (1547–53), who lived hereabouts.

West Harding Street. Named after one Agas or Agnes Hardinge, who bequeathed property hereabouts to the Worshipful Company of Goldsmiths in 1513. Thus also *East Harding Street.*

West Smithfield or *Smithfield* (first recorded in around 1145 as *Smethefelda*), also *Smithfield Street.* Take their names from the Old English '*smethe*', meaning smooth, and '*feld*', in reference to a flat field outside the *City Wall* where apprentices and others practised martial arts, and where, from the twelfth century onwards, fairs and other events were held, including the Bartholomew Fair (made famous by Ben Jonson's satirical play of the same name, written in 1614). This was also a site of public execution: plaques commemorate the sites of execution of the Scottish freedom fighter William Wallace under the 'Hammer of the Scots' – and Welsh – Edward I in 1305, and of the Protestant heretics John Rogers, John Bradford, John Philpot and others under the Catholic Queen 'Bloody' Mary in 1555–7. Moreover, the Peasants' Revolt of 1381 came to an end when its leader, Wat Tyler, was fatally stabbed here by the Lord Mayor of London, William Walworth. The present meat market was built in 1868. A 'Museum of London Archaeology Service' monograph describes in detail the findings of recent archaeological excavations at the nearby Medieval *Charterhouse* and associated 'Black Death' burial ground (Barber & Thomas, 2002).

Westminster (first recorded as *Westmynster* in around 975). Takes its name from the 'minster', or monastery, to the west of the City. A Benedictine monastery stood here in the tenth century.

Westminster Abbey, Parliament Square. Originally built on the site of the above-mentioned Benedictine monastery, under the Saxon King, Edward III, the Confessor, in 1045; and rebuilt, in the Early Gothic style, under Henry III in 1245, and extended, in the Late Gothic style, under Henry VII in 1503–19 (Jenkyns, 2011). The present structure is essentially surviving thirteenth- to sixteenth-century, although with some eighteenth-century additions in the form of the west towers, by Hawksmoor, and some twentieth-century restorations.

There are a great many important monuments in the interior, including those of no fewer than seventeen monarchs. An equally large number of important state occasions have been held here, including all of the Coronations since that of the first Norman king, William I, the Conqueror, in 1066. A 'Museum of London Archaeology Service' monograph describes in detail the findings of archaeological excavations undertaken at the site as part of the Jubilee Line Extension Project in 1991–8 (Thomas *et al.*, 2006).

Westminster Hall, Parliament Square. Originally built in 1097–9, rebuilt in 1394–1401, and incorporated into the Houses of Parliament in 1547.

Whetstone Park. Named after William Whetstone, a tobacconist who traded here during the reign of Charles I.

White Bear Yard. Takes its name from the 'White Bear' Tavern that once stood here. The white bear from which the tavern in turn took its name was a polar bear given by the King of Norway in 1251 to Henry III to keep in his Tower Menagerie. The public was admitted to the Menagerie on payment of a small fee, or, so it was said, on production of a cat or dog to feed to the bear!

Whitechapel (first recorded in 1340 as *Whitechapele by Algate*), also *Whitechapel High Street* and *Road*. Take their names from the 'White Chapel' of Saint Mary Matfelon or Matefelon that stood here from the thirteenth century (Bennett, 2009). The church was seriously damaged by bombing in 1941 (a photograph of the bombed building taken in 1941 still survives), and was subsequently demolished in 1952, whereupon its former site was converted into a garden, now named Altab Ali Park (in honour of a young Bengali who was murdered nearby in 1978). Richard Brandon, the rag-man from the Royal Mint who was given the task of beheading Charles I in 1649, is buried in the churchyard.

The present Whitechapel Bell Foundry on the corner of Whitechapel Road and Plumber's Row was built in 1738, on the site of one that had been there since 1570, and where founders had been working since 1420. What was to become the Liberty Bell was cast here, in 1752; as was Big Ben, in 1858.

Whitecross Street (first recorded in 1226 as *Whitecruchestrete*). Takes its name from a white cross that stood here in Medieval times.

Whitefriars Monastery. Having been driven away from their spiritual home on Mount Carmel in the Holy Land by the Saracens in the early thirteenth century, the '*Fratres beatae Mariae de Monte Carmeli*' or Carmelites, or White Friars, established a monastery in grounds bounded to the north by *Fleet Street*, to

the east by *Whitefriars Street*, to the south by the River Thames, and to the west by the *Temple*, in 1253. The White Friars were popular with the populace, and largely spared during the Peasants' Revolt in 1381. They were even granted temporary sanctuary following the Dissolution of the Monasteries during the reign of Henry VIII in the sixteenth century, but ultimately suffered the same fate as the Black, Grey and other Friars, when an instruction was given to 'pull down to the grounds all the walls of the churches, stepulls, cloysters, fraterys, dorters [and] chapterhowsys'. The inhabitants of the site after the Dissolution continued to claim the right of sanctuary, and exemption from local law, and their claim was upheld by the reigning monarchs Elizabeth I in 1580 and James I in 1608, and only revoked by Acts of Parliament in 1697 and 1723. In consequence, in the late sixteenth and seventeenth centuries, the site became notorious for its fugitive criminals and criminality, and eventually to be known as 'Alsatia', after the literally lawless territory lying between France and Germany and outside the jurisdiction of either. Macaulay wrote that 'at any attempt to extradite a criminal, bullies with swords and cudgels [and] termagant hags with spits and broomsticks poured forth by the hundred and the intruder was fortunate if he escaped back to Fleet Street, hustled, stripped and jumped upon'. Remarkably, the crypt of the Whitefriars Monastery still survives, preserved behind plate glass in the basement of an office block owned formerly by the *News of the World*, and can be viewed from the foot of a flight of steps in an unprepossessing concrete courtyard at the junction of *Ashentree Court* and *Magpie Alley*. It came to light during renovation of the *News of the World* offices in 1895.

Whitefriars Street (indicated on map of 1520 as *Water Lane* (Fleet Street)). Named after the White Friars, or Carmelites, who once had a monastery here.

Whitehall (first recorded as *Whitehale alias Yorke place* in 1530). Takes its name from the former Whitehall Palace, also known as *York Place*, the London residence of the Archbishops of York (Brown, 2009). The palace was undamaged in the Great Fire of 1666, but substantially burnt down in another fire in 1698. Essentially only the Banqueting House, built by the Neoclassical or Palladian architect Inigo Jones in 1622, and notable as the first Renaissance building in London, still stands. York House Water Gate, also built by Inigo Jones, in 1626, stands nearby, on the Embankment.

Wild Street. Named after Humphrey Weld, who built Weld House here in 1640.

Wine Office Court. Takes its name from the Wine Office that issued licenses to sell wine that stood here in the sixteenth and seventeenth centuries. The building was destroyed in the Great Fire of 1666.

Wood Street (first recorded in 1157 as *Wodestrata*). Thought by most to take its name from the wood once sold here. Stow had an alternative suggestion, that it was named after a former builder, owner or occupant, such as Thomas Wood, a Sheriff of London in 1491. Note, though, that usage of the name from the twelfth century pre-dates at least Thomas Wood's occupation in the fifteenth.

Wormwood Street (indicated on map of 1520 as *Cock's Rents* (one can only imagine what went on here)). Adjoins *Camomile Street*, and similarly also takes its name from a herb used in early medicine.

Wych Street. Presumably takes its name from the Old English *'wic'*, meaning trading settlement. Photographs taken in the early twentieth century show that at this time a number of pre-Great Fire houses still stood on the street.

York Buildings, Place. Originally built in the thirteenth century. Named after the Archbishops of York, who moved into the former residence of the Bishops of Norwich here, in the sixteenth.

APPENDIX
SUGGESTED ITINERARIES
FOR WALKS

Timings are dependent upon personal preferences. Allow at least a couple of hours for either complete itinerary, or a few hours to allow more time to explore at least some interiors (check opening times beforehand, church ones at www.london-city-churches.org.uk). The *Tower of London*, *St Paul's*, *Temple Church* and *St Bartholomew the Great* merit more time than even the extended itinerary allows to explore properly, and separate visits (please note that they also all charge for admission).

And remember, part of the art of exploring London is getting lost, gracefully! And, it's not just the old, and it's not just the new, it's the juxtaposition of the two, that makes it what it is.

Walk One: Tower to Temple (see also Inwood, 2008 and Wittich & Phillips, 2008)

First covers Roman, Saxon and Medieval localities on the south-eastern edge of the City (Stops One and Two). Then the centre, substantially destroyed in the Great Fire of 1666, and rebuilt by Wren and others, on essentially the same street plan as before (Stops Three through Twelve). Some additional amusement can be had here tracking down the Corporation 'Blue Plaques', parish boundary markers etc. that are essentially all that remain of *St George Botolph Lane*, *St Leonard Eastcheap*, *St Margaret New Fish Street*, *St Martin Orgar*, *St Swithin London Stone*, *St Mary Bothaw*, *St John the Baptist upon Walbrook*, *St Benet Sherehog*, *St Mildred Poultry*, *St Mary Woolchurch Haw*, the *Stocks Market*, *St Mary Colechurch*, *St Olave Jewry*, *St Martin Pomary*, *All Hallows Honey Lane*, *St Mary Magdalen Milk Street*, *St Peter Westcheap* and *St Michael le Querne*. Finishes up on the south-western side, immediately without the walls (Stops Thirteen through Twenty-One).

Can be split into two halves on either side of St Paul's.

Stop One: Tower Hill (outside Tower Hill Tube Station, 3E on Map One). Roman and Medieval *City Wall* and Medieval *Postern Gate*, and views

over *Tower of London* to south (see body of text for further details). The statue of the emperor Trajan is thought to be an eighteenth- or nineteenth-century replica of a Roman original. It was salvaged from a scrap-yard in Southampton, and put up in its present location in 1959.

Stop Two: All Hallows Barking (Byward Street/Great Tower Street, 6 on Map One). Saxon church.

Stop Three: St Mary-at-Hill (off Eastcheap, 29 on Map One, 19 on Map Two). Wren church incorporating Byzantine quincunx plan of Medieval structure.

Stop Four: St Magnus the Martyr (Lower Thames Street, 13 on Map Two). Wren church, with model of Old *London Bridge* in interior. Also timber from Roman wharf in porch.

Stop Five: Monument.

Stop Six: The Olde Wine Shades (Martin Lane, 18 on Map One). Originally built in 1663. The only drinking establishment within the walls of the City to survive the Great Fire.

Stop Seven: Site of *Roman Governor's Palace* and *London Stone* (Cannon Street, 4 on Map One).

Stop Eight: St Mary Aldermary (Queen Victoria Street, 28 on Map One, 18 on Map Two). Wren church incorporating Perpendicular Gothic elements of Medieval structure.

Stop Nine: Temple of Mithras (Queen Victoria Street, 5 on Map One). Roman temple.

Stop Ten: Guildhall (Gresham Street, 1 and 12 on Map One). Medieval *Guildhall,* and site of Roman *Amphitheatre.*

Stop Eleven: St Mary-le-Bow (Cheapside, 20 on Map Two). Wren church with surviving Medieval crypt.

Stop Twelve: St Paul's (31 on Map One). Wren cathedral and Medieval Chapter House.

Stop Thirteen: Site of *Bridewell Palace* (New Bridge Street). Medieval.

Stop Fourteen: St Bride (off Fleet Street, 6 on Map Two). Wren church with surviving Saxon and Medieval crypt.

Stop Fifteen: Whitefriars Monastery (off Whitefriars Street, 36 on Map One). Remains of Medieval monastery.

Stop Sixteen: The Tipperary (Fleet Street, 34 on Map One). Originally built in 1605. Survived the Great Fire.

Stop Seventeen: St Dunstan-in-the-West (Fleet Street, 23 on Map One). Medieval statues of King Lud and his sons, and of Queen Elizabeth I, that used to stand on *Ludgate.*

Stop Eighteen: Inner Temple Gatehouse (Fleet Street, 15 on Map One). Jacobean.

Stop Nineteen: Temple Church (off Fleet Street, 33 on Map One). Plantagenet church of the Knights Templar, modelled on the Church of the Holy

Sepulchre in Jerusalem. The architectural style is part Norman, or Romanesque, and part Early Gothic.

Stop Twenty: Middle Temple Hall (off Fleet Street, near Temple Tube Station, 17 on Map One). Elizabethan.

Stop Twenty-One (optional): Roman – or Roman-style – *bath-house* (Strand Lane, near Temple Tube Station).

Walk Two: London Wall (see also Inwood, 2008, Wittich & Phillips, 2008 and Harris, 2009)

First covers Roman, Saxon and Medieval localities on the south-eastern edge of the City (Stops One and Two). Then the north-east, largely unaffected by the Great Fire of 1666, around Aldgate and Bishopsgate (Stops Three through Ten). And along the line of the old City Wall to the north, past Moorgate and Cripplegate (Stops Eleven through Thirteen), and to the north-west, past Aldersgate, Newgate and Ludgate (Stops Fourteen through Eighteen). Finishes on the south-western edge of the City, where the Fleet meets the Thames (Stops Nineteen through Twenty-One). Look out for evidence of *St Katherine Coleman, St James Duke's Place, St Martin Outwich* and *St Olave Silver Street*.

Can be split into two halves on either side of the Museum of London. Follows parts of the old MoL 'London Wall Walk', which is waymarked.

Stop One: Tower Hill (outside Tower Hill Tube Station, 3E on Map One). Roman and Medieval *City Wall* and Medieval *Postern Gate*, and views over *Tower of London* to south (see body of text for further details).

Stop Two: All Hallows Barking (Byward Street/Great Tower Street, 6 on Map One). Saxon church.

Stop Three: St Olave Hart Street (corner of Hart Street and Seething Lane, 30 on Map One). Medieval church.

Stop Four: All Hallows Staining (Mark Lane, 8 on Map One). Tower of Medieval church.

Stop Five: St Katharine Cree (Leadenhall Street, 27 on Map One). Predominantly mid-seventeenth-century church, featuring interesting mix of Late Gothic and Renaissance or Neoclassical architecture.

Stop Six: Holy Trinity Priory, Aldgate (76 Leadenhall Street, 13 on Map One). Remains of Medieval priory.

Stop Seven (optional): The Hoop and Grapes (Aldgate High Street, 14 on Map One). Originally built in 1290.

Stop Eight: St Helen (Great St Helens, off Bishopsgate, 26 on Map One). Medieval church.

Stop Nine: St Andrew Undershaft (Leadenhall Street and St Mary Axe, 20 on Map One). Medieval church.

Stop Ten: St Ethelberga, also known as *St Ethelburga the Virgin* (Bishopsgate, 24 on Map One). Medieval church.

Stop Eleven: All Hallows London Wall (3N on Map One). Roman *City Wall* and eighteenth-century church by George Dance the Younger.

Stop Twelve: Moorgate. Site of Medieval Postern Gate and Causeway across *Moorfields*.

Stop Thirteen: St Alphage (London Wall, 19 on Map One). Ruins of Medieval church.

Stop Fourteen: St Alphage Highwalk, near Museum of London (3W on Map One). Fine views over Roman and Medieval *City Wall*, with battlements and a substantially intact bastion.

Stop Fifteen: St Bartholomew-the-Great (West Smithfield, 21 on Map One). Magnificent Norman church.

Stop Sixteen: 41 Cloth Fair (11 on Map One). Fine Jacobean private residence.

Stop Seventeen: St Bartholomew-the-Less (West Smithfield, 22 on Map One). Medieval church. Also *St Bartholomew's Hospital*.

Stop Eighteen: St Sepulchre (Giltspur Street/Holborn Viaduct, 32 on Map One). Medieval church.

Stop Nineteen: Apothecaries' Hall (Blackfriars Lane, 9 on Map One). Medieval livery company hall.

Stop Twenty: Blackfriars Monastery and *St Ann Blackfriars* (Church Entry and Ireland Yard, 10 on Map One). Remains of Medieval monastery and church. The site of a play-house in Shakespeare's time (and of one of his London residences).

Stop Twenty-One: Blackfriars Bridge (near Blackfriars Tube Station). Where the Fleet meets the Thames.

CITED AND OTHER REFERENCES

Ackroyd, P., 2000. *London: The Biography*. Chatto & Windus.

Ackroyd, P., 2003. *Illustrated London*. Chatto & Windus.

Ackroyd, P., 2008. *Thames*. Vintage.

Ackroyd, P., 2009. *The Canterbury Tales: A Retelling*. Penguin.

Ackroyd, P., 2011. *London Under*. Chatto & Windus.

Allinson, K., 2008. *Architects and Architecture of London*. Architectural Press.

Anonymous, 1996. *Southwark: A History of Bankside, Bermondsey and 'The Borough'*. Southwark Heritage Association.

Arnold, C., 2008. *Bedlam: London and its Mad*. Pocket Books.

Arnold, C., 2010. *City of Sin: London and its Vices*. Simon & Schuster.

Badsey-Ellis, A., 2010. *What's in a Street Name?* Capital History.

Baker, T., 1970. *Medieval London*. Cassell.

Baker, T. M. M., 2000. *London: Rebuilding the City after the Great Fire*. Phillimore.

Barber, B. & Bowsher, D., 2000. *The eastern cemetery of Roman London*. Museum of London Archaeology Service (Monograph No. 4).

Barber, B. & Thomas, C., 2002. *The London Charterhouse*. Museum of London Archaeology Service (Monograph No. 10).

Barron, C. M., 2004. *London in the Later Middle Ages: Government and People 1200–1500*. Oxford University Press.

Barton, N., 1962. *The Lost Rivers of London*. Book Club Associates.

Bastable, J., 2011. *Inside Pepys' London*. David & Charles.

Bateman, N., 2000. *Gladiators at the Guildhall: The Story of London's Roman Amphitheatre and Medieval Guildhall*. Museum of London Archaeology Service.

Bateman, N., 2011. *Roman London's Amphitheatre*. Museum of London Archaeology Service.

Bateman, N., Cowan, C. & Wroe-Brown, R., 2008. *London's Roman Amphitheatre (Guildhall Yard, City of London)*. Museum of London Archaeology Service (Monograph No. 35).

Beard, G., 1982. *The Work of Christopher Wren*. Bloomsbury.

Belcher, V., Bond, R., Gray, M. & Wittrick, A., 2004. *Sutton House – A Tudor Courtier's House in Hackney*. English Heritage.

Bennett, J. G., 2009. *E1: A Journey through Whitechapel and Spitalfields*. Five Leaves.

Besant, W., 1894. *London*. Chatto & Windus.

Betjeman, J., 1993. *City of London Churches*. Pitkin.

Birchenough, A., Dwyer, E., Elsden, N. & Lewis, H., 2010. *Tracks through Time: Archaeology and History from the London Overground East London Line. Revised Edition*. Museum of London Archaeology for London Transport.

Black, G., 2007. *Jewish London: An Illustrated History*. Tymsder.

Blatherwick, S. & Bluer, R., 2009. *Great Houses, Moats and Mills on the South Bank of the Thames: Medieval and Tudor Southwark and Rotherhithe*. Museum of London Archaeology Service (Monograph No. 47).

Cited and Other References

Bloom, C., 2003. *Violent London: 2,000 Years of Riots, Rebels and Revolts.* Sidgwick & Jackson.

Bluer, R., Brigham, T. & Nielsen, R., 2006. *Roman and Later Development East of the Forum and Cornhill: Excavations at Lloyds Register, 71 Fenchurch Street, City of London.* Museum of London Archaeology Service (Monograph No. 30).

Bowsher, D., Dyson, T., Holder, W. & Howell, J., 2007. *The London Guildhall: An archaeological history of a neighbourhood from early medieval to modern times.* Museum of London Archaeology Service (Monograph No. 36).

Bowsher, J. & Miller, P., 2009. *The Rose and the Globe – Playhouses of Shakespeare's Bankside, Southwark: Excavations 1988–90.* Museum of London Archaeology Service (Monograph No. 48).

Boyd, P. D. A., 1981. 'The Micropalaeontology and Palynology of Medieval Estuarine Sediments from the Fleet and Thames in London', pp. 274–292 in Neale, J. W. & Brasier, M. D. (eds), *Microfossils from Recent and Fossil Shelf Seas.* Ellis Horwood.

Bradley, S. & Pevsner, N., 1997. *The Buildings of England: London 1: The City of London.* Penguin (reprinted in 2002 by Yale University Press).

Bradley, S. & Pevsner, N., 1998. *London: The City Churches.* Yale University Press.

Brandon, D. & Brooke, A., 2011. *Bankside: London's Original District of Sin.* Amberley.

Brickley, M., Miles, A. & Stainer, H., 1999. *The Cross Bones Burial Ground, Redcross Way, Southwark, London* ... Museum of London Archaeology Service (Monograph No. 3)

Brigham, T. & Woodger, A., 2001. *Roman and Medieval Townhouses on the London Waterfront: Excavations at Governor's House, City of London.* Museum of London Archaeology Service (Monograph No. 9).

Brooke, A., 2010. *Fleet Street: The Story of a Street.* Amberley.

Brooke, A. & Brandon, D., 2004. *Tyburn: London's Fatal Tree.* Sutton.

Brooke, A. & Brandon, D., 2010. *Olde London Punishments.* The History Press.

Brown, C., 2009. *Whitehall – The Street that Shaped a Nation.* Simon & Schuster.

Bull, R., Davis, S., Lewis, H., Phillpotts, C. & Birchenough, A., 2011. *Holywell Priory and the Development of Shoreditch to c. 1600: Archaeology from the London Overgound East London Line.* Museum of London Archaeology Service (Monograph No. 53).

Burch, M., Treveil, P. & Keene, D., 2011. *The development of early medieval and later Poultry and Cheapside: Excavations at 1 Poultry and vicinity, City of London.* Museum of London Archaeology Service (Monograph No. 38).

Burke, T., 1949. *The Streets of London: Fourth Edition.* Batsford.

Butler, J., 2006. *Reclaiming the Marsh: Archaeological Excavations at Moor House, City of London, 1998–2004.* Pre-Construct Archaeology (Monograph No. 6).

Byrne, M. & Bush, G. R. (eds), 2007. *St Mary-le-Bow: A History.* Wharncliffe Books, Barnsley.

Callaway, E., 2011. 'The Black Death Decoded: The genome of a 660-year-old bacterium is revealing secrets from one of Europe's darkest chapters.' *Nature* 478: pp. 444–446.

Campbell, J. W. P., 2007. *Building St Paul's.* Thames & Hudson.

Christopher, J., 2012. *Wren's City of London Churches.* Amberley.

Clark, J., 2010. 'London Stone: Stone of Brutus or Fetish Stone – Making the Myth.' *Folklore* 121(1): pp. 38–60.

Clayton, A., 2008. *The Folklore of London: Legends, Ceremonies and Celebrations Past and Present.* Historical Publications.

Clements, D. (compiler), 2010. *The Geology of London. Geologists' Association Guide* No. 68.

Clout, H., 2004. *The Times History of London: New Edition.* Times Books.

Cohen, N. & Stevens, N., 2011. Medieval Fishing on the Isle of Dogs. *London Archaeologist* 13(2): p. 55.

Collyer, B., 2003a. *The Great Plague.* Folio Society.

Collyer, B., 2003b. *The Great Fire.* Folio Society.

Cooper, M., 2003. *Robert Hooke and the Rebuilding of London*. Sutton.

Cowan, C., 2003. *Urban development in north-west Roman Southwark*. Museum of London Archaeology Service (Monograph No. 16).

Cowan, C., Seeley, F., Wardle, A., Westman, A. & Wheeler, L., 2009. *Roman Southwark settlement and economy*. Museum of London Archaeology Service (Monograph No. 42).

Cowie, R. & Blackmore, L., 2008. *Early and Middle Saxon Rural Settlement in the London Region*. Museum of London Archaeology Service (Monograph No. 41).

Davies, P., 2009. *Lost London: 1870–1945*. English Heritage.

Day, M., 2011. *Shakespeare's London*. Batsford.

Defoe, D., 1722 (reprinted in 2003). *A Journal of the Plague Year*. Penguin.

De la Bedoyere, G., 1995. *The Diary of John Evelyn*. The Boydell Press.

De la Ruffiniere du Prey, P., 2000. *Hawksmoor's London Churches: Architecture and Theology*. The University of Chicago Press.

Downes, K., 1970 (reprinted in 2005). *Hawksmoor*. Thames & Hudson.

Downes, K., 1988. *The Architecture of Wren: Third Edition*. Redhedge.

Drummond-Murray, J., Thompson, P. & Cowan, C., 2002. *Settlement in Roman Southwark: Archaeological Excavations (1991–8) for the London Underground Limited Jubilee Line Extension Project*. Museum of London Archaeology Service (Monograph No. 12).

Dunwoodie, L., 2004. *Pre-Boudican and later activity on the site of the forum: Excavations at 168 Fenchurch Street, City of London*. Museum of London Archaeology Service (Archaeology Studies Series No. 13).

Dyson, T., Samuel, M., Steele, A. & Wright, S. M., 2011. *The Cluniac Priory and Abbey of St Saviour Bermondsey, Surrey*. Museum of London Archaeology Service (Monograph No. 50).

Elsden, N. J., 2002. *Excavations at 25 Cannon Street, City of London*. Museum of London Archaeology Service (Archaeology Studies Series No. 5).

FitzStephen, W., 1183. '*Descriptio nobilissimae civitatis Londiniae*' (preface to *Vita St Thomae*).

Foxell, S., 2007. *Mapping London: Making Sense of the City*. Black Dog.

Grainger, I., Hawkins, D., Cowal, L. & Mikulski, R., 2008. *The Black Death Cemetery, East Smithfield, London*. Museum of London Archaeology Service (Monograph No. 42).

Grainger, I. & Phillpotts, C., 2010. *The Royal Navy Victualling Yard, East Smithfield, London*. Museum of London Archaeology Service (Monograph No. 45)

Grainger, I. & Phillpotts, C., 2011. *The Cistercian Abbey of St Mary Graces, East Smithfield, London*. Museum of London Archaeology Service (Monograph No. 44)

Griffiths, A. & Kesnerova, G., 1983. *Wenceslaus Hollar: Prints and Drawings*. British Museum Publications, in association with the Museum of London.

Griffiths, P., 2008. *Lost Londons: Change, Crime and Control in the Capital City, 1550–1660*. Cambridge University Press.

Griffiths, P. & Jenner, M. S. R. (eds), 2000. *Londinopolis: Essays in the Cultural and Social History of Early Modern London*. Manchester University Press.

Grovier, K., 2008. *The Gaol: The Story of Newgate, London's Most Notorious Prison*. John Murray.

Gurr, E., 2009. *The Rose: Bankside's First Theatre (1587)*. Rose Theatre Trust.

Hahn, D., 2003. *The Tower Menagerie*. Simon & Schuster.

Halliday, S., 2006. *Newgate: London's Prototype of Hell*. Sutton.

Hammer, F., 2003. *Industry in north-west Roman Southwark*. Museum of London Archaeology Service (Monograph No. 17).

Hanawalt, B. A., 1993. *Growing up in Medieval London: The Experience of Childhood in History*. Oxford University Press.

Hanson, K., 2001. *The Dreadful Judgement: The True Story of the Great Fire of London*. Doubleday.

Harkness, D. E., 2007. *The Jewel House: Elizabethan London and the Scientific Revolution*. Yale University Press.

Harris, E., 2009. *Walking London Wall*. The History Press.

Heard, K. & Goodburn, D., 2003. *Investigating the Maritime History of Rotherhithe: Excavations at Pacific Wharf, 165 Rotherhithe Street, Southwark*. Museum of London Archaeology Service (Archaeology Studies Series No. 11).

Hibbert, C., 1969. *London: The Biography of a City*. Longmans.

Hill, J. & Rowsome, P., 2011. *Roman London and the Walbrook Stream Crossing: Excavations at 1 Poultry and Vicinity, City of London*. Museum of London Archaeology Service (Monograph No. 37).

Hill, J. & Woodger, A., 1999. *Excavations at 72–78 Cheapside/83–93 Queen Street, City of London*. Museum of London Archaeology Service (Archaeology Studies Series No. 20).

Hollis, L., 2008. *The Phoenix: The Men Who Made Modern London*. Phoenix.

Hollis, L., 2011. *The Stones of London: A History in Twelve Buildings*. Weidenfeld & Nicolson.

Holmes, M., 1969. *Elizabethan London*. Cassell.

Hostettler, E., 2000. *The Isle of Dogs, 1066–1918: A Brief History*. Island History Trust.

Howard, R. & Nash, B., 2010. *Secret London: An Unusual Guide*. Jonglez.

Howe, E., 2002. *Roman Defences and Medieval Industry: Excavations at Baltic House, City of London*. Museum of London Archaeology Service (Monograph No.7).

Howe, E. & Lakin, D., 2004. *Roman and Medieval Cripplegate, City of London: Archaeological Excavations 1992–8*. Museum of London Archaeology Service (Monograph No. 21).

Howell, J., 1657. *Londinopolis: An Historical Discourse or Perlustration of the City of London ...*

Huelin, G., 1996. *Vanished Churches of the City of London*. Guildhall Library Publications.

Humphrey, S., 2011. *London's Churches and Cathedrals*. New Holland.

Hyde, R., 1999. *London in Paintings*. Guildhall Art Gallery.

Hyde, R., Fisher, J. & Cline, R., 1992. *The A to Z of Restoration London (The City of London, 1676)*. London Topographical Society (Publication No. 145).

Impey, E., 2008. *The White Tower*. Yale University Press.

Impey, E. & Parnell, G., 2000. *The Tower of London: The Official Illustrated History*. Merrell.

Inwood, S., 1998. *A History of London*. Carroll & Graf.

Inwood, S., 2008. *Historic London: An Explorer's Companion*. MacMillan.

Jackson, P., 2002. *London Bridge: A Visual History: Revised Edition*. Historical Publications.

Jeffery, P., 1996. *The City Churches of Sir Christopher Wren*. Continuum.

Jenkyns, R., 2011. *Westminster Abbey: Revised and Updated Edition*. Profile.

Jones, N., 2011. *Tower: An Epic History of the Tower of London*. Hutchinson.

Keene, D., Burns, A. & Saint, A., 2004. *St Paul's: The Cathedral Church of London, 604–2004*. Yale University Press.

Keevill, G., 2004. *The Tower of London Moat: Archaeological Excavations 1995–9*. Oxford Archaeology (Historic Royal Palaces Monograph No. 1).

Kent, W., 1947. *Lost Treasures of London*. Phoenix House.

Kent, W., 1970. *An Encyclopaedia of London*. J. M. Dent.

Kenyon, N. (ed.), 2011. *The City of London: Architectural Tradition & Innovation in the Square Mile*. Thames & Hudson.

Kingsford, C. L., 1915. *The Grey Friars of London*. Aberdeen.

Knight, H., 2002. *Aspects of Medieval and later Southwark: Archaeological Excavations (1991–8) for the London Underground Limited Jubilee Line Extension Project*. Museum of London Archaeology Service (Monograph No. 13).

Latham, R. (ed.), 1985. *The Shorter Pepys: (A Selection Edited by Robert Latham from 'The Diary of Samuel Pepys, a New and Complete Transcription', Edited by Robert Latham and William Matthews)*. Bell & Hyman.

Leary, J., Branch, N. & Rayner, L. 2011. 'Prehistoric Southwark: Neolithic, Bronze Age and Iron Age activity on Horselydown Eyot.' *London Archaeologist* 13(2): pp. 31–35.

Lewis, J. E. (ed.), 2008. *London: The Autobiography (2,000 Years of the Capital's History by Those Who Saw it Happen)*. Robinson.

Lobel, M. D. (ed.), 1989. *The British Atlas of Historic Towns, Vol. III: The City of London from Prehistoric Times to c. 1520*. Oxford.

Long, D., 2007. *Tunnels, Towers & Temples: London's 100 Strangest Places*. Sutton.

Long, D., 2011. *Hidden City: The Secret Alleys, Courts and Yards of London's Square Mile*. The History Press.

Lubbock, P. J. A., 1981. *The Halls of the Livery Companies of the City of London*. The Lavenham Press.

Lyon, J., 2007. *Within these walls: Roman and medieval defences north of Newgate at the Merrill Lynch Financial Centre, City of London*. Museum of London Archaeology Service (Monograph No. 33).

Malcolm, G., Bowsher, D. & Cowie, R., 2003. *Middle Saxon London: Excavations at the Royal Opera House, 1989–99*. Museum of London Archaeology Service (Monograph No. 15).

Malcolm, J. P., 1807. *Londonium Redivivium*. Rivington.

Marriott, J., 2011. *Beyond the Tower: A History of East London*. Yale University Press.

Marsden, P., 1975. 'The Excavation of a Roman Palace Site in London, 1961–1972.' *Transactions of the London and Middlesex Archaeological Society* 26: pp. 1–102.

Marsden, P., 1994. *Ships of the Port of London: First to Eleventh Centuries*. English Heritage.

Merrifield, R., 1969. *Roman London*. Cassell.

Merrifield, R., 1983. *London: City of the Romans*. Batsford.

Merriman, N., 1990. *Prehistoric London*. Museum of London.

Miles, A., White, W. & Tankard, D., 2008. *Burial at the site of the parish church of St Benet Sherehog before and after the Great Fire: Excavations at 1 Poultry, City of London*. Museum of London Archaeology Service (Monograph No. 39).

Millar, S., 2011. *London's City Churches*. Metro.

Millar, S., 2011. *London's Hidden Walks*. Metro.

Mills, A. D., 2010. *A Dictionary of London Place Names: Second Edition*. Oxford University Press.

Milne, G., 1985. *The Port of Roman London*. Batsford.

Milne, G., 2003. *The Port of Medieval London*. Tempus.

Milne, G. & Cohen, N., 2002. *Excavations at Medieval Cripplegate, London: Archaeology after the Blitz, 1946–68*. English Heritage.

Moore, B., 2010. *The Square Mile: A Photographic Portrait of the City*. Frances Lincoln.

Myers, A. R., 2009. *Chaucer's London: Everyday Life in London 1342–1400*. Amberley.

Myers, S., 2011. *Walking on Water: London's Hidden Rivers Revealed*. Amberley.

Oates, J., 2009. *Attack on London: Disaster, Rebellion, Riot, Terror & War*. Wharncliffe.

Panton, K., 2003. *London: A Historical Companion*. Scarecrow.

Parnell, G., 1998. *Tower of London Past and Present*. The History Press.

Payne, H., 2011. 'The First Olympic Village: Finished 3,000 Years Ahead of Schedule (Bronze Age Settlement at the Olympics Aquatic Centre).' *London Archaeologist* 12(12): pp. 315–320.

Pearson, D., 2011. *London: 1,000 Years (Treasures from the Collections of the City of London)*. Scala.

Pevsner, N., 1957. *The Buildings of England: London 1: The Cities of London and Westminster*. Penguin.

Picard, L., 1997. *Restoration London*. Weidenfeld & Nicolson.

Picard, L., 2003. *Elizabeth's London*. Weidenfeld & Nicolson.

Pitt, K., 2006. *Roman and medieval development south of Newgate.* Museum of London Archaeology Service (Archaeology Studies Series No. 14).

Porter, R., 1994. *London: A Social History.* Hamish Hamilton.

Porter, S., 2008. *The Plagues of London.* The History Press.

Porter, S., 2009. *The Great Fire of London.* The History Press.

Porter, S., 2011a. *Shakespeare's London: Everyday Life in London 1580–1616.* Amberley.

Porter, S., 2011b. *Pepys's London: Everyday Life in London 1650–1703.* Amberley.

Porter, S. & Marsh, S., 2010. *The Battle for London.* Amberley.

Prockter, A. & Taylor, R. 1979. *The A to Z of Elizabethan London.* London Topographical Society (Publication No. 122).

Pulley, J., 2006. *Streets of the City: Histories of the City of London's Principal Streets.* Capital History.

Riches, C., 2011. *The Times Atlas of London.* Times Books.

Ross, C. & Clark, J., 2008. *London: The Illustrated History.* Allen Lane.

Roud, S., 2008. *London Lore: The Legends and Traditions of the World's Most Vibrant City.* Random House.

Rowse, A. L., 1972. *The Tower of London in the History of the Nation.* Weidenfeld & Nicolson.

Rowsome, P., 2000. *Heart of the City: Roman, Medieval and Modern London Revealed by Archaeology of No. 1 Poultry.* Museum of London Archaeology Service.

Saunders, A., 1984. *The Art and Architecture of London: An Illustrated Guide.* Phaidon.

Saunders, A., 2001. *St Paul's: The Story of the Cathedral.* Collins & Brown.

Schofield, J., 1984. *The Building of London from the Conquest to the Great Fire.* British Museum Publications, in association with the Museum of London.

Schofield, J. (ed.), 1987. *The London Surveys of Ralph Treswell.* London Topographical Society (Publication No. 135).

Schofield, J., 1995 (reprinted 2003). *Medieval London Houses.* Yale University Press.

Schofield, J., 2011a. *London 1100–1600: The Archaeology of a Capital City.* Equinox.

Schofield, J., 2011b. *St Paul's Cathedral Before Wren.* English Heritage.

Schofield, J., 2011c. Bringing London's Archaeology to a Wider Public: The Work of the City of London Archaeological Trust). *London Archaeologist* 13(2): pp. 37–41.

Schofield, J. & Lea, R., 2005. *Holy Trinity Priory, Aldgate, City of London.* Museum of London Archaeology Service (Monograph No. 24).

Schofield, J. & Pearce, J., 2009. 'Thomas Soane's Buildings near Billingsgate, London, 1640–66.' *Post-Medieval Archaeology* 43: pp. 282–341.

Seeley, D. & Drummond-Murray, J., 2005. *Roman Pottery Production in the Walbrook Valley: Excavations at 20–28 Moorgate, City of London, 1998–2000.* Museum of London Archaeology Service (Monograph No. 25).

Seeley, D., Phillpotts, C. & Samuel, M., 2006. *Winchester Palace: Excavations at the Southwark Residence of the Bishops of Winchester.* Museum of London Archaeology Service (Monograph No. 31).

Sidell, J., Wilkinson, K., Scaife, R. & Cameron, N., 2000. *The Holocene Evolution of the London Thames: Archaeological Excavations (1991–1998) for the London Underground Limited Jubilee Line Extension Project.* Museum of London Archaeology Service (Monograph No. 5).

Sinclair, G., 2009. *Historic Maps and Views of London Publishers.* Black Dog & Leventhal.

Sloane, B., 2011. *The Black Death in London.* The History Press.

Sloane, B. & Malcolm, G., 2004. *Excavations at the Priory of the Order of the Hospital of St John of Jerusalem, Clerkenwell, London.* Museum of London Archaeology Service (Monograph No. 20).

Stephenson, A., 1996. *Cannon Place, London EC4.* Museum of London Archaeology Service Assessment Report.

Stow, J., 1598 (reprinted in 2005). *A Survey of London*. Sutton.

Strype, J., 1720. *Survey of the Cities of London and Westminster*. Churchill.

Stuttard, J., 2008. *From Whittington to World Financial Centre: The City of London and its Lord Mayor*. Phillimore.

Sutcliffe, A., 2006. *London: An Architectural History*. Yale University Press.

Swift, D., 2008. *Roman Waterfront Development at 12 Arthur Street, City of London*. Museum of London Archaeology Service (Archaeology Studies Series No. 9).

Talling, P., 2011. *London's Lost Rivers*. Random House.

Tames, R., 1995. *City of London Past*. Historical Publications.

Tames, R., 2002. *London: A Traveller's History: Fourth Edition*. Cassell.

Tames, R., 2006. *The City of London Book*. Historical Publications.

Tames, R., 2008. *The London We Have Lost*. Historical Publications.

Tames, R., 2009. *Shakespeare's London on Five Groats a Day*. Thames & Hudson.

Thomas, C. 2002. *The Archaeology of Medieval London*. Sutton.

Thomas, C., 2003. *London's Archaeological Secrets*. Yale University Press, in association with the Museum of London Archaeology Service.

Thomas, C., Cowie, R. & Sidell, J., 2006. *The Royal Palace, Abbey and Town of Westminster on Thorney Island: Archaeological Excavations (1991–8) for the London Underground Limited Jubilee Line Extension Project*. Museum of London Archaeology Service (Monograph No. 22).

Thomas, C., Sloane, B. & Phillpotts, C., 1997. *Excavations at the Priory and Hospital of St May Spital, London*. Museum of London Archaeology Service (Monograph No. 1).

Thurley, S., 2009. *Somerset House: The Palace of England's Queens*. London Topographical Society (Publication No. 168).

Timbs, J., 1865. *Romance of London: Historic Sketches etc*. R. Bentley.

Tindall, G., 2003. *The Man Who Drew London: Wenceslaus Hollar in Reality and Imagination*. Pimlico.

Tinniswood, A., 2001. *His Invention So Fertile: A Life of Christopher Wren*. Jonathan Cape.

Tinniswood, P., 2004. *By Permission of Heaven: The Story of the Great Fire of London*. Pimlico.

Tomalin, C., 2002. *Samuel Pepys: The Unequalled Self*. Penguin.

Tucker, T., 2010. *The Visitor's Guide to the City of London Churches*. The Horizon Press.

Tudor-Craig, P., 2004. *'Old St Paul's': The Society of Antiquaries' Diptych, 1616*. London Topographical Society and The Society of Antiquaries of London.

Warner, M., 1987. *The Image of London: View by Travellers and Emigres 1550–1920*. Barbican Art Gallery/Trefoil.

Watson, B., 2004. *Old London Bridge Lost and Found*. Museum of London Archaeology Service.

Watson, B., Brigham, T. & Dyson, A., 2001. *London Bridge: 2,000 Years of a River Crossing*. Museum of London Archaeology Service (Monograph No. 8).

Watson, S., 2003. *An Excavation in the Western Cemetery of Roman London*. Museum of London Archaeology Service (Archaeology Studies Series No. 7).

Watson, S. & Heard, K., 2006. *Development on Roman London's western Hill: Excavations at Paternoster Square, City of London*. Museum of London Archaeology Service (Monograph No. 32).

Webb, S., 2011a. *Life in Roman London*. The History Press.

Webb, S., 2011b. *Unearthing London: The Ancient World beneath the Metropolis*. The History Press.

Weinreb, B., Hibbert, C., Keay, J. & Keay, J. (eds), 2008. *The London Encyclopaedia: Third Edition*. MacMillan.

Weinstein, R., 1994. *Tudor London*. Museum of London.

Whinney, M., 1971 (reprinted in 2005). *Wren*. Thames & Hudson.

Whipp, D., 2006. *The Medieval Postern Gate by the Tower of London*. Museum of London Archaeology Service (Monograph No. 29).

Whitfield, P., 2006. *London: A Life in Maps*. The British Library.

Willows, H. (ed.), 1988. *A Guide to Worship in Central London*. London Central YMCA (distributed by Fowler Wright books).

Wittich, J., 1990. *Discovering London Curiosities: Third Edition*. Shire.

Wittich, J., 1996. *Discovering London Street Names: Third Edition*. Shire.

Wittich, J. & Phillips, R., 2008. *Discovering Off-Beat Walks in London*. Shire.

Yule, B., 2005. *A prestigious Roman building complex on the Southwark waterfront: excavations at Winchester Palace, London, 1983–90*. Museum of London Archaeology Service (Monograph No. 23).

OTHER RESOURCES

Ackroyd's *London: The Biography* (abridged version on Audio CD, read by Simon Callow). Random House Audio Books.
Four Very Detailed Maps, Medieval to Twentieth Century London (1520, 1666, 1843, 1902). Old House Books, Moretonhampstead, Devon.
Londinium: a New Map and Guide to Roman London. Museum of London Archaeology Service.
Pepys's Diary (abridged version on Audio CD, read by Kenneth Branagh). Hodder & Stoughton Audio Books.
Pepys's London iPhone and iPad apps (available for purchase through iTunes).
Streetmuseum iPhone and iPad apps (produced by the Museum of London).
Streetmuseum Londinium iPhone and iPad apps (produced by the Museum of London).
www.british-history.ac.uk
www.britishmuseum.org.uk
www.cathedral.southwark.anglican.org (Southwark Cathedral).
www.cityoflondon.gov.uk (contains many useful links, for example, to the Guildhall Library, and to the London Metropolitan Archives).
www.cityoflondon.gov.uk/blueplaques
www.cityoflondontouristguides.com
www.colas.org.uk (City of London Archaeological Society).
www.facebook.com/TheLostCityofLondon
www.friendsoffriendlesschurches.org.uk
www.greatstbarts.com (St Bartholomew the Great).
www.hrp.org.uk/TowerOfLondon
www.incheapside.co.uk
www.london-city-churches.org.uk (Friends of the City Churches).
www.lostcityoflondon.co.uk
www.museumoflondon.org.uk
www.nationalarchives.gov.uk
www.oldlondonbridge.com
www.pepysdiary.com
www.stpauls.co.uk
www.templechurch.com
www.vam.ac.uk (Victoria and Albert Museum).
www.visitlondon.com/travel/detail/209511-city-of-london-information-centre (City of London Information Centre).
www.westminster-abbey.org
www.parliament.uk/about/living-heritage/building/palace/westminsterhall
William Shakespeare's London: A Commemorative Souvenir of Shakespearean London (featuring a reproduction of the Braun & Hogenberg map of 1572). Shakespeare's Globe.

LIST OF ILLUSTRATIONS

1. © Robert Wynn Jones
2. © Robert Wynn Jones
3. © Robert Wynn Jones
4. © Robert Wynn Jones
5. © Robert Wynn Jones
6. © Robert Wynn Jones
7. © Robert Wynn Jones
8. © Robert Wynn Jones
9. © Robert Wynn Jones
10. © Robert Wynn Jones
11. © Robert Wynn Jones
12. © Robert Wynn Jones
13. © Robert Wynn Jones
14. © Robert Wynn Jones
15. © Robert Wynn Jones
16. © Robert Wynn Jones
17. © Robert Wynn Jones
18. © Robert Wynn Jones
19. © Robert Wynn Jones
20. © Robert Wynn Jones
21. © Robert Wynn Jones
22. © Robert Wynn Jones
23. © Robert Wynn Jones
24. © Robert Wynn Jones
25. © Robert Wynn Jones
26. © Robert Wynn Jones
27. © Robert Wynn Jones
28. © Robert Wynn Jones
29. © Robert Wynn Jones
30. © Robert Wynn Jones
31. © Robert Wynn Jones
32. © Robert Wynn Jones
33. © Stephen Porter
34. © Robert Wynn Jones
35. © Robert Wynn Jones
36. © Robert Wynn Jones
37. © Robert Wynn Jones
38. © Robert Wynn Jones
39. © Robert Wynn Jones
40. © Robert Wynn Jones
41. © Robert Wynn Jones
42. © Robert Wynn Jones
43. © Robert Wynn Jones
44. © Robert Wynn Jones
45. © Robert Wynn Jones
46. © Robert Wynn Jones
47. © Robert Wynn Jones
48. © Robert Wynn Jones
49. © Jonathan Reeve
 JR1074b3fp156 15501600
50. © Robert Wynn Jones
51. © Robert Wynn Jones
52. © Robert Wynn Jones
53. © Robert Wynn Jones
54. © Robert Wynn Jones
55. © Robert Wynn Jones
56. © Jonathan Reeve
 JR1076b3fp166 16001650
57. © Robert Wynn Jones
58. © Robert Wynn Jones
59. © Robert Wynn Jones
60. © Robert Wynn Jones
61. © Robert Wynn Jones
62. © Robert Wynn Jones
62. © Robert Wynn Jones
63. © Robert Wynn Jones
64. © Jonathan Reeve
 JR1077b3fp174 16001650
65. © Robert Wynn Jones
66. © Robert Wynn Jones
67. © Robert Wynn Jones
68. © Jonathan Reeve
 JR1952b22p1248 16001650
69. © Robert Wynn Jones
70. © Jonathan Reeve
 JR376b21p346 16001650
71. © Jonathan Reeve
 JR182b4p787 15501600
72. © Robert Wynn Jones
73. © Jonathan Reeve
 JR1947b25p1510 16501700
74. © Jonathan Reeve
 JR1949b25p1537 16501700
75. © Stephen Porter

76. © Stephen Porter
77. © Robert Wynn Jones
78. © Robert Wynn Jones
79. © Robert Wynn Jones
80. © Robert Wynn Jones
81. © Jonathan Reeve
 JR1904b94fp130 16501700
82. © Jonathan Reeve
 JR2067b67plxxii 16001650
83. © Robert Wynn Jones

84. © Robert Wynn Jones
85. © Robert Wynn Jones
86. © Stephen Porter
87. © Stephen Porter
88. © Stephen Porter
89. © Stephen Porter
90. © Stephen Porter
91. © Stephen Porter
92. © Stephen Porter

Also available from Amberley Publishing